Outdoor Sculpture

OBJECT AND ENVIRONMENT

Outdoor Sculpture

OBJECT AND ENVIRONMENT **MARGARET A. ROBINETTE**

WHITNEY LIBRARY OF DESIGN an imprint of WATSON-GUPTILL PUBLICATIONS/NEW YORK

Library of Congress Cataloging in Publication Data
Robinette, Margaret A 1932-
Outdoor sculpture.
Bibliography: p.
Includes index.
1. Sculpture—United States. 2. Sculpture, Modern
—20th century—United States. 3. Art, Municipal—
United States. 4. Urban beautification—United States.
I. Title.
NB212.R62 731′.8 75–34326
ISBN 0–8230–7406–4

First Printing, 1976

To Gary
For positive criticism,
generous advice, and
unwavering support in
all my projects

Contents

Preface

This book is not an argument for the value of placing art in the contemporary environment. Today's urgent concern for the quality of life places a heavy burden of responsibility upon those people and groups — environmental designers, community organizations, governmental agencies, business, and other institutions—who play significant roles in determining the quality of the physical environment. These people are well aware of the essential contribution of the visual arts.

The use of outdoor sculpture is one of the most visible and easily accessible ways to include the visual arts in the environment. Outstanding projects of recent years testify to this, as do new ones currently being undertaken by communities, business, and other public and private institutions. Many of these projects reflect most favorably upon the communities or institutions with which they are associated. Take, for example, Alexander Calder's great stabile in Grand Rapids, Michigan, or Jean Dubuffet's Group of Four Trees at Chase Manhattan Bank in New York City or Pablo Picasso's giant abstract steel work in Chicago's Civic Center Plaza. There are many more, some not so famous, but equally significant.

Not all works of outdoor sculpture are successful, not all programs undertaken have been well received, and not all worthwhile programs have been carried beyond the conceptual stage. One reason for the first situation is lack of communication among those involved in the processes of designing the setting and selecting and placing the work. This lack of communication causes problems that result in disharmony in the environment.

For example, a sculptor may create works intended to be placed in an outdoor setting — urban, suburban, or rural. An architect may design an office building or a landscape architect a city park for a client who wishes to place a work of sculpture near the building or in the park. It is possible that neither the sculptor nor the environmental designer will have any part in the selection and placement of the work, but that it will be chosen by the client or his agent, on the basis of personal preference. Even if the designer makes the selection there are many factors that he or she may overlook. The ideal situation of course is for informed collaboration among designer, artist, and client from the inception of the entire project. The information required for such informed collaboration is as essential when the selection and placement process occurs after the design is under way or even completed, which unfortunately is very often the case.

This kind of information comes from a consideration of both the setting and the work of sculpture to be placed there and includes elements such as the nature of the setting — whether urban or rural, whether defined by architecture or enclosed by trees — and the subject matter of the sculpture as well as its scale, form, and color in relation to the setting. Many artists and designers and a few clients are aware of some of these factors, but there is no literature that documents such information as a basis for communication among those who select and place outdoor sculpture. This book is a step in that direction, which, I hope, will prove useful, adaptable, and challenging.

The unavoidable truth that not all outdoor sculpture is well received by its audience, the public, must be acknowledged. Sometimes negative response is replaced in time with tolerance and a sort of casual pride, as in the case of the Picasso in Chicago's Civic Center. Sometimes initial hostility is transformed in a relatively short period of time to genuine appreciation and pride, as in the case of the Calder in Grand Rapids, Michigan. Sometimes animosity is exacerbated by misunderstanding to the point of stubborn rejection, as in the case of the monumental work by Mark di Suvero that ultimately was removed from in front of the Alameda County Courthouse in Oakland, California.

It is difficult to determine the reasons for negative reaction toward a work of public sculpture. Some people shrug their shoulders and say that hostility toward abstract or nonrepresentational art is "normal" and that it will subside in time. There may be some truth in this, but not a lot. One thing is certain, while public art cannot and should not be selected according to public taste, people do like to be consulted about their feelings toward art. Evidence of this was apparent in the pilot public opinion survey conducted as a part of this study. Similar surveys as well as other user-response studies and information programs on contemporary artists and their art could have a very positive influence on audience reaction and response.

That not all worthwhile outdoor sculpture programs are actually undertaken and brought to completion is an educated guess based on three years of research for this project and on inquiries from environmental designers and community groups. Among the obstructions are a lack of enthusiasm by those needed to support such programs and a lack of information on how they can be carried out. It is hoped that the examples cited throughout this book will kindle enthusiasm by demonstrating the variety of worthwhile projects that have been accomplished and that the information describing how it was done will encourage the launching and completion of new and even better outdoor sculpture projects in the future.

This book makes no pretense of being definitive or all-inclusive. There are many outstanding sculpture programs which of necessity have not been included. The sources of information listed in Appendix C are a beginning, not an end. Obviously this is not an art history book, and certainly not a recipe book on how to choose and place outdoor sculpture. Rather it is an information/inspiration book, which is intended to be put to practical use.

This entire project has been an information/inspiration experience for me. I am indeed grateful to all those who gave assistance and information. For recognizing the need for the project and approving the grant for the study, as well as for information and counsel, I am indebted to Bill N. Lacy, Director of the Architecture + Environmental Arts Program of the National Endowment for the Arts; to my friend and advisor Karel Yasko, Counselor to the Administrator on Fine Arts and Historic Preservation of the General Services Administration, for counsel and encouragement; to Dr. Charles S. Harris, Senior Associate, Roy Littlejohn Associates, Washington, D.C., for his invaluable assistance in preparation and evaluation of the public opinion survey; to my good friend Anita Margrill for her sustained interest, encouragement,

and excellent counsel; to Mrs. M. S. Keeler of Grand Rapids, Michigan, for hospitality, enthusiasm, and abundant supply of information about the Grand Rapids art programs; to Tony Rosenthal for his interest and generosity in supplying information; to Don Conway, Director of Research Programs, the American Institute of Architects, for time spent discussing viewer response and for numerous sources of information. Others who contributed information and materials are Frederick A. Gutheim, Washington, D.C.; Art Brenner, Paris; James Wines of SITE, Inc., New York; Theodore Osmundson of Osmundson & Associates, San Francisco; William Bridgers of Cornell, Bridgers, Troller & Hazlett of Los Angeles; Henry G. Gardiner, Director, Fine Arts Gallery of San Diego; Dorothy Mayhall, former Director, Storm King Art Center, Mountainville, New York; Frederick P. Walkey, Executive Director, DeCordova Museum, Lincoln, Massachusetts; The North Jersey Cultural Council; Grace Borgenicht Brandt, Director, Grace Borgenicht Gallery, New York; Jacquelyn Wright, Lantern Gallery, Ann Arbor, Michigan; Jack Mognaz and Pierre Apraxine, Marlborough Gallery, New York; Paul Frankel, Galerie Denise René, New York; The Chase Manhattan Bank N.A., New York; Gould, Inc., Rolling Meadows, Illinois; Burson-Marsteller, Chicago office; The Atlanta Georgia Chamber of Commerce; W. H. Sanders, Peachtree Center, Atlanta; Joseph Clough, *Grounds Maintenance* magazine; and many other individuals and organizations too numerous to thank individually.

Finally I wish to thank my editors, Susan Davis and Susan Braybrooke of the Whitney Library of Design. Their combined energy, skill, and experience have of course been the final ingredients in the transformation of manuscript into book. To Susan Davis I am especially indebted for the patience, insight, and understanding required to bring the manuscript to publishable form.

The research and photography for this book were supported by a grant from the Architecture + Environmental Arts Program of the National Endowment for the Arts, a federal agency. Portions of this book have been adapted from a thesis submitted to George Washington University, Washington, D.C., as partial fulfillment of the requirements for the degree of Master of Arts, awarded in May 1974.

1 Significance and Functions of Outdoor Sculpture

It has been said that "the language of sculpture is a universal language and it can speak directly to us even though we know nothing whatever about a particular work apart from what we can see of it in front of our eyes."[1] The language of sculpture is also a timeless one, for people have used its vocabulary to create expressions of their inner spirit as well as of their social and cultural milieu from the age of the pyramids to the age of the skyscrapers and beyond (we are at present nosing our uncertain way into that world of the "beyond").

L. R. Rogers suggests that perhaps it is a mistake "to speak of the art of the past as if in contrast with the art of the present . . . pieces of sculpture which were produced hundreds or thousands of years ago exist here and now and are present to our senses in the same way as those that were produced yesterday."[2] Certainly viewing the colossal magnificence of the four seated kings at Abu Simbel in Egypt is probably a no less moving experience, though in a different way, for the 20th-century tourist than it was for the 20th-dynasty Egyptian. "There is no such thing," says Rogers, "as aesthetic obsolescence."[3] Thus it seems reasonable to assume that the enduring value of sculpture — of exterior sculpture—is closely related to esthetic qualities and to people's reaction to and appreciation of such qualities. In 1938 James Earle Fraser, an American sculptor, wrote an article on the topic "Why Sculpture?" Expressing surprise that this art form was in need of defense, Fraser observed that "the study of form seems not to need defense. . . . It is enjoyed beyond most human assets, even though it may be little realized. . . . The glaciers that molded the hills and the valleys, the air and the sea, are sculptors without equal."[4]

Roles throughout History

It was not, however, the individual's intuitive appreciation of form that motivated him or her to create the first monumental outdoor sculpture. Surely this innate response to the gentle curves of hills, the twisted trunks and limbs of trees, the stark outcroppings, and the sheer size of rocks and boulders guided the creative process and influenced the product of primitive sculptors. The primary motive was the desire to create a symbolic image that would honor and please the gods or commemorate the dead. Thus the ancient Sumerians ornamented the doorways of thei temples with images like that of Im-dugud, the lion-headed eagle whose benevolence brought rain after drought, and the Egyptians created their seemingly unending procession of funerary statues. The secondary motive (though the order may well be reversed) was the individual's desire to somehow perpetuate himself — to attain immortality. That explains the giant royal statues erected at Abu Simbel by Rameses II and the magnificent relief carvings on the exterior walls of the palace complex of Darius and Xerxes at Persepolis.

Greek exterior sculpture continued to fulfill the religious/symbolic function in the adornment of temples to the gods, but the individual ego was subordinated to the concept of the "ideal," as artists struggled to harmonize the concept of fidelity to nature with that of ideal beauty. The Greek concern with the *esthetics* of a harmonious and healthy society reminds us that certain human and social problems must be solved anew by each succeeding civilization.

The Romans, though strongly imitative of the Greeks, seem to have had a greater ego involvement, creating such monumental commemorative works as the Arch of Constantine and Trajan's Column. The format of the latter, a portrait statue atop a high pedestal, remained the accepted form for honoring soldiers, kings, statesmen, heroes, and other notables, at least until the last few decades; possibly it will never be permanently discarded. A relatively recent example is the London portrait statue of Winston Churchill that was unveiled in October 1973. Hadrian's villa at Tivoli, with its statues adapted from Greek models, illustrates another enduring form of exterior sculpture — that of several works placed in a park-like setting.

Top left: Foreground, Auguste Rodin, *Balzac*; far right, Henri Matisse, *The Backs,* Hirshhorn National Museum and Sculpture Garden, Washington, D.C. The language of sculpture is a universal language.

Bottom left: James E. Fraser, *Abraham Lincoln,* Jersey City, New Jersey. A portrait statue atop a high pedestal is a traditional way of memorializing heroes and statesmen.

Right: Ivor Roberts-Jones R.A., *Winston Churchill,* London. This portrait statue of Winston Churchill was unveiled in Parliament Square in 1973. Photograph courtesy of the British Tourist Authority, New York.

Below: People experience an innate response to the sculptural forms of trees.

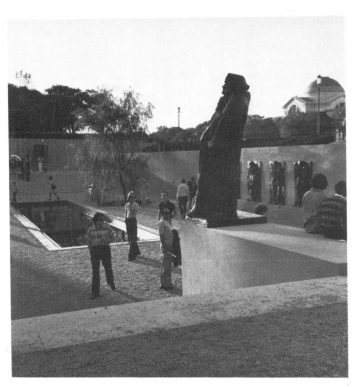

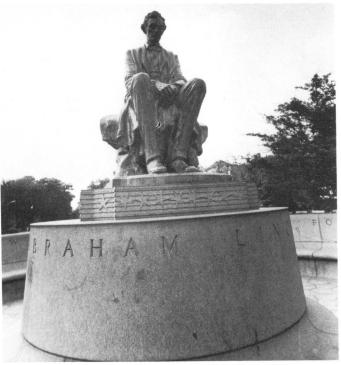

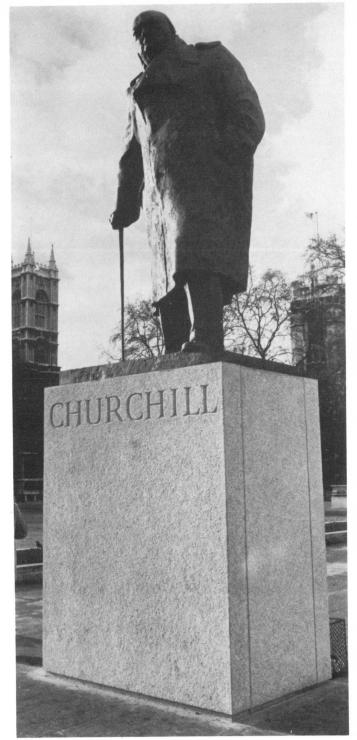

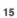

Although the appropriateness of the label "Dark Ages" has been thoroughly debated, the temper and quality of life during that period (roughly from 400 to 1000 A.D.) produced little in the way of exterior sculpture. As F. A. Gutheim points out, "The great renewal of monumental sculpture came with the cathedral-building years of the Middle Ages."[5] To the religious/symbolic functions of such sculpture was now added a didactic or educational one. The solemn rows of biblical figures, kings, and symbols that greeted the humble worshipper at the entrances of the great cathedrals were there to teach the truths of faith and conduct that people were unable to read about. This type of outdoor sculpture, inherently and often structurally a part of the architecture, conforms to a total programming of several art forms in order to convey a particular message, to emphasize a selected theme, or to create a unity of design. Contemporary examples of this kind of total programming are found, strangely enough, in some of our more carefully designed shopping malls (see Chapter 2, page 34).

It was in the Italian Renaissance that sculpture "reasserted its independence from architecture,"[6] emerging in such powerful declarations of the spirit of humanism as Michelangelo's *David* or *Moses*. Equestrian monuments commemorated heroes, and fountains with allegorical/mythological/symbolical themes began to play a significant role in the ornamentation of gardens and the marking of special places, such as plazas or squares in cities. Giovanni Lorenzo Bernini's great Baroque monument in Rome, the *Fountain of the Four Rivers,* is surely a climactic statement in the development of this genre of exterior sculpture, while André Lenôtre's magnificent garden-park at Versailles, with its collection of sculpture and fountains, set a precedent as a monument to the

human ego that has never been surpassed. Although it was open to a very select public, it was nevertheless a public display. How else could all the world admire the greatness of Louis XIV?

In spite of all this, as Gutheim observes, "The ultimate flowering of the statue in a public place awaited the coming of the nineteenth century street memorials."[7] The remarkable proliferation of statues of heroes in marble and bronze can be attributed to the new patriotism and the new nationalism of that era, as well as to the fact that the technique of bronze casting had been recently perfected. In America the desire to honor heroes—not only those of the Civil War, but of the Revolutionary War as well—was responsible for the legion of portrait statues, commissioned by local or federal government, which still populate small town parks or even large urban malls and sometimes perch precariously in the center of what has become a busy intersection, scarcely noticed by the 20th-century crowd hurrying by in the rush of pedestrian and automobile traffic. It has been said that the new wave of patriotism and the desire to immortalize heroes produced "an endless parade of commonplace generals on prancing chargers and trite admirals with brass telescopes and cocked hats."[8] There is more than a grain of truth to this claim, and yet in that endless parade are some monuments whose grace and magnificence—not to mention familiarity as landmarks — would be sorely missed were they removed.

In the 1930s, when there was even stronger criticism of the dull naturalism and hackneyed neoclassicism of some of these statues in public places, and there was some agitation for their removal, F. A. Gutheim wrote the following perceptive comments:

While we may criticize and ridicule them on the ground of our present aesthetic dogmas and

from our modern point of view, these old stones have a unique eloquence quite beyond their value as antiquities. . . . They should stand as they were designed, monuments in public places. They should show us that there is little fixed and immutable in our opinions and beliefs today—least of all in art. They should remind us of past greatness and past errors alike, and aid in fixing the traditional principles and continuity in life. As object lessons they would thus serve their purpose: they are the milestones of taste which mark our cultural progress.[9]

Today's Changing Roles and Forms

Today's milestones of taste indicate that our culture has indeed changed since the 19th and early 20th centuries. A good deal of this change in style and form in outdoor sculpture may be attributed to the total modern art movement. Modern sculpture was born in Europe early in the 19th century, first in Paris and then in Moscow. America was slow on the uptake, probably because of a long devotion to European neoclassicism and academicism and a persistent self-consciousness about the quality and acceptability of an independent idiom. Americans have always been overburdened with a concern for status. Thus, as Wayne Craven points out, "What began in Europe before World War I did not really flower in the United States until after 1946. Only then did America in general really become aware of 'modern art.' "[10]

Left: E.S. Woods, *Nathan Hale,* Hartford, Connecticut. Portrait statues of heroes still abound in American communities—from small towns to large cities.

Top right: Louis T. Rebisso, *Brigadier General James B. McPherson,* Washington, D.C. The myriad statues of generals on prancing chargers make up a substantial cavalry in bronze.

Bottom right: Pablo Picasso, *Untitled,* Chicago. Today's milestones of taste are indicative of cultural change.

16

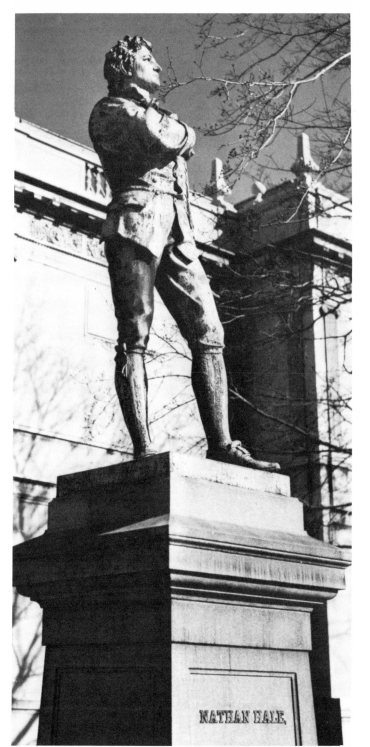

NATHAN HALE.

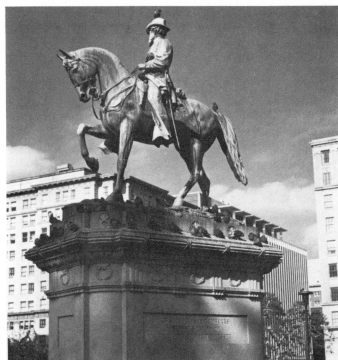

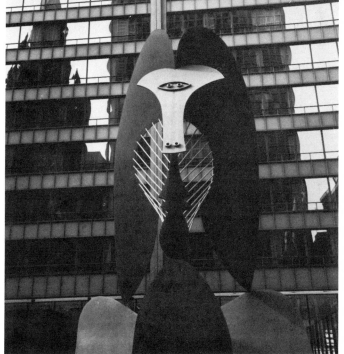

18

Following World War II American artists like David Smith and José de Rivera, assisted by such gifted European expatriates as Jacques Lipchitz, Naum Gabo, Alexander Archipenko, Elie Nadelman, and Marcel Duchamp, were responsible for the revolution in American sculpture[11] that ultimately brought about the change from traditional academic representationalism to nonrepresentational forms of "modern" art such as abstract expressionism and constructivism. Recognizing the primary role of the artist in creating new forms in any stylistic movement, we should be aware of some other influences upon sculpture in general and upon outdoor sculpture in particular. One of these factors is the availability of new materials, or the technology to use materials that have never before been used to create sculpture. Besides the traditional varieties of wood, stone, metal, and concrete, the sculptor uses such materials as a considerable variety of plastics, glass, cloth, found objects (including both manufactured and natural materials), new metals, and even beams of light.[12] These materials, adopted and adapted by sculptors, are appearing with increasing frequency in the outdoor environment in works expressing stylistic approaches known by such labels as abstract expressionism, constructivism, or minimalism. Sculpture in which abstract or nonrepresentational form is used for symbolic, expressive, or esthetic purposes is by no means new, yet to most people whose daily lives do not involve an intimate association with any branch of the arts, works in such styles are simply "modern art." However, with increasing public concern with the quality of life as well as greater general interest in and knowledge of the arts, the average person often displays a surprising sophistication and a genuine appreciation of all styles of contemporary sculpture.

Although architects most certainly play a significant role as selectors of sculptors or works of sculpture to adorn the exterior spaces related to their buildings, it is the change in architectural style itself that has influenced the kind of sculpture found in urban spaces. Surely an abstract work of adequate scale and harmonizing material is better suited to the plaza framed by steel and glass office buildings than a bronze equestrian portrait statue would be. That is not to say that representational sculpture is no longer suited to our contemporary environment, for there are innumerable varieties of settings and spatial situations in the modern world. Nor have we discarded and torn down all the architecture of preceding eras. Indeed, Paul Manship's gilded *Prometheus* in Rockefeller Plaza does, as Wayne Craven points out, belong to the era of Radio City Music Hall[13] and to the architecture of the 1930s and early 1940s. It still suits its setting admirably, and if taste in public sculpture has since changed, we can exercise F. A. Gutheim's benign rationality, accepting it as a milestone marking the cultural attitude and achievement of another day. The same philosophy might also prove helpful for those who find themselves reacting negatively to the newest cultural contributions.

Among other changes, a change in the purpose of public sculpture began to affect the creative task of the sculptor as early as the 1930s. Mr. Gutheim's perception is manifest in his assessment of this change:

The tasks that sculptors were called upon to perform in the past were primarily the memorializing of men and the commemoration of events. . . . But today, while the human equation remains as strong and the work of the individual as powerful as ever, it has become evident that the things we would prefer to remember are not personalities. They are rather the significant goals and advances which have been made, in some cases by individuals, in others by groups.

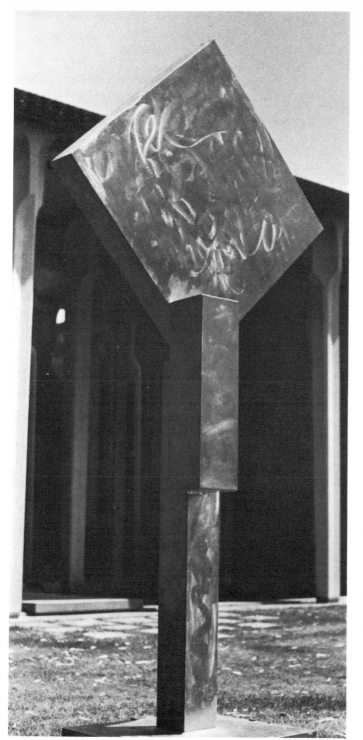

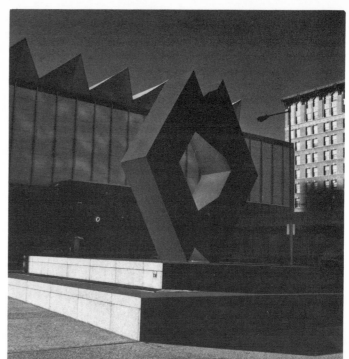

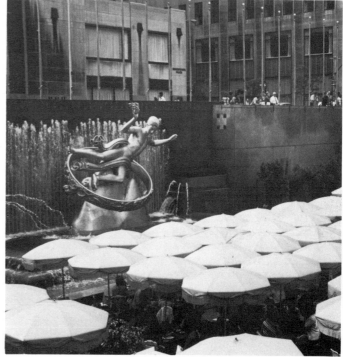

Is it not possible that the new task that faces the modern sculptor is to find artistic expression for these new and impersonal accomplishments? Are we still content to think of Einstein as a person: or is his significance in human thought capable of some richer, more symbolic expression?[14]

Since the 1930s a good many war memorials have been erected all over the world, commemorating great victories, great defeats, and great sacrifices. Many of them are symbolic abstractions—a fact that does not lessen their meaning or significance, but only enhances it.

Today further change in the purpose of public sculpture is evident. It rarely commemorates heroes and events, nor symbolizes accomplishments and goals. Instead its task appears to be esthetically enhancing its setting. It is expected to contribute visually and experientially to the quality of life of those who experience it as an element in their daily environment. There is, however, a sense that it is still symbolic and expressive, at least of the technological world in which we live.

The importance of new materials must not be underrated in the creation of today's sculpture. These new materials are only a by-product of a new society —a technological society—in which great changes have occurred and are occurring constantly. While artists are often conceptualists and avant-garde thinkers, we sometimes mistakenly feel that they are foisting upon us their radicalism via new art forms. What often happens in reality, as Douglas Davis points out in his book *Art and the Future*, is that "what begins as a conscious attempt to fit new materials into old forms ends with new forms based on those materials."[15] Perhaps we should think of one function of art and artists — of sculpture and sculptors — as helping us to better understand and feel more comfortable in our technological world.

Instead of commemorating goals and accomplishments, today's public sculpture is more likely to function as a community symbol or a corporate image. Often its purpose is commercial as well as cultural. Lest we too quickly condemn this as evidence of materialistic obsession, let's remember that cigar-store Indians are today prized artifacts whose commercialism and possible lack of esthetic quality do not offend us in the way that some contemporary advertisements do. Nor should we overlook the fact that some institutions have created extremely tasteful corporate images, while others have commissioned works of sculpture whose esthetic quality — not merely status — will enhance their community as well as their public image.

Beginning with the erection of the first monumental statues of the god Min in predynastic Egypt and continuing to the unveiling of the Calder *Flamingo* in Chicago in October 1974, the purposes and function of outdoor sculpture have varied considerably. It is a mistake to assume that any one of them has ceased to exert an influence in the creation of today's sculpture, although time has certainly brought some modifications and changes in emphasis. Powerful and awe-inspiring religious symbolism like that which characterized the sculpture of the Middle Ages was never a major factor in American exterior sculpture. Yet religious sculpture is still being created, and the symbolic element in all sculpture is inescapable. One can scarcely say that commemorative public monuments are no longer an influence in the outdoor environment. Not only the works that have endured for decades, or even centuries, but those that have been erected in more recent years — the *Marine Corps War Memorial* in Arlington, Virginia; Barnett Newman's *Broken Obelisk* in Houston, Texas;

Top left: Isamu Noguchi, New York. One of the primary functions of contemporary public sculpture is to contribute visually and experientially to the quality of daily life.

Bottom left: Some institutions have created tasteful corporate symbols or logos, such as the Celanese symbol on Sixth Avenue in New York City.

Top right: Jean Dubuffet, *Group of Four Trees,* New York. Other institutions have commissioned works that enhance both the corporate image and the community. Here Dubuffet's work is shown in Chase Manhattan Plaza.

Bottom right: Felix de Weldon, *Marine Corps War Memorial,* Arlington, Virginia. This is a commemorative monument inspired by Joe Rosenthal's Pulitzer prize-winning photograph of Marines on Iwo Jima during World War II.

Below: Alexander Calder, *Flamingo,* Chicago. Alexander Calder's *Flamingo* in the Federal Plaza is shown here in preparation for the official unveiling in October 1974.

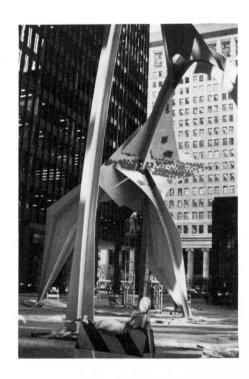

20

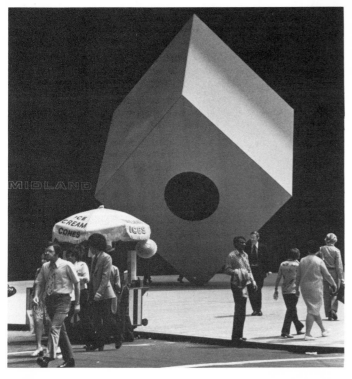
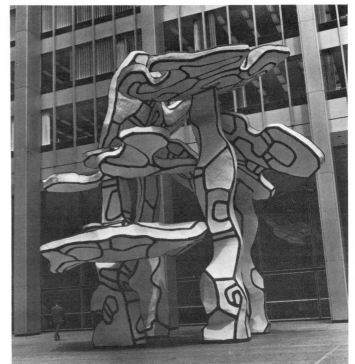

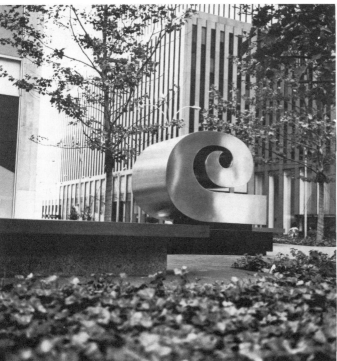
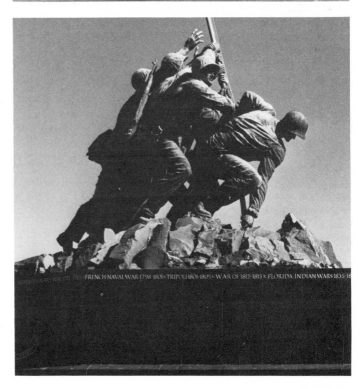

22

Barbara Hepworth's *Single Form* at the United Nations headquarters in New York; Robert Berks' *Mary McLeod Bethune Memorial* in Washington, D.C. —were raised in the memory of contemporary heroes and events. And because the purpose of such monuments is to *remind* us of past events or people, they are to some degree educational. A child asks the meaning and a parent or teacher explains. Or there may be a tablet giving a brief history of the person or event or perhaps explaining the significance of the work, usually supplying the names of sculptor and donor, and often noting the material of which the sculpture is made.

Commercial institutions often display monumental outdoor works for their status appeal, but there is a tendency to frown upon this particular purpose as an example of conspicuous consumption. However, not just business organizations, but educational, cultural, and governmental institutions — not to mention the American public in general — admittedly or not, are susceptible to this appeal of works of art. It is somewhat gratifying to be able to point out to visitors and tourists a "Calder," a "Henry Moore," or a "Picasso" in the civic center plaza of your hometown or better ytt in front of the building where you live.

Yet it is not the power of status appeal that causes the average citizen to habitually walk through the small park with its sculpture fountain or past the monumental abstract work in the bank plaza. Curiosity may be the first attraction, but curiosity is soon satisfied, and it is the age-old human fascination with and response to created expressions — the object in the environment — which draws the individual consistently to those places that provide such enrichment.

Evidence strongly suggests that people almost always register some de-

gree of awareness of a work or works of art in the outdoor environment. It adds another dimension to daily existence and serves to enrich and enhance, to humanize, the environment. Yet sculpture in the outdoor environment may elicit a negative response— some works inevitably do from some people — or a positive but subliminal response. There may be something in the form, the texture, the color of the work that the viewer associates unconsciously with pleasant memories, events, concepts, or forms. Of course there is the enthusiastically overt and positive reaction, which even in the case of contemporary sculpture is more common than one might expect. An elderly (and one might be tempted to assume reactionary) New Yorker was exuberant in his response to William Crovello's *Cubed Curve* located on the corner of 50th Street and Avenue of the Americas. He thought it was marvelous; he liked the shapes and the color; he was delighted that someone had taken the trouble to place it where it was a part of the everyday world of the average New Yorker.

Community institutions or cities and communities themselves deserve special emphasis. Exploitation of the status appeal of public sculpture can serve a very practical purpose for them. At first the drawing power of status attracts uublic interest. This interest is focused upon the particular place or area of the community where the work of sculpture is located. If the work itself has been judiciously selected and placed, it acts to sustain and encourage the interest and activity that has been generated, thus bringing new life to an older area or giving identity and character to a newer area of the community. This is a pragmatic use of sculpture in the environment, but it is not new, not a result of our materialistic age — simply one that is today more

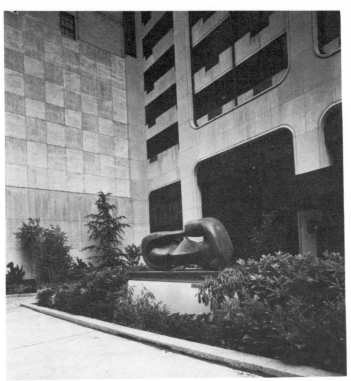

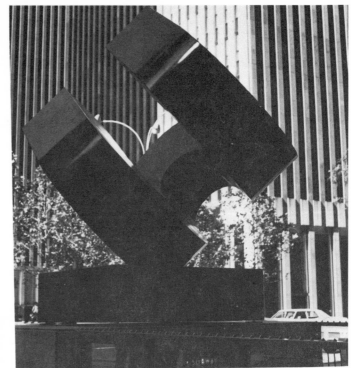

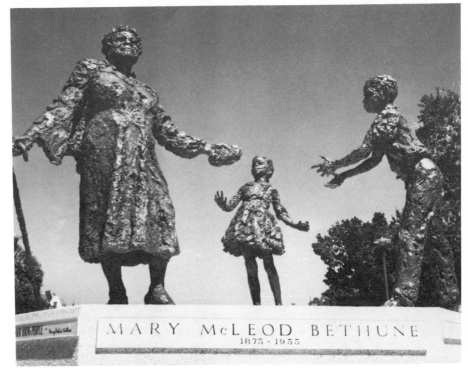

MARY McLEOD BETHUNE
1875 · 1955

24

readily acknowledged and utilized. Nor need such a function detract from others, such as education and enrichment. The potential for creating a positive and attractive image is one of the primary advantages in the use of outdoor sculpture in cities and communities. Commenting on this, Louis Redstone in his outstanding book *Art in Architecture* quotes Charles Blessing, the former director of the Detroit Planning Commission:

. . . the lesson is clear that just as hardheaded business corporations have of late acknowledged the value to them of beauty and of the public's good opinion of them, so too cities across the nation are now recognizing that the cultural climate of a city, the appearance of a city, the educational and cultural facilities of a city . . . are desirable not only because the people want them, need them, deserve them and insist on having them, but because it is good business for the city to provide them.[16]

Today's sculptors who create works of sculpture for the outdoor environment are influenced by the general change in purpose of public sculpture and seek to create works that harmonize with and enhance their setting. Also, because many of these artists desire to reach a broader audience with a more definite impact, they create sculptures that attempt to communicate with or invite the participation of the viewer.

With changing forms and materials and with new approaches to the meaning of art have come questions about the meaning of sculpture. It is not the intent of this book to delve into the definition, reexamination, and redefinition of sculpture or art, nor to deal with new styles and/or forms in a critical or evaluative sense. Rather the point is to show the individual's innate need for and appreciation of sculpture in the outdoor environment, its significance and functions throughout history, and its changing roles and forms today, all of which make it relevant to contemporary life.

It has been argued that almost until the middle of this century all sculpture was essentially an imitation or interpretation of nature or of life. If we conceive of "life" as encompassing all that touches or influences the existence of human beings, today's most radical forms of sculpture are still an expression, imitation, or interpretation of life, though some may seem far removed from the world of nature. Life today is much different than it was 1,000, 500, or 50 years ago; and to imitate, interpret, or express one's reaction to any part of it demands and permits great flexibility. Although, and perhaps because, we are not nearly so close to the natural world as we once were, our need for sculptural expression, interpretation, and sometimes celebration of life as we experience it is as urgent as ever. Perhaps more so.

Time assists taste in determining the ultimate value of any work of exterior sculpture, but there are factors to consider as well as tools that can be used in the development of successful, relevant, and functional sculpture programs in the contemporary outdoor environment. The various kinds or types of outdoor sculpture in relation to different settings, public response to outdoor sculpture, and methodologies for implementing outdoor sculpture programs and vocabulary or criteria for evaluation will be considered in succeeding chapters.

2 Kinds of Sculpture and Settings

Far right: Armand Vaillancourt, *The Grand Fountain,* San Francisco. Fountains abound throughout the country; some are abstract and architectural in scale and form.

Right: Paolo Soleri, the architect/sculptor's workshop near Scottsdale, Arizona. *Sculpture-as-architecture* may take the form of an environmental shell, a sculptural volume apprehended from both interior and exterior.

Below: Clement Meadmore, Lippincott, Inc., North Haven, Connecticut. *Sculpture-as-object* may be apprehended and appreciated as an independent work, with minimal reference to its setting.

One of the first steps toward translating knowledge into comprehensive form is organizing it into various categories. In the case of outdoor sculpture, as with nearly any kind or group of phenomena, there are several approaches to classification, all of which focus on the sculpture, the setting, or both.

Kinds of Sculpture

Functional, Historical Approach

The approach toward categorizing types of sculpture developed by James M. Goode, curator of the Smithsonian Building in Washington, D.C., and author of *The Outdoor Sculpture of Washington, D.C.: A Comprehensive Historical Guide*, is both functional and historical. He divides sculpture into ten categories: "statues, equestrian statues, relief panels, aluminum and bronze doors, fountains, architectural sculpture, pediments, animal, cemetery and abstract sculpture.[1] Although most of the works of outdoor sculpture in Washington, D.C., are traditional representational monuments, most medium- to large-size cities in fact contain at least one or two examples of outdoor sculpture from nearly every one of Goode's categories. While the preference for free-standing abstract works seems to dominate in most contemporary outdoor sculpture programs, relief panels, fountains, sculptured doors, and other kinds of architectural sculpture can be adapted to the abstract approach.

Perceptual, Experiential Approach

Another way of classifying sculpture has been developed by the sculptor and author Art Brenner, who uses a perceptual and experiential approach to divide sculpture into three categories:

1 **Sculpture-as-object**, or "free" sculpture, is conceived as a piece to be appreciated solely on its own independent, esthetic merits.

2 **Sculpture-as-architecture** may be defined as an environmental shell in which people may live, work, or play—an enclosed sculptural volume seen from both inside and out. It might equally be called architecture-as-sculpture.

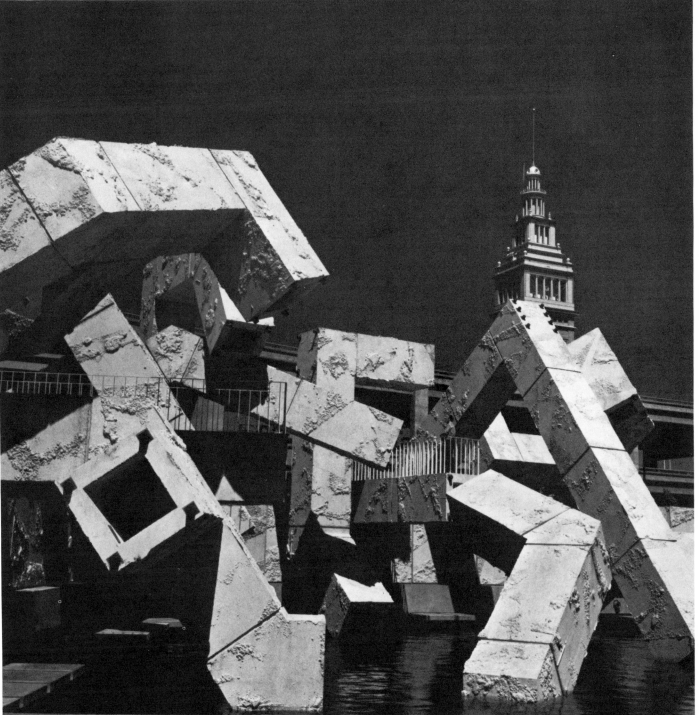

Top left: Willi Gutmann, *The Big One,* Peachtree Center, Atlanta, Georgia. *Sculpture-in-architecture* is neither a free object nor a building.

Bottom left: Willi Gutmann, *The Big One,* Peachtree Center, Atlanta, Georgia. *Sculpture-in-architecture* is an integral part of the architectural design in the same way as the architectural and landscape forms are integral to the artistic conception of the sculpture.

Right: L.B.C. & W. Associates of Virginia (clock tower), Reston, Virginia. *Sculpture-in-architecture* may, in addition to its esthetic value, serve a practical function, such as telling the time of day.

Below: Eero Saarinen, *Gateway Arch,* St. Louis, Missouri. Saarinen's work illustrates sculpture-as-architecture or architecture-as-sculpture.

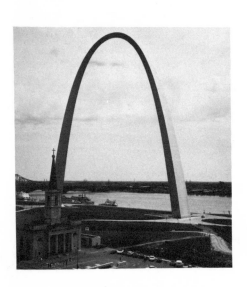

3 **Sculpture-in-architecture** is not a free object nor is it a building, rather it is an integral part of the architectural design just as the architectural forms are integral to the artistic conception of the sculpture.[2]

Much exterior sculpture fits into Brenner's first category, inasmuch as selections for outdoor display are often made from already completed works. In many garden or park settings where architecture is not an integral or immediate element in the setting, entire collections can be arranged so that each work may be apprehended and appreciated as a single piece. The skillful placement of the works in the summer 1972 outdoor sculpture exhibit at the DeCordova Museum in Lincoln, Massachusetts, permits this kind of viewing. In this sculpture-as-object category, there may sometimes be remarkable harmony between setting and sculpture, and sometimes startling contrast. Brenner alerts us to the problems inherent in placing an object or free sculpture in an architectural setting where it fails to meet "the requirements for relating one plastic volume with another."[3]

The category sculpture-as-architecture or architecture-as-sculpture is one that is not included in this book primarily because of the size and sometimes mechanical complexity, which make such works exorbitantly expensive, and also because of the latitude of the definition. Although examples are not nearly so plentiful as are those in the other two categories, two well-known examples are the great arch in St. Louis, Missouri, and the gigantic obelisk in Washington, D.C. — both significant sculptural objects in our national environment. Sometimes sculpture-as-architecture involves not only the total form of the structure, as in Eero Saarinen's air terminal in Virginia, but also the sculptural ornamentation of the structural surface. It is hoped that in the future the complex and much debated question of perceiving architecture as sculpture will permit an architecture that reconciles function and economy with the need for beauty in the environment.

Today's urgent concern with the quality of our environment frequently focuses attention on outdoor sculpture in the highly urbanized setting and on sculpture related to architecture, or sculpture-in-architecture. Described by Brenner as "an integral part of the architectural design,"[4] such sculpture is not necessarily a structural part of the architecture, nor must it be attached in any way to a building or other structure — wall, stairway, door, ramp — although it may be. It may also be a free-standing object occupying a space formed or defined by architectural, engineering, or landscape elements. It may or may not serve a practical function, such as providing light or water or telling the time of day. To the extent to which it is integrated with the spaces and solids created by architects, landscape architects, and engineers in its immediate environment, such a work becomes an inseparable and essential element in the total design. Illustrating such integration is the sculpture of Constantino Nivola at Yale's Morse and Stiles dormitories in New Haven, Connecticut.

Sometimes there is a certain ambiguity in the distinction between the completely independent sculpture-as-object and the sculpture-in-architecture. Sculpture-as-object becomes sculpture-in-architecture when there is a discernible and harmonious visual and spatial relationship between sculpture and architecture. Not all successful outdoor sculpture is totally integrated into an architectural composition. Certain situations hinder or prevent this or require a different solution.

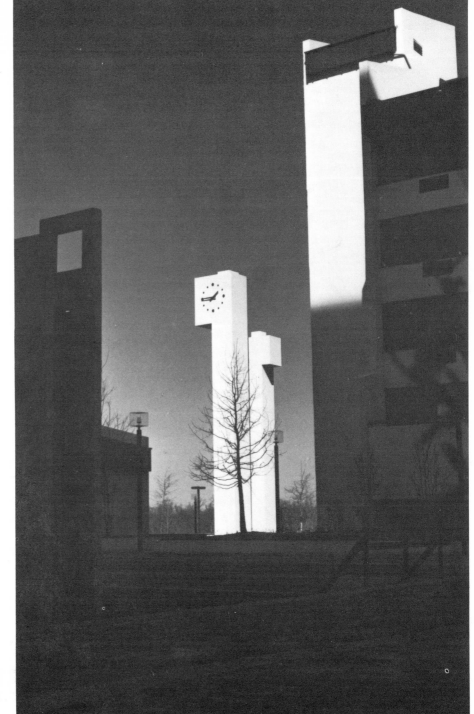

32

Although both could be labeled sculpture gardens, the Museum of Modern Art's relatively permanent collection installed in an enclosed garden in the middle of New York City imposes different conditions on both viewer and sculptures than did the display of contemporary sculpture on the parklike grounds of the DeCordova Museum in Lincoln, Massachusetts, in the summer of 1972. In the former each individual work seems an inseparable part of the larger composition, while in the latter each work was easily isolated for solitary contemplation by the viewer.

Sometimes sheer contrast or even incongruity will set a work of sculpture so apart from its setting that the viewer is forced to consider it as an independent work. Scale, form, and brilliant color make the giant Calder stabile in Hartford, Connecticut, a note of striking contrast in its small urban plaza.

Generally the viewer consciously *looks at* a work of outdoor sculpture and appraises its merits as an independent piece, while he or she subconsciously *sees* and responds to its relationship to its setting. Daily use of a given environment reinforces the unconscious response as the user has habitual contact and interaction with the total design of the area.

Examples of the categories sculpture-as-object and sculpture-in-architecture are the most frequently encountered in today's environment. To the latter should be added *sculpture-in-landscape.* As much as it is possible for a work of sculpture to just sit as an isolated object in a landscaped setting, it is also possible for it to be an integrated element in a carefully designed landscape composition.

Stylistic Approach

Outdoor sculpture may also be categorized stylistically, ranging from traditional to more modern forms of representationalism and from the now generally accepted forms of abstract expressionism to any number of newer forms of nonobjective art.

Some kinds of sculpture have been purposely omitted. Almost no mention is made of play sculpture, one of the most important areas in outdoor sculpture. It's so important that it deserves separate consideration. Also fountains and water-oriented sculpture are referred to only briefly in discussions on function or utility and environmental relationships. Perhaps the most universally appreciated form of outdoor sculpture, it too is worthy of separate study. Although making up a much larger proportion of three-dimensional objects in our contemporary environment than most observers realize, commercially conceived sculpture that exhibits a quality conservatively described by the term *kitsch* is not considered.

The purpose of this book is not to argue the relative merits of any stylistic type or development, but to suggest that representatives of each may find an appropriate setting and use. It is the concern of the environmental designer and others involved in such projects to ensure that the most appropriate work is selected and placed in a given setting.

Kinds of Settings

Successful integration of sculpture with the setting demands knowledge not only of the various kinds of sculpture, but of the requirements and limitations imposed by different types of settings.

Classification of settings for outdoor sculpture can be determined by numerous criteria. Perhaps the simplest is that of location: urban, suburban, or rural. There is of course the possibility of overlapping, especially between

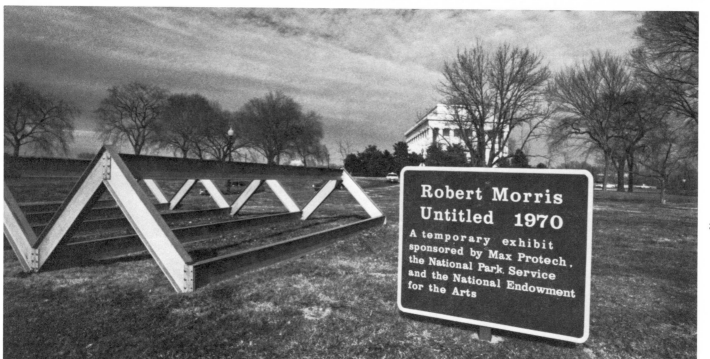

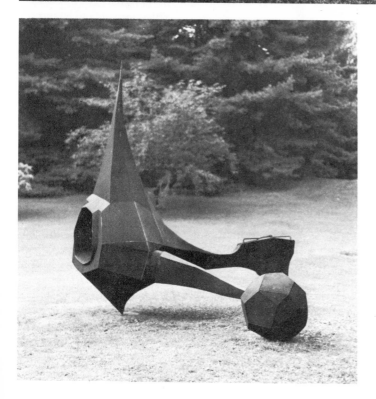

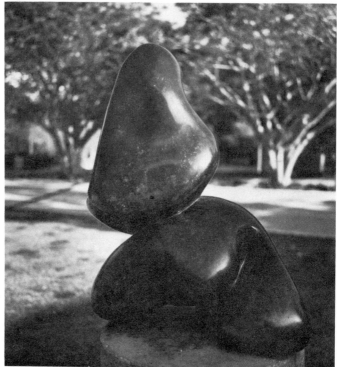

urban and suburban, but in general the distinction is discernible. Within these broad areas settings can be further specified by designations such as commercial, industrial, governmental, institutional, educational, cultural, residential, transportation related (those associated with the various systems of transportation), and exposition-type (those monumental works displayed at expositions). Additional distinctions may be made according to whether the dominant factor in a given setting is the architecture, the landscape architecture, or the sculpture itself.

Commercial

An urban/commercial setting, for example, would be one associated with a bank, department store, restaurant, hotel or motel, or any one of the myriad retail establishments that deal on a person-to-person basis with the general public and thus attract to their premises a relatively large number and varied assortment of American consumers. Because of the size and height of buildings that are constructed in high-land value downtown areas, architecture would very likely be the dominant factor in an urban/commercial setting.

A suburban/commercial setting would involve the same kinds of business establishments, but here the architecture might, though not necessarily, take second place to landscape architecture as the dominant element in the setting. Perhaps the most characteristic suburban/commercial setting is the shopping center, whose extensive plazas and malls afford numerous spaces that are or could be enhanced by sculpture. The nature of such settings permits considerable variety in the kind of sculpture used. The corporate image may be promoted by a well-designed logo, or a monumental abstract work may adorn the space, while at the same time becoming a focal point or landmark for a particular area. The atmosphere in many plazas and malls is often light, bright, and cheery. Here is a setting where sculpture may be whimsical, gay, perhaps even humorous. Although the busy housewife on an endless tour of errands has neither time nor inclination to ponder profound works, she will be aware of and attracted by appropriate sculpture skillfully placed. The impact, both immediate and long-range, of such works on her children is a positive factor that, although not measurable, ought not be discounted.

Gothic cathedrals exemplify the type of design program in which architecture, painting, stained glass, and sculpture were all coordinated to present a single message. It is in the shopping centers of today—in some sense descendants of the medieval marketplace, with the cathedral as its focal point—that such a design program is uniquely possible. The unifying theme, rather than a religious message, may be some regional or local characteristic with which the residents would be proud to associate themselves. It might be educational in nature, or it might also raise the identity consciousness of the surrounding community. The by-products resulting from positive, goal-oriented communication among artists, architects, planners, merchants, and community leaders in effecting such a program should not be overlooked either. Nor should the prosaic but pertinent fact that the end result could be very good for business.

Industrial

The industrial setting, found on the premises of factories involved in both light and heavy industry, on the grounds surrounding research laboratories, and in industrial parks, is most likely today to be suburban or perhaps rural. In some large cities there are of course many older establishments that maintain plants in the heart of the city. Although perhaps not as "public" as commercial settings, those of industry function as important parts of the daily environment for a large segment of the population. Because the work performed in industrial areas is frequently high-pressure, production-oriented, and often accompanied by a certain amount of unavoidable noise and dirt, it would seem that the use of outdoor sculpture makes a vital contribution to the industrial environment. A particularly adaptable setting is provided by the large industrial parks that are proliferating throughout rural and suburban America. An outstanding example is the one at Gateway Park near Atlanta, Georgia. Although playful sculpture might find a place here, and the expression of the corporate image should not be excluded, one of the most challenging possibilities is of translating materials of modern industry into a sculptural expression of our technological society.

Top: Peter Forakis (entrance sculpture), Gateway Industrial Park, Atlanta, Georgia. Gateway Industrial Park near Atlanta incorporates outdoor sculpture in an industrial park setting.

Bottom left: George Sugarman, First National Bank, St. Paul, Minnesota. An urban/commercial setting might be associated with a bank.

Bottom right: Joseph A. McDonnell, *Moby Dick*, Northland Mall, Detroit, Michigan. The open spaces in contemporary shopping malls offer numerous sites for outdoor sculpture.

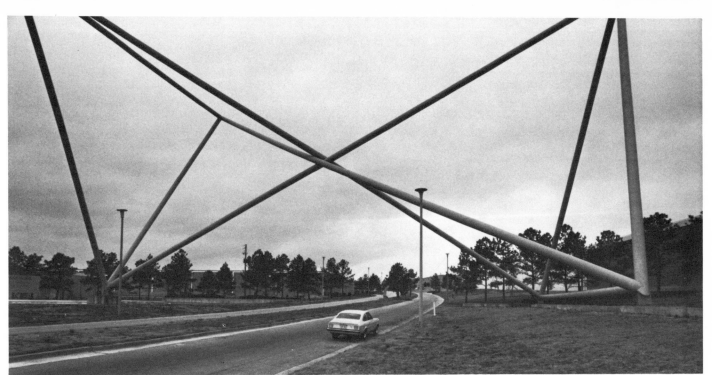

There is a certain amount of hostility today toward contemporary works of sculpture created from industrial materials. However, as people become more knowledgeable about principles of design and craftsmanship, they will become aware of the differences between a piece of leftover material and a work in the same material created by an artist. This is not to say of course that understanding or appreciation of such a work is automatically assured. The industrial setting seems a logical situation for expressing the concept that materials and processes of the workaday world are not isolated from esthetics, nor is the life and thought of the worker. Although there is no known documentation of such an effect, it has been argued that an introduction to art in the working environment may open the door for the worker to seek further contact with it in museums and sculpture gardens.

Governmental

Governmental settings are most commonly urban and are usually associated with buildings such as city halls, county courthouses, state capitols, post offices, and various kinds of federal office buildings. The General Services Administration program for Art in Federal Architecture has been responsible for numerous outstanding examples of outdoor sculpture throughout the country in such places as Boston, Chicago, and Salt Lake City.

Federal architecture is of course only one segment of the governmental category. Although the funds available for erecting a work of sculpture in the entrance plaza of a small town city hall may not be as substantial as those spent on a federal arts project, the impact of such a work may be equally significant. Many governmental jurisdictions in cities or states are now considering or have already established 1 percent for art in architecture programs that require the use of sculpture and other art works in public buildings.

In the past, works of outdoor sculpture in governmental settings were expected to embody in recognizable form such abstract concepts as duty, justice, or equality. Today abstract works in similar settings provide visual enhancement, leaving their precise meaning to the imagination of the viewer.

Institutional

An institutional setting is one that relates to hospitals, insurance company offices, and other specialized office buildings. Its location could be urban, suburban, or rural. These establishments, although open to the public with certain restrictions, still do not have quite the casual accessibility of those in the commercial category. An institutional setting might include anything from a city center utility company office, to a suburban clinic, to a rural company headquarters with extensive parklike grounds, such as those of the Connecticut General Insurance Company near Hartford, Connecticut, or the Pepsico Company in Purchase, New York. The effectiveness of sculpture in forming or reinforcing a public image, as well as the benefit to the employee whose daily environment it enhances, makes outdoor sculpture in institutional settings especially desirable.

Those institutions involved in preserving health have the opportunity to express themes of human compassion in sculptural form or to celebrate advances in the field of medicine. Hospitals and nursing homes that provide extended care can make outdoor spaces used by the patients more pleasant if they include sculpture. Other possibilities are available for specialized institutions. Why not a sculpture garden for the blind?

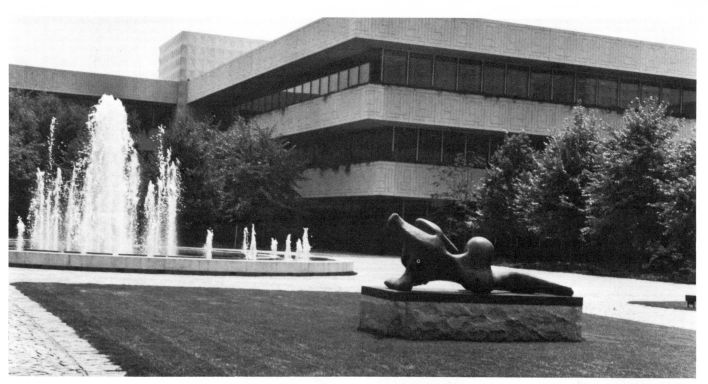

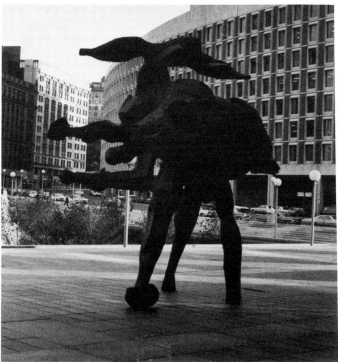

38

Educational

Educational institutions constitute a separate category of settings, which range from the strictly limited and architecturally framed spaces of center-city schools to the ample, seminatural settings of suburban and occasionally urban campuses. The institutions involved may be public or private. They may be kindergarten, primary, secondary, or university level and also include trade schools and other schools of specialized training. The work of sculpture that would best serve the situation would be determined by a number of variables, including the kind of school, location, number and age range of students, amount and kind of space available, and any specific limitations or possibilities peculiar to a given institution. In Baltimore, Maryland, the city's fine arts committee "has adopted a policy favoring forms of Abstract Art in the public schools. The educational purpose behind this decision rests on the fact that realistic shapes and subject matter are less challenging to the creative minds of children and adolescents."[5] At two inner-city schools in New York City and Washington, D.C., imaginative abstract works by William Tarr provide symbols of identity and status.

Within the category of educational institutions, college campuses offer a number of different settings. The extensive parklike campus may provide the setting for a collection of works by established artists, as is the case at Princeton, UCLA, Long Beach State, or Cranbrook Institute. An alternative might be the display, temporary or permanent, of significant student work, as at George Washington University, Washington, D.C.

Cultural

The designation "cultural setting" is applied to those spaces for exterior sculpture that are associated with such institutions as art centers, libraries, civic centers, museums of all kinds, and of course parks. The cultural setting seems a natural one for outdoor sculpture. Here there is great latitude in the type of sculpture that can be used, the determining factors being those imposed by the individual site, its nature or atmosphere, and the purpose or purposes for which the sculpture is intended. While this category contains such outstanding and well-known examples as the Museum of Modern Art Sculpture Garden in New York City, Brookgreen Gardens in South Carolina, and the Hirshhorn National Museum and Sculpture Garden in Washington, D.C., it also includes the less spectacular settings found in small towns on the grounds of community arts centers.

Residential

The various kinds of spaces associated with apartment complexes, condominiums, subdivisions, and new towns constitute the residential type of setting. One example is Philadelphia's Society Hill complex where the works of Leonard Baskin are in the plaza formed by the giant residential units. In the new Minneapolis development of Cedar Riverside, abstract sculptural forms articulate space and add interest in a variety of highly urbanized settings that might otherwise be severely dominated by the high-rise concrete architecture. In urban residential settings the architecture is likely to be the dominant element, while in suburban and rural new towns there is ample space for landscape settings. Although there is some validity in the criticism of the careful and systematic placement of "sculpturelike objects" in the "manicured landscape"[6] of the new town of Reston, Virginia, its program is an encouraging example of the concern for inclusion of sculpture in the environ-

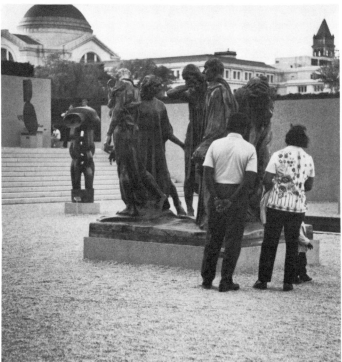

ment from the beginning of the planning stages of the development. In addition to its capacity for enriching the domestic environment, residential exterior sculpture can also serve as a symbolic image associated with a particular community, as does the famous "people tree" in the lakeside mall at Columbia, Maryland.

Transportation Related

Settings that relate to the transportation industry constitute a separate category. The spaces associated with facilities such as airports, railway and bus stations, as well as the myriad structures — bridges, highways, toll stations, and even service stations — that make up the fabric of the automobile transportation system, are linked together because of their relationship to transportation facilities. There is scarcely a member of contemporary society whose daily activities do not bring him or her into contact with such settings. Although not so ubiquitous, facilities associated with water transportation are also included here. There is great variety among the settings within this category, determined not only by the different modes of transportation, but by the requirements within each system for many kinds of facilities in a variety of locations, ranging, for example, from toll booths to waiting stations.

In the 1930s and 1940s when America was involved in building great cross-continental highways, the significance of these mighty engineering works was judged worthy of commemoration. Thus in 1930 a monumental sculpture of Abraham Lincoln was placed at the beginning of the famous Lincoln Highway in Jersey City, New Jersey. Following that, there was a considerable period when American highways and their immediate surroundings just grew, with little or no attention to environmental esthetics. And we are all

too familiar with the results. Today, in addition to the attempt to get rid of some of the ugliness, some thought is being given to combining man-made works of art with nature's works of art in settings where each enhances the other. Along Vermont Interstate Highway 89 and 91 are some exciting results of implementation of this concept.

Exposition Type

An additional category that involves a less ordinary aspect of contemporary life should be mentioned. It is the extensive setting of the exposition or fair, whose various outdoor spaces provide individual settings for large-scale and sometimes experimental works. From the 65-foot high statue of George Washington at the 1939 New York World's Fair to the gigantic Calder stabile at Montreal's "Man and His World — Expo '67," such works are indicative of the cultural and social climate of the day, as well as of stylistic tendencies. At Spokane, Washington's Expo '74, sculptural structures in brilliantly colored fabric added to the holiday atmosphere.

Although neither exhaustive nor definitive, the preceding categorization provides a guideline to aid in the process of selection and coordination of sites and sculpture in the exterior environment. The vocabulary needed to evaluate the selection of sites and placement of sculpture has not been defined. Guidelines for such evaluation will be considered in Chapter 3.

A. Dieter Trantenroth, Vermont Interstate 89 South. Along Vermont's interstate highways, exquisite natural settings enhance works of sculpture.

3 Vocabulary for Evaluating Outdoor Sculpture

There is a vast literature on the subject of sculpture—its styles, history, critical analysis — and of sculptors and their work. But there appears to be little or nothing available dealing with the use of sculpture in the outdoor environment. Thus there are no recorded principles or criteria to be used as guidelines for evaluating the selection and placement of outdoor sculpture, although obviously some sort of criteria are used whenever the process occurs. One explanation for this lack is that the selection and placement of outdoor sculpture involves people from several different disciplines and areas of responsibility, including politicians, administrators, community and business leaders, architects, artists, landscape architects, planners, museum personnel, arts administrators, and a wide spectrum of others with interests in community development, promotion of the arts, or environmental enhancement. Each discipline concerned with or responsible for outdoor sculpture programs tends to deal with the selection and placement process in terms of its own professional vocabulary, which may or may not be clearly understood by members of the other groups. Therefore the development of a vocabulary providing terms of reference clearly understood by members of all groups involved in outdoor sculpture programs is a necessary step in the promotion of better communication, planning, and execution.

In a study of many works of sculpture in many settings, certain elements can be put together as a checklist to be kept in mind during the selection and placement process. The criteria in this list are presented as preliminary principles and guidelines for the development of a vocabulary to be used in evaluating outdoor sculpture.

Obviously the two primary factors for consideration are the sculpture itself and the setting. Five different areas of interaction between these two factors offer sources of criteria: contextual relevance, physical qualities (of the sculpture), staging, apprehension and revealment, and environmental relationship.

Contextual Relevance

Contextual relevance refers to the way in which a work or works of sculpture fit into the total fabric of its setting, both general and specific. There are elements or characteristics of both the sculpture and the surroundings that could or do relate to one another either positively or negatively. Some aspects that determine contextual relevance are subject matter, chronology, utility, and sociocultural acceptability.

Subject Matter

The subject matter of a work of sculpture may not necessarily be, and today most often is not, the representational depiction of a person, thing, or idea. It may be a symbolic abstraction — the artist's concept of a form that represents an idea or theme. There may be no definable subject matter at all other than the visual expression of an esthetic concept.

Some consideration should be given to how or if the subject matter of a work relates to its setting. The setting may require a work that is representational or abstract, that may have an obvious message or theme or that may not. Frequently an abstract work is the preferred choice because the nonspecificity of the subject matter is less likely to arouse controversy. Gaston Lachaise's *Standing Woman,* for example, is generally acceptable in a museum or university sculpture garden, but would probably be a poor choice for a convent or monastery garden.

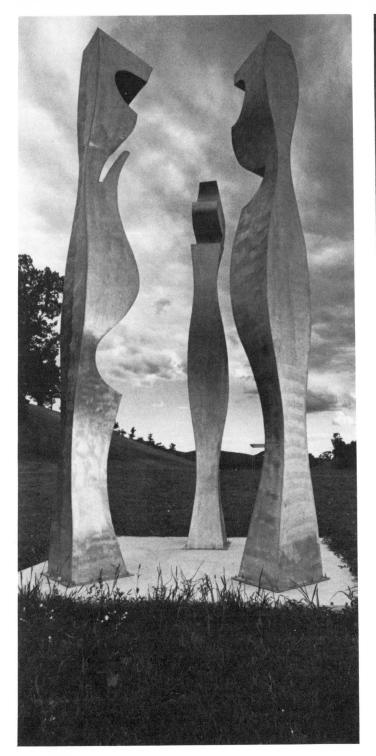
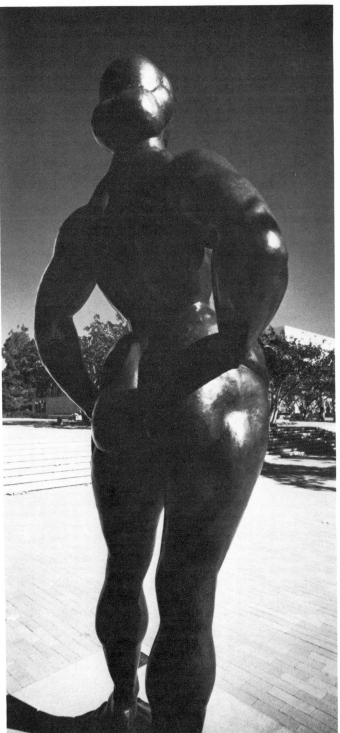

However, nonrepresentationalism does not guarantee noncontroversy. A great deal of unfavorable reaction arose in Chicago at the 1967 unveiling of Picasso's giant, weathered steel sculpture in the Civic Center Plaza. John Canaday, writing about the uproar over the work, notes with perception that the difficulty in the public's acceptance of the work arose not so much because it does not look like anything (that is, it is an abstract work), but rather because in spite of its abstraction it looks too much like something.[1] Indeed, the work has been at times referred to as a sphinx, at other times as a lion. Canaday mentions that the design is "abstracted from a woman's head, and as a woman's head . . . is disturbingly snouted and just plain ugly" and also that a photographer friend of Picasso's "identified the frontal view of the sculpture . . . as a 'portrait' of Picasso's long-nosed and long-eared pet Afghan hound."[2] Aside from making it almost impossible to view the sculpture as a work of art, this sort of conjecture succeeded in offending a number of Chicagoans. However, the sculpture has weathered in more than one way and is today generally accepted for what it is — an abstract work of art intended to enhance or accent a particular setting. A lesson learned from this is that if a work selected or commissioned is to be abstract, it should be unmistakably that or if representational, its referent should at least be appropriate.

Chronology

Chronology concerns the relationship of certain styles or forms of sculpture to certain styles of architecture associated with different historical periods. Representational works of sculpture in traditional Beaux-Arts or American naturalistic styles seem most comfortable in their settings when there is synchronization of sculptural and architectural styles. It is of course difficult — often impossible — to maintain chronological correctness in today's world, nor is it always desirable. The statue, *Samuel Adams* in Boston, seen against the background of Faneuil Hall, seems entirely appropriate. However, when viewed against the contemporary structure of the Boston City Hall, it is not only out of scale, but out of time and place. Another statue, *Benjamin Franklin* in Washington, D.C., is scarcely noticed amid the confusion of traffic and against the background of the immense new FBI building. It almost seems as though the old gentleman is gesturing vainly to shush the uproar of the 20th-century world. In some instances, particularly in settings of historical significance, the chronological harmony has been carefully preserved, as illustrated by the statue *Professor Joseph Henry*, in front of the old Smithsonian castle in Washington, D.C.

The situation also arises where a work of contemporary sculpture placed in a generally consistent setting must compete from one or more viewpoints with an architectural background of another era. Such is the case with a work by Jerome Kirk in the Phoenix, Arizona, Civic Plaza, as well as one by Masayuki Nagare at the Bank of America Headquarters Plaza in San Francisco. Sometimes the contrast of new sculpture with old architecture — and vice-versa — is pleasing or stimulating. Sometimes it is neither.

Probably the classic example of chronological harmony is the monument to the Confederate soldier placed on the green in front of an old Southern courthouse. There are no rules for chronological relevance, only the necessity for thoughtful, intelligent consideration.

Utility

Often, outdoor sculpture has a function or functions in addition to that of esthetic enhancement (see Chapter 1, pages 14–24). One might be a physical use such as providing water, light, or seating, or telling the time of day. It might also have a psychological use, as, for example, when a work serves as an image or symbol of identity for a business organization or community. Such a function is performed by the Celanese symbol on Sixth Avenue in New York City, by the Calder stabile in Grand Rapids, Michigan, and by the "people tree" in Columbia, Maryland. Locational identity, or serving as a landmark, is often a by-product function of the psychological, as, for example, when a number of people agree to "meet at the Calder."

Left: Anne Whitney, *Samuel Adams*, Boston. Boston's *Samuel Adams*, viewed against the 20th-century contemporary architecture of City Hall, seems out of time and place.

Top right: Masayuki Nagare, San Francisco, California. Often a work of contemporary sculpture is seen from one or more viewpoints against an architectural background of another era.

Bottom right: Athelstan Spilhaus, New York. In the lower plaza of the McGraw-Hill building in New York City, Athelstan Spilhaus's giant solar triangle tells the time of year.

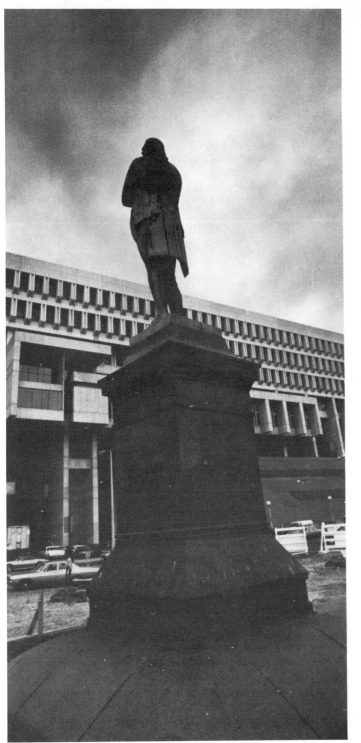

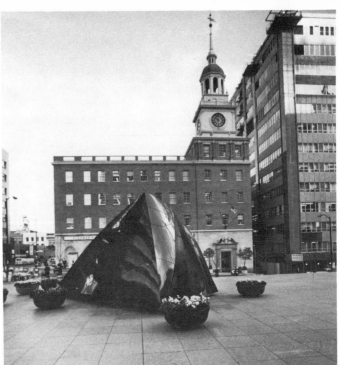

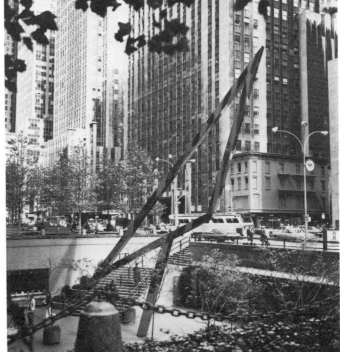

Top: Claes Oldenburg, Newport, Rhode Island. In the vastness of the natural landscape it is nearly impossible for a work of sculpture to be too large.

Bottom: Eduardo Ramirez, Vermont Interstate 89 South. In the Vermont Highway Sculpture Program the scale of the sculpture is adjusted to the pedestrian viewer at the rest stop.

Below: Louise Nevelson, New York. Because the meaning or subject matter of a work of abstract sculpture is not always discernible, each viewer may make his or her own interpretation.

48

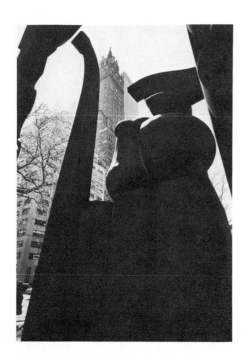

Sociocultural Acceptability

Sociocultural acceptability, or the extent of acceptance shown to a particular work of outdoor sculpture by the majority of the community members, is determined in part by such factors as subject matter, chronology, and utility. It is quite difficult to assess the sociocultural acceptability of a work of sculpture with absolute certainty prior to its installation, but consideration of the three factors as well as of the needs and attitudes of the community and/or client is helpful.

Generally the adverse reactions are in response to form and subject matter, actual or imagined. People are usually more willing and able to relate to and accept traditional representational works because the style is familiar and they feel they understand the subject matter and meaning. Because abstract works do not communicate obvious messages (that is, are not instantaneously *understood*), people often feel uncomfortable; even patronized, because they do not "get the message," even though no message was intended. Hence the perennial question, "What is it?" and the often uncomplimentary sobriquets applied to works of sculpture in the public environment.

It sometimes seems as though the public is trying to "get back at" the artist whom they feel has attempted to invade their territory with esoteric creations that have no meaning to the person on the street. The artist, however, reads this sort of reaction as the public's basic, general hostility toward the arts, as well as the lack of ability to appreciate any abstract or conceptual art. Neither of these reactions is a correct assessment. Attempting to promote better understanding of the goals of the artist, as well as of the limitations imposed and the problems involved in achieving them, is a significant step in bridging the communications gap between artist and audience, whether the audience is a commercial client, a select group, or the general public.

Of course there are some works that probably would never be generally accepted as public art, no matter what the setting. However, the public's continually expanding knowledge and awareness is increasing the sociocultural acceptance of many forms of contemporary sculpture.

Physical Qualities

Awareness and understanding of the physical qualities of sculpture — size and/or scale, shape and/or form, material, mass and density, complexity— are essential in the process of evaluation. These qualities are determining factors in all areas of consideration of outdoor sculpture programs and are particularly pertinent to contextual relevance and staging.

Size and/or Scale

Size and scale should be determined by the setting, especially by the specific setting. One of the most frequent reasons for the lack of impact on the environment is inadequate scale. Usually, though not always, this simply means it's too small.

The factors that influence scale in outdoor sculpture are the generally more rapid movement of the viewer (in comparison with that indoors); the many distracting elements, particularly in an urban setting; and most of all the much greater scale of the outdoor environment itself — both the manufactured, such as buildings, highways, bridges, and the natural, such as hills, mountains, rivers, sky. Art Brenner, an American sculptor working in Paris,

feels that "it is almost impossible for a piece of sculpture (especially out-of-doors and not in direct relationship with a building) to be too large."[3]

The scale of a work designed in conjunction with or commissioned for placement within an architecturally created exterior space is best determined by the architecture itself and by the size and nature of the space. *Group of Four Trees* by Jean Dubuffet, created for and placed at the bottom of a "well" formed in part by the sixty-story Chase Manhattan Bank headquarters building in New York City, may appear inconsequential when viewed from twenty, thirty, forty, or more stories above or from a distance. However, the relationships among the sculpture, the space it occupies, the spaces it creates itself, and the pedestrian moving through the plaza reinforce its actual, considerable size and bulk and make its impact substantial in the specific environment.

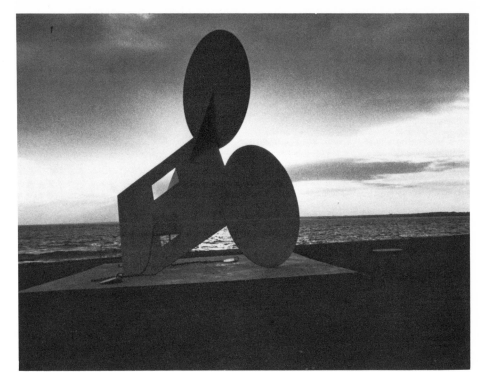

Since outdoor sculpture in the contemporary urban environment is most commonly placed in a pedestrian-oriented setting, an important determinant of scale, in addition to the architecture and the space, is the human viewer. The importance of adequate scale notwithstanding, it is possible for a work to be of such overwhelming size, especially in a limited urban setting, that the spectator is repelled rather than attracted. Such is not the case with the Dubuffet work. The nature of its form, the size of the space in which it is placed, and its accessibility make it comprehensible to the viewer.

In the Vermont Highway sculpture program the scale of the sculpture is related primarily to the specific settings of the rest areas where the works are viewed by travelers resting or simply stretching their legs. The proximity of the viewer to this sculpture heightens the impression of its size. The same

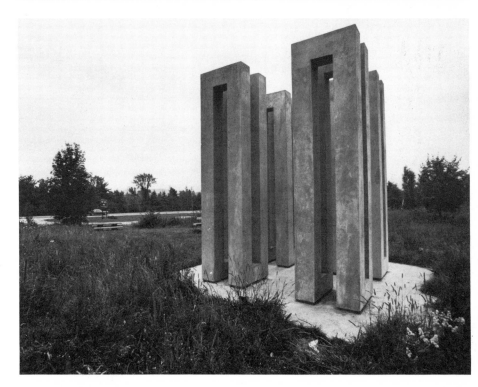

50

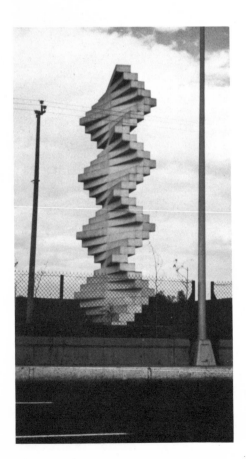

sculptures, when and if they can be seen from an auto speeding by on the highway, are generally of an inadequate or unnoticeable scale.

Another highway landscape, less spectacular perhaps than the one in Vermont, is that of the Olympic Highway near Mexico City. Here most of the sculptures are placed immediately adjacent to the highway and are intended to be viewed from the windows of passing autos, although in most cases one can pull off the road for a more leisurely inspection. They are all enormous works and could scarcely go unnoticed by travelers. However, partly because of this overpowering scale as well as the topography of the land, these works are visible far enough in advance to intrigue viewers as they move nearer, rather than to distract or startle them by appearing suddenly up close.

Shape and/or Form

While shape more accurately refers to the two-dimensional appearance, as in a silhouette, and form relates to structure and to the three-dimensional aspect, both terms are often used interchangeably. The possibilities for varieties of shape and form in works of sculpture are of course almost infinite. There may be either a harmonious blending of the shape and form of a work of sculpture with its setting or a striking contrast. A factor to remember is that outdoor sculpture is often seen in silhouette, either by day or at night, and thus should present a comprehensible outline.

Another consideration during the selection process is the difficulty in envisioning accurately, when contemplating a small model, the ultimate appearance of the full-scale work. Generally outdoor sculpture has the most impact if it is relatively simple, bold, and clearly readable.

Material

The material or materials from which a work of sculpture is made exert a powerful influence on its form, texture, color, and durability. The possibilities are myriad, including traditional materials, such as stone, concrete, wood, and bronze, as well as some that are relatively new to the sculptor, such as glass, new kinds of metals, numerous kinds of plastics and synthetics, fabrics, and even laser light beams.

A classic example of outdoor sculpture that harmonizes with its setting — the works of Constantino Nivola at Morse and Stiles Colleges in New Haven, Connecticut — demonstrates material and form extremely compatible with the architectural surroundings.

Although a variety of textures can be mechanically induced or applied on the surface of most materials, the artist usually allows the material itself to dictate, at least to a certain extent, the texture.

Color is related to and determined to a degree by the material, either because of the natural color of the material itself (granite, marble, bronze, weathered steel, stainless steel, for example), or because of the ease with which color may be applied. Metal and plastic works permit a brilliant range of colors. The bright red-orange of many of the Calder stabiles is a particularly striking color, quick to attract attention in the outdoor environment. This may be the reason for its popularity, for there seem to be an increasing number of contemporary works, including several by other sculptors, whose color could be labeled "Calder red."

Certain materials are by nature more suited to outdoor sculpture because of their ability to withstand or respond favorably to weathering and also because they are not easily damaged or vandalized. Ivor de Wolfe in his book

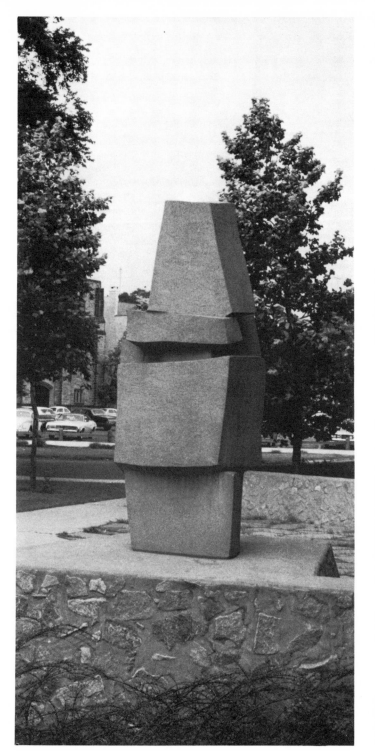

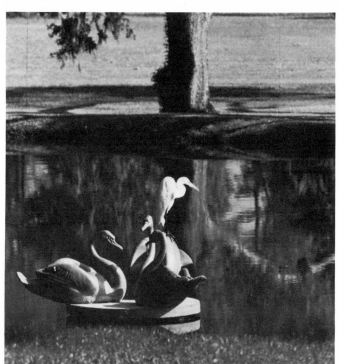

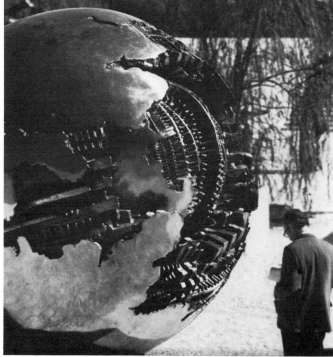

52

The Italian Townscape refers to kinds of outdoor sculpture as "toughies" and "softies."[4] Although he includes aspects other than material, a "soft" material would certainly negate "toughness" of form. Evidence suggests that works of sculpture that have demonstrated durability in the outdoor environment were created from materials such as stone, metal, and concrete. New varieties of plastics are also proving their ability to hold up in the outdoor world.

Mass and Density

Material and form determine to a considerable extent the mass and density of a work of sculpture. *Mass* refers to the impression of weight and volume that the viewer experiences, while *density*, although sometimes used synonymously with mass, is determined by how closely sculptural forms are massed, as well as by the quantity rather than the quality of the material used.

One usually thinks of mass in terms of weighty materials such as stone, concrete, or metal. Cast bronze works convey a sense of mass, even though they may be hollow. Certain sculptural forms suggest weight and volume, as do most of the works of Henry Moore, Barbara Hepworth, and Tony Rosenthal. It is possible for a work to convey a sense of substantial volume and yet have little density. Such a work might be translucent or transparent, and would require very careful staging in relation to background and enframement (see page 54). Other works may be composed of numerous elements massed to create a high degree of density and yet have no real sense of weight or volume. Still another variation is the work that by the nature of its form as well as the material of which it is composed exhibits neither mass nor density. Some of the kinetic works of George Rickey possess these char-

acteristics. When judiciously placed to enhance and be enhanced by the setting, these are intriguing and exciting works. Careless placement can make them become virtually invisible.

Complexity

Complexity is not an exclusively physical quality of sculpture, yet it is related to such physical qualities as shape and form. It is perhaps more applicable to meaning or message, which, it so happens, is expressed by shape and form. Often the viewer of sculpture in the outdoor environment is preoccupied with or distracted by any number of factors other than the sculpture. Thus when the viewer's attention is drawn to it, he or she should be able to readily apprehend form, color, and the visual relationship of the work to its setting — to enjoy it as an esthetic experience — without struggling to extract meaning and significance embodied in forms too numerous or too intricate to absorb in a limited amount of time. Complexity in outdoor sculpture requires a relaxed and contemplative setting — a sculpture garden or quiet park — for proper appreciation.

Staging

Staging refers to planning and executing both the placement of a work of sculpture and the design of the setting so as to present each to its best advantage. An important consideration is that outdoor sculpture in any context is almost always three-dimensional. (The exceptions are relief sculpture and works that are placed flat against a wall.) It's possible to move around outdoor sculpture and to view it from any number of angles. Part of the enjoyment of sculpture in the out-of-doors comes from the many views and aspects that the viewer can experience, as well as from the effects upon the

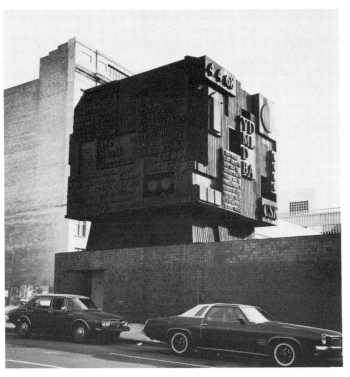 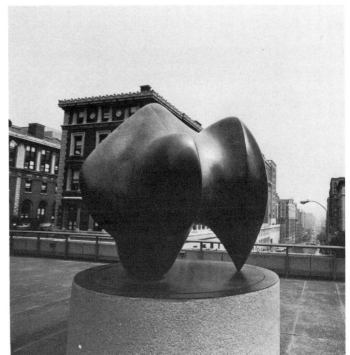

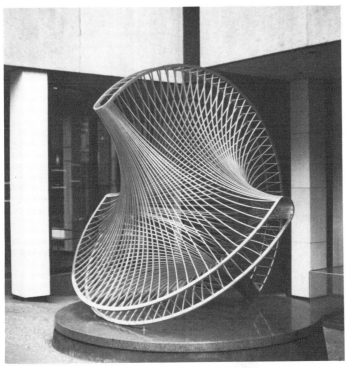 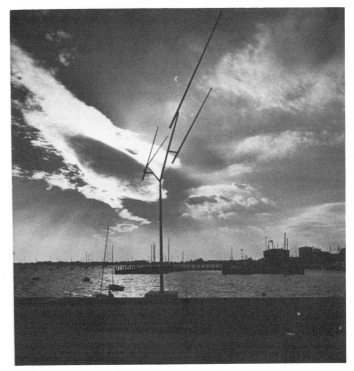

54

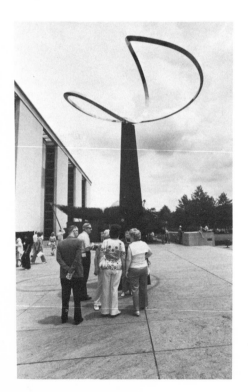

sculpture of natural elements such as plants and sunlight. Since the outdoor environment is more difficult to control than the indoor one, successful staging requires attention to such factors as background, foreground, enframement, base, and lighting.

Background

Since it is often possible to move completely around a work of outdoor sculpture, the background for any given piece may vary depending upon the position of the viewer. It may consist of plant material, water, architecture, or any combination of these. Some of the factors that should be considered are the background's height and breadth, the material of which it is composed, its proximity to the sculpture, and whether it must also serve a function such as screening a view or providing partial protection for the work. In many cases, particularly in urban settings, the background is a given element and the sculpture must be placed so as to take best advantage of the situation.

Foreground

The foreground for a work of sculpture may be an extension or modification of the background, or it may be entirely different. Over, through, or across the materials that make up the foreground, the viewer is encouraged and enticed to observe the work of sculpture and if possible to approach for a closer look. Again, because of the multiple viewpoints from which a piece of outdoor sculpture may be seen, the foreground may vary considerably. Or there are instances in which it may be relatively uniform as, for example, when a piece of sculpture is placed in the center of a large grassy area. The design of the foreground controls to some extent how close the viewer must be before seeing the sculpture, as well as how much is seen from any given viewpoint

(see Apprehension and Revealment, page 56).

Enframement

Obviously both background and foreground are elements of enframement, which has to do with the way in which the spectator views the work. It may also delineate the boundaries of the specific setting, while in some cases— for example, in the extensive rural park — it may be only barely suggested. Controlling enframement may involve taking advantage of existing natural elements while creatively using others. It may also involve the use of manufactured structures, either those that already exist or those that are specially designed and constructed for the setting. Although anything approaching complete control of enframement in the outdoor environment is almost impossible to achieve, the results of careful planning are usually well worth the effort.

Base

Although there is a definite trend away from the base in contemporary sculpture, it is still needed in some cases, either for technical and practical or for esthetic reasons. The lyrical stainless steel work by José de Rivera on the mall entrance to the Smithsonian Museum of History and Technology in Washington, D.C., is raised on a very tall triangular pylon of polished black granite. Here the height of the base increases the visibility of the work by drawing the eye upward to it, while the color contrast enhances the gleaming stainless steel. A more pragmatic result of the sculpture's lofty perch is protection from vandalism.

The material from which a base is made, its shape, its height, and its size in relation to the work are all significant considerations. An ill-chosen base can substantially detract from the esthetic quality of a piece of sculpture.

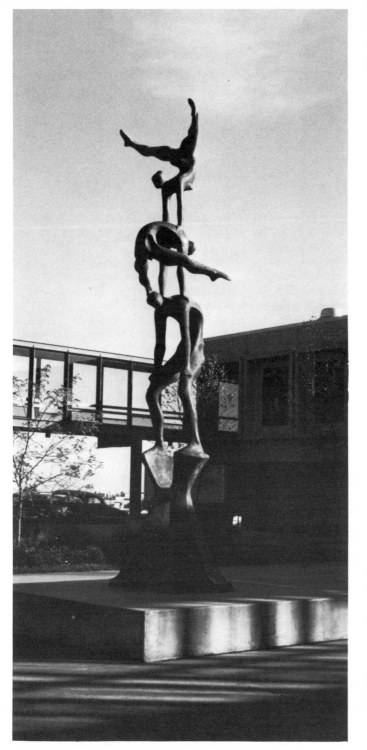

Lighting

Lighting may be either natural or artificial and is an effective tool in enhancing such qualities of a sculpture as form, texture, mass, and density. For example, sculpture with a highly polished and reflective surface presents a different appearance on cloudy and rainy days or when placed in shadow, in contrast to the brilliant effect produced by bright sunshine. Daylight of course changes with the rotating position of the sun and is also subject to seasonal variation. Amount and extent of sunlight available might well be an important factor to consider in selecting sculpture and designing the background, foreground, and enframement of the specific setting. The control of natural light depends upon the work of sculpture selected; its orientation, or how and where it is placed; and the handling of natural and sometimes of manufactured elements.

Controlled night lighting can produce impressive results. Effective night lighting involves not only the placement of the piece of sculpture, but also the amount, type, and the precise location of the lighting. Often the light source may originate from the background rather than from the foreground of the setting, creating a silhouette of the sculpture. Or it may come from above or below the work. The combination of sculpture, water, plants, and night lighting often creates a dramatic composition.

Apprehension and Revealment

Apprehension and revealment, the fourth area of consideration, relates to the position from which the spectator views a work of sculpture and how much of it is seen at a given time and for how long. The physical qualities of the work itself as well as how the staging is handled have a good deal to do with the apprehension and revealment of a sculpture. Other factors to consider are the speed of the viewer, the angle of vision, and the distance or distances from which the sculpture is seen.

Speed

Imagine, for instance, that if increased speed and distance lessen one's apprehension, then the *Washington Monument* is of approximately the right scale and simplicity of form to be viewed by a passenger in a jet plane either taking off from or landing at National Airport in the Washington, D.C., area. To consider a more common situation, pedestrians view the same work of sculpture at a much slower speed than do automobile passengers; also their view is not restricted by the frame, windows, and roof of the automobile. Of course even in the case of pedestrians, speed may vary from a brisk walk to a slow stroll or to the relative motionlessness of standing or sitting. Thus to place a relatively small-scale work on a traffic triangle in the middle of a busy intersection where most of the viewers will be passengers in cars or buses is to condemn it to obscurity—although the height of the bus does help somewhat. The same work would be better placed in one of those delightful tree-and-bench-filled city parks designed for the warm-weather enjoyment of the brown-bag crowd.

Angle, Height, Distance

The importance of the angle of view, distance, and height must not be overlooked, nor must the nature and location of visual screens and barriers. In commercial areas of large cities a sculpture may only be glimpsed at a distance down long, narrow corridors formed by tall buildings. Often the full revealment of a work comes only when one emerges suddenly into the open space or plaza that is its specific setting. An additional viewpoint peculiar to this type of setting is that from the height of a multistoried building. Of course it requires a work of substantial scale to be visible with any clarity from sixty or eighty stories. The distance on the ground of the viewer from the work, especially of a large-scale work, also affects the angle of view. Looked at head on from a distance a sculpture's total composition can be fully taken in; but standing at the base requires an acute tilting of the head if one is to apprehend the entire work. Changing positions obviously changes the appearance of the work. Thus a very large work in a very small space would provide only limited apprehension. In a rather rare situation, William Crovello's *Cubed Curve* in New York City is placed over the entrance to a subway so that the angle of view changes as the spectator walks down the steps.

When not coping with existing buildings as screening or view-blocking elements, a designer may create, by using natural materials such as plants, land forms, or water, a pattern of partial revealment and/or concealment of a work of sculpture, which will attract the viewer and increase interest in and enjoyment of both sculpture and setting.

Top left: David Smith, Albright-Knox Museum, Buffalo, New York. Sculpture with a highly polished or burnished surface is at its best when it's placed to catch the sunlight.

Bottom left: Robert Cook, New York. The pedestrian and the automobile passenger view the same work of sculpture at different speeds and distances.

Right: Robert Helsmoortel, Atlanta, Georgia. A rather common, but often ignored viewpoint for outdoor sculpture in the city is that from the windows of multistoried buildings.

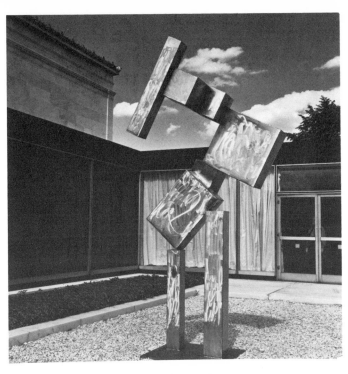

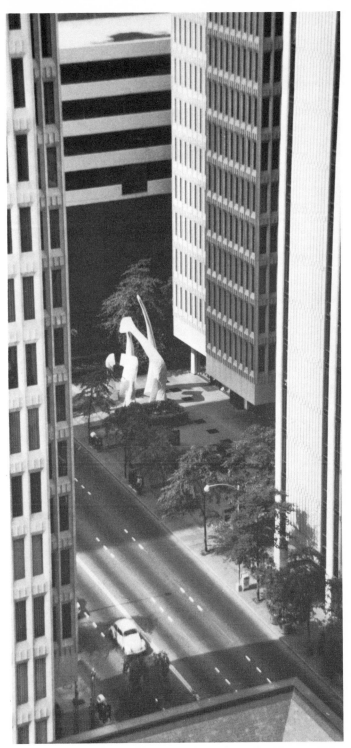

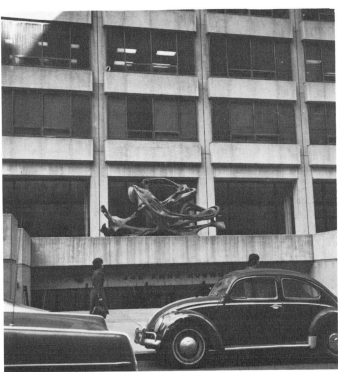

58

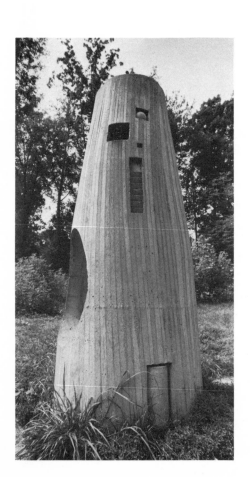

Environmental Relationship

The evaluative categories listed thus far — contextual relevance, physical qualities, staging, apprehension and revealment — all relate in various ways to the interaction of outdoor sculpture with its environment. Within the category of environmental relationship, there are some basic elements of the natural and the man-made environment that should not be overlooked in planning and evaluating outdoor sculpture programs. These elements are land forms, water, plants, architecture, and animals.

Land Forms

Although the future promises more experimentation and innovation in forms of outdoor sculpture that may be airborne — like kites or balloons — or composed of such nonmaterial substances as light or smoke, a work of sculpture, whether with or without a base, usually rests quite obviously upon terra firma (the exception is those whose base at least appears to be water). Such an inescapable relationship merits some thought in the selection and placement process. Whether a given work appears to stand solidly upon the earth, to nestle into it, to spring from it, or even to float above it depends upon the physical qualities of the sculpture, the staging, and of course the nature of the terrain. Only occasionally is the designer presented with the opportunity of selecting and placing sculpture in a natural environment where there may be such features as rolling hills, steep slopes, or jutting cliffs. Generally, the best descriptive adjective for the kind of land in most urban and suburban settings is *flat*. This is not always the case; sometimes land forms are structured for specific purposes. Whatever the nature of the terrain, it is unfortunate when a work of sculpture is simply plunked down on the surface of the earth or paving of whatever sort with no thought as to how it should relate to the topography of the setting.

Water

The introduction of water or the use of existing water in the design and placement of outdoor sculpture may produce a considerable change in the character or appearance of the sculpture. Water may function as a basic material in the sculptural composition as it does in many fountains. It may also serve as base, background, foreground, or all three. In addition, water in the form of rain or snow may substantially alter the appearance of a work. Rain may change the color or add sleekness and shininess to the surface. Snow may articulate the forms by sticking in crevices or along joint lines; or it may change the form and add another color by mounding on horizontal planes; or it may simply change the nature of the setting by blanketing the ground.

Plants

Perhaps the most important natural elements in the outdoor environment are plants. Growing behind, in front of, around, and sometimes on works of sculpture, plants with their infinite variety of texture and color may function as background, foreground, base, or any combination of these. Tall plants or trunks of trees may provide vertical enframement or partial screening from various viewpoints. Massed plants — hedges and clumps of shrubs — may compose outdoor "rooms" or "galleries" in which to display works of sculpture. The same kind of planting may also control or direct the spectator's view of the sculpture. Leaves and branches may serve as light filters, varying the color and surface pattern of a work. Plants may in fact determine or create the total at-

mosphere of a given setting. Whether the sculpture harmonizes closely with its setting or contrasts sharply, the use of plants in the design of the setting can usually help produce the desired effect. However, the introduction of a few potted petunias into a barren plaza will not transform a badly chosen or placed sculpture into a successful one.

Architecture

Architecture has been mentioned as a determinant of scale in outdoor sculpture. There are other ways in which sculpture relates to architecture and vice versa. Architecture may serve as a framing device for a work of sculpture or as a background or foil. Sculpture may serve to articulate a space created by architecture. It may provide an accent or mark a significant place, such as an entrance. One of its most important functions involves another environmental element when it serves as a link between architectural and human scale. Architecture and sculpture should complement, not detract from, one another.

Animals

Although not usually associated with outdoor sculpture, the fauna of the outdoor environment, simply by virtue of proximity, bear a relationship to sculpture. In the contemporary urban environment probably the most frequently encountered varieties of fauna are people (relatively large), dogs and cats (relatively small), and pigeons, starlings, and sparrows (quite small but extremely numerous). While dogs and cats may generally be discounted, the perching or roosting habits of the last group can produce rather disfiguring results on works of outdoor sculpture. Although there seems to be a preference for traditional commemorative works (perhaps contemporary abstract works offer less perchable surfaces), this might be a factor to consider in

selection and placement, particularly in urban areas.

Today there is much greater emphasis on works of sculpture that encourage participation by the human viewer. Obviously works of outdoor sculpture are to be touched. Many of them have moving parts that are intended to be manipulated by the viewer. Many of them create spaces that are to be walked under. Often works of sculpture are leaned against, sat upon, or under; climbed upon; and in some cases written upon. Whether or not any of those activities was originally intended—and in many cases it was—works of sculpture in the outdoor environment are increasingly being used by people. This relationship is happiest when the sculpture not only attracts people, but also neither suffers nor inflicts serious damage.

The suggested vocabulary terms are presented as a basis for further development as a tool in the successful selection and placement of outdoor sculpture. The terms are not comprehensive or definitive, nor do they replace the essential ingredient of guidance from arts professionals. Rather, they are intended to assist those involved in implementing outdoor sculpture projects and to improve communication among the various professions.

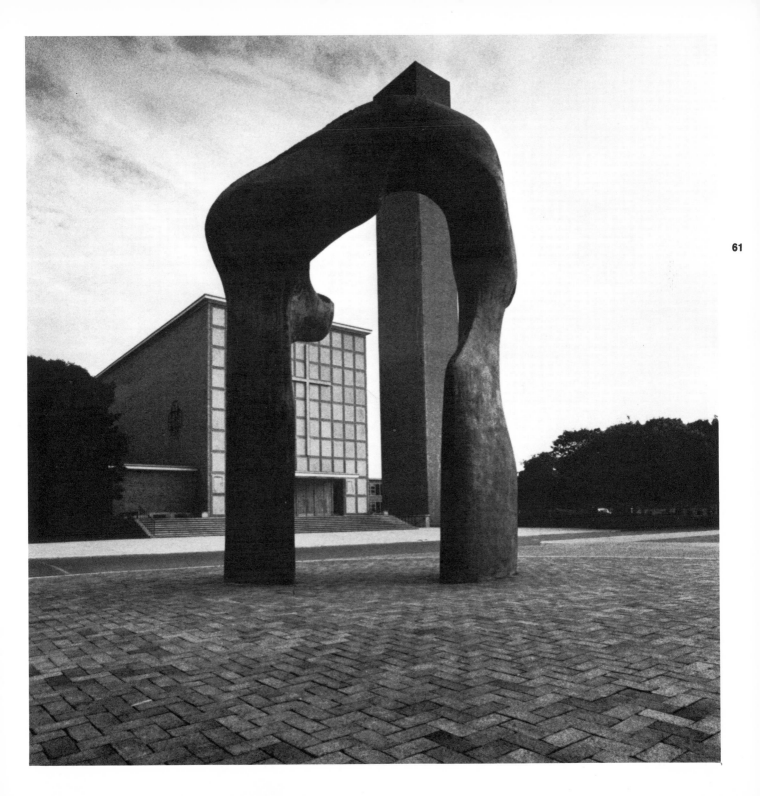

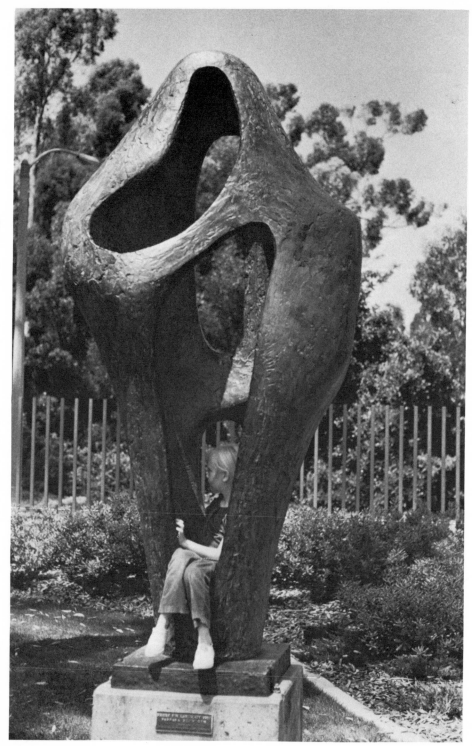

Barbara Hepworth, Fine Arts Gallery of San Diego, California. Works of sculpture that have a pleasant environmental relationship attract people and, by nature of material and form, neither sustain nor inflict damage.

4 Achievements in Outdoor Sculpture

The purpose of this book is to offer guidelines, not guaranteed formulas for successful outdoor sculpture programs. One way of arriving at criteria is by examining a variety of actual examples. These examples are listed according to what has been accomplished and by whom; an accounting (more complete in some cases than in others) of how it was accomplished, indicating the tools or means utilized; and the steps involved in the process. Although, for the sake of following some order of presentation, these examples are listed under headings indicating what individuals and/or organizations were involved, often there was a combination of several agencies participating in the programs.

Government Agencies

Active government support of the use of art in federal architecture dates to the inception of the Public Works of Art Project (PWAP) in 1933. Interest was revitalized with John F. Kennedy's 1962 "Guiding Principles for Federal Architecture" and again in 1973 with the program for improvement of federal design. The General Services Administration (GSA) maintains a program that requires that ½ of 1 percent of the total cost of construction be spent for art in all new federal buildings. Among the many outstanding examples throughout the country of the use of exterior sculpture with federal buildings are the monumental work by Dimitri Hadzi at Boston's John F. Kennedy Federal Center; the precast concrete group by Angelo Caravaglia in Salt Lake City; and the giant red-orange stabile by Alexander Calder in Chicago. Although this program is administered by the fine arts division of the GSA, it is a function of the Visual Arts Program of the National Endowment for the Arts (NEA) to provide consultation in the Art in Federal Architecture selection process, which works as follows:

1 After awarding the construction contract for a project that will have artwork, the General Services Administration requests the National Endowment to nominate artists to be considered for the commission. NEA appoints a panel that consists of the architect for the project, plus three other members from the local arts community. They may be museum directors or curators, art critics, or faculty members of a university art department.

2 This panel, taking into consideration the requirements of the specific and general setting, makes a selection of from three to five local, regional, and nationally recognized artists whose work the panel members feel would be appropriate.

3 The names of the artists nominated are then sent to the General Services Administration in Washington, D.C., where they are reviewed by the GSA Fine Arts Design Review Panel. The panel makes recommendations to the Administrator of General Services, whose approval of the final selection makes it official.

By no means confined to art in federal architecture, the Visual Arts Program of NEA directs among many other projects a matching grants program for Works of Art in Public Places. Public places are defined as "city spaces, outdoor and indoor," and include such places as "airports, subways, and highways."[1] Although it is the most powerful government agency in the realm of public art, and hence of public outdoor sculpture, the National Endowment for the Arts cannot be considered an instigator of programs, but rather a supporter and coordinator. It has functioned as the primary supportive factor in numerous community programs throughout the country.

An example of federal involvement in an outdoor sculpture program is the Libby Dam project in northwest Montana, where a giant commemorative relief by Albert Wein embellishes the upstream face of the 50-foot Treaty Tower. Celebrating the cooperation between the United States and Canada in developing the resources of the Columbia River basin, this sculpture represents the first American use of a work of art in the structure of a dam.[2] To select the design, a competition was held by the Seattle District, U.S. Army Corps of Engineers. From the 240 entrants from the United States and Canada, three finalists were chosen. After visiting the site of the Libby Dam, the three sculptors prepared models of their designs, which were then judged by a jury of professionals in the fields of sculpture and architecture. After a final selection was made, a contract was negotiated with the Corps of Engineers for professional services required to complete the work. The winning artist, Albert Wein, was awarded $15,000.

Although in a sense the achievements in public outdoor sculpture in Baltimore, Maryland, might be credited to community effort, it is primarily a function of government to pass and enforce laws, and in 1964 Baltimore enacted a 1 percent art in architecture law for public structures. This law of course covers all forms of art that can be incorporated into architecture. Some examples of outdoor sculpture associated with this program are the work by Harry Bertoia at Lake Clifton Senior High School, the

Right: Harry Bertoia, Baltimore, Maryland. One of many works of art placed in public spaces due to Baltimore's 1 percent for art in architecture law is this one by Harry Bertoia at Lake Clifton Senior High School.

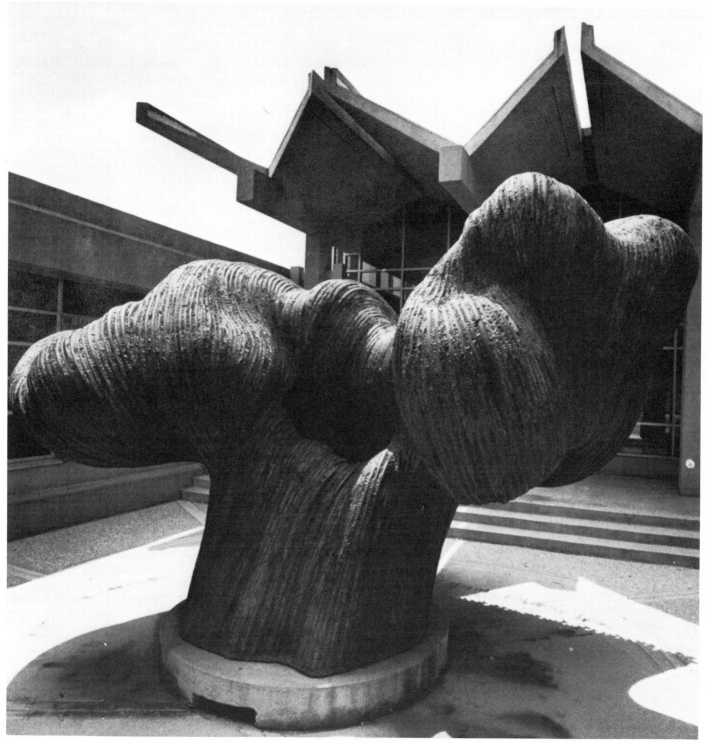

Right: André Bloc, Long Beach, California. The Long Beach symposium provided facilities for sculptors to work on a scale not possible in their own studios.

Below: Jack Zajac, Franklin D. Murphy Sculpture Garden, Los Angeles. The Franklin D. Murphy Sculpture Garden offers students the opportunity to live in intimate contact with works of art.

columnar metal sculpture by Roger Majorowicz at the Broadway Branch Library, and the works by Alfredo Halegua and Pierre duFayet at the Walbrook Junior-Senior High School. An informative publication on the Baltimore achievement is *1% Art in Civic Architecture*, funded by the National Endowment for the Arts. Other cities that have enacted 1 percent for art in architecture laws are Philadelphia, San Francisco, and Seattle.

Educational Institutions

Educational institutions have some unique resources available for planning and executing outdoor sculpture programs. Often on a large campus there is ample space to exhibit works of monumental scale, while an art department offers ideas and supportive professionals and the student body is a generally open-minded and receptive audience. The first International Sculpture Symposium in the United States was held at California State University at Long Beach (CSULB) in the summer of 1965. Eight internationally known sculptors were invited to spend eight weeks on campus, where each sculptor created one monumental sculpture that was to remain at the university. The sculptors invited to participate were selected by a committee composed of the directors of five major southern California museums. Each sculptor received an honorarium of $800, plus travel and living expenses. All materials, equipment, tools, and facilities were furnished by CSULB or donated by local industries. Funding for the operating budget, in addition to support provided by CSULB, was provided by donations from the community, from business and industry, and from individuals. Selected graduate students from throughout the United States participated as assistants to the symposium sculptors, enrolling as

regular students and paying standard fees. Among the benefits derived from such a program are the cultural exchange among nations, the communication between artists and technicians, the opportunity for sculptors to work experimentally and on a scale not possible in their own studios, the exceptional learning experience for the students involved, and perhaps most importantly a collection of outstanding monumental sculpture that transforms the campus into an outdoor museum.

One of the most successful sculpture gardens in the country is on the campus of the University of California at Los Angeles (UCLA). Named after Franklin D. Murphy, who in 1968 concluded "a dynamic and productive eight-year tenure"[3] as chancellor of the university, the sculpture garden is the realization of Murphy's dream that "students should live in intimate contact with great works of art of their time."[4] A dusty parking lot was transformed into a courtyard and garden setting for sculpture through the design of the landscape architectural firm of Cornell, Bridgers, Troller & Hazlett of Los Angeles. The first work of sculpture placed was Jacques Lipchitz's *The Song of the Vowels*, contributed jointly by Mr. and Mrs. Norton Simon and the UCLA Art Council, an active organization dedicated to the support of the arts at UCLA. With the exception of one large gift of several works from the private collection of David E. Bright, the entire Murphy collection has been assembled a work at a time through the gifts of individuals and small groups, the UCLA Art Council Fund, memorial funds, and the gifts of at least one graduating class. Flanked by Dickson Art Center, the Theater Arts Building, the Business Administration Building, the Social Science Building, and the Research Library, the sculpture garden is a vital outdoor public space where "students live casually in the

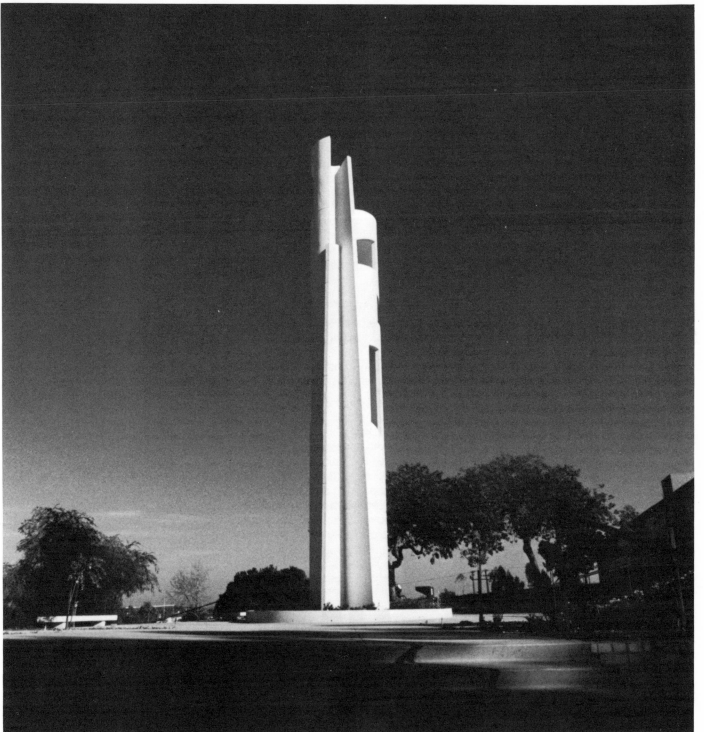

68

uninsistent presence of great achievement."[5]

In a situation with a different set of qualifications because of the nature of the site and the size and type of the school, George Washington University, a privately endowed institution in the heart of Washington, D.C., placed an exceptional work of contemporary sculpture in a lower entrance court of the student center. The work was created by Rudolph Heintze as partial fulfillment for MFA degree requirements. When he first conceived of the sculpture, Heintze was not aware of its ultimate placement, but after receiving approval from the architect of the student center and from the Graduate Art Department of the university, he built a scale model of the sculpture as it would appear in the specific setting. The work was funded by an alumnus of the George Washington University Law School, who donated the cost of the material and assemblage, most of which was done by the artist himself.

Another university showed a unique but logical approach to an outdoor sculpture program. Having accumulated through its development projects substantial funds "allocated for the procurement of exterior fine arts elements,"[6] the University of Pennsylvania hired landscape architects Collins, DuTot, & Associates of Philadelphia to carry out a study to develop

guidelines for determining the nature and suitable location of these elements, the relative amount of funds to be expended on them, and their priorities with respect to location. . . .

The study proceeded from a graphic analysis of the physical environment of the campus, an examination of the nature and effectiveness of existing fine arts elements, and an exploration of the potential use of these elements in the campus environment, to the establishing of location priorities, budget allocations, and phasing for development with specific guidelines for treatment of selected locations.[7]

After receiving the completed study, the university established a Fine Arts

Committee to select works of art to be placed on the campus. In 1975 a 60-foot high tubular steel structure by Alexander Liberman was erected in a large plaza near the western entrance of the campus. The giant red-orange work functions as a landmark and ceremonial gateway to the university. In the same year a contemporary work by Tony Smith was installed in another area of the campus.

Other universities that have placed works of sculpture on campus are Princeton, Yale, Massachusetts Institute of Technology, Washington University in St. Louis, and Southern Methodist University in Dallas, Texas.

Business and Industry

The world of business and industry has contributed far more in the realm of the arts than is realized. Some credit is due the Business Committee for the Arts (BCA), a national, nonprofit organization, composed of prominent businessmen who aim to encourage business support of the arts. By carrying out research, providing information and counseling for corporations wishing to become involved in art programs, and acting as an interface between the business world and art community, BCA has significantly influenced the rise of business support for the arts from $110 million in 1970 to $144 million in 1973. While no more recent figures are available, a spokesperson for BCA stated that this trend was not significantly diminished by the economic situation of 1974 and 1975.

There are myriad examples of outdoor sculpture for which business and industry have been responsible. Among those that are best known are the works by Jean Dubuffet and Isamu Noguchi in Chase Manhattan Plaza in New York City, the work by Willi Gutmann in Embarcadero Center in San

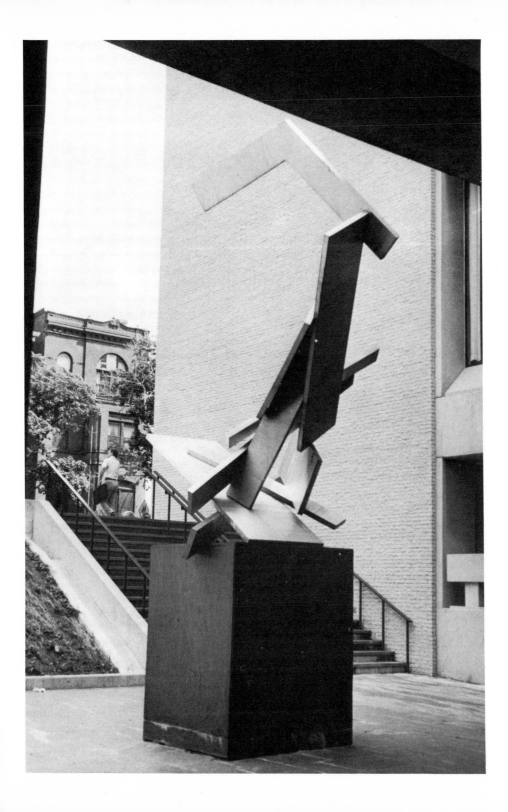

Francisco, and the work by Masayuki Nagare in the Bank of America Headquarters Plaza also in San Francisco. In downtown Atlanta's Peachtree Center the outstanding works of contemporary sculpture that enhance the urban area include those by Robert Helsmoortel, Willi Gutmann, and Charles O. Perry. Peachtree Center is a gigantic office, retail, hotel, entertainment, and wholesale showroom center on 10 acres of Peachtree Street at Atlanta's highest point. It was developed with private capital, and it is impossible to talk about how it happened without mentioning the name of John Portman, "perhaps the nation's foremost example of an architect who participates in the ownership of many of his own projects, notably Peachtree Center."[8] Portman believes that "today, architecture must reorient itself to people. It must appeal to their eternal needs to be close to nature, and to have order, variety, and spaciousness. . . . It must relate to the human scale. Most of all, it should lift the human spirit."[9] One way of achieving the latter two of course is by including outdoor sculpture in architectural design. The works of sculpture in Peachtree Center are selected on the basis of esthetic quality as well as compatibility with the theme and goals of the project.

In an entirely different suburban setting the Pepsico Company has established a collection of contemporary sculpture that is open to the public at its headquarters in Purchase, New York. In this case again it was initially the architect, Edward Durell Stone, who suggested that outdoor sculpture would be particularly appropriate in the parklike setting. The Pepsico Board Chairman, Donald Kendall, concurred with this suggestion, and the site was developed accordingly under the direction of landscape architects Edward D. Stone, Jr., & Associates. Subsequently

Kendall approved the purchase and placement of thirteen works by eight internationally known sculptors. Each work was selected by Pepsico's Director of Architectural and Facilities Services for a specific, carefully chosen site.

Atlanta's Gateway Industrial Park, mentioned in Chapter 2, should be cited again as a unique contribution in the realm of outdoor sculpture. A collection of between thirty and forty works of contemporary sculpture is placed throughout the park, where covenants controlling parking, loading facilities, landscaping, and the quality of architecture ensure the quality of the total environment to some degree. Although some of the problems inherent in such a project have not been completely solved, the feasibility of an outdoor sculpture program in an industrial environment has been unquestionably demonstrated.

Such enterprises as banking, real estate development, and the production and marketing of consumer goods fit easily into the category of business and industry. However, art too is part of the business world. Commercial art galleries acting as agents for artists provide showrooms where works of art are displayed for sales purposes. Today many galleries specialize in sculpture or both sculpture and painting for use in architectural projects, either indoors or outdoors (see Appendix C). In conjunction with and sometimes separately from the sale of works, they may offer an advisory service to such clients as architects, planners, landscape architects, communities, and developers. Although a good many of these galleries are located in New York City, there are others in various cities throughout the country that offer similar services.

For example, in Ann Arbor, Michigan, the Lantern Gallery (now the Alice

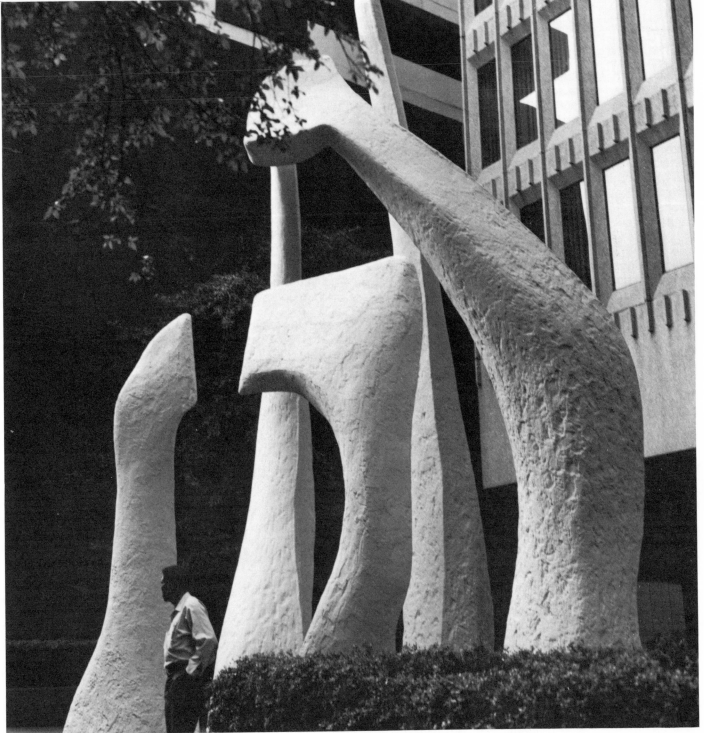

Simsar Gallery) during approximately one year (1973 – 1974) worked with fifteen different clients, a large proportion of whom were architectural firms, to select works of art appropriate to the buildings and sites associated with their projects. While the gallery of course operates as agent for a given number of artists, it can and does offer to clients the work of artists who are represented by other galleries. Its staff members are available to visit the offices of architects, landscape architects, and planners, making presentations that include slides and photographs showing the work of various sculptors as well as the site where the work is to be placed. In addition to making knowledgeable suggestions about the most appropriate kinds of sculpture, these consultants can also advise on the cost of transportation and installation. An example of a work in whose selection and placement the Lantern Gallery was involved is the welded steel sculpture by Bill Barrett at the University of Michigan Dental School. In this case the gallery provided consulting services to the architect of the building.

Museums

The term "museum" generally connotes an institution concerned with the protection and preservation of works of art that are displayed to the public in an indoor setting. Yet museums are increasingly demonstrating a concern for bringing art to the public and concomitantly for placing sculpture out of doors. In 1955 the Museum of Modern Art (MOMA) created its Abby Aldrich Rockefeller Sculpture Garden, designed by Philip Johnson, in which a "mutually respectful relationship between architecture, sculpture, and plants" is complemented by a "fine reciprocity between formality and freedom."[10]

The changes over the years — the maturing of plant materials, the replacement of some and addition of others, and the rearrangement and addition of works of sculpture — have only enriched the experience for the viewer. On a clear winter morning, a bright spring day, a warm summer night, or a sparkling autumn afternoon, this is unquestionably one of the most delightful outdoor urban spaces in the world.

Museums that have followed MOMA's lead in establishing permanent outdoor sculpture gardens include the Art Institute of Chicago and the Cleveland Art Museum. Adjacent to the new Hirshhorn National Museum in Washington, D.C., a sunken sculpture garden displays works from the magnificent private collection given by Joseph Hirshhorn to the people of the United States. A major portion of designing the facility was carried out by the late Douglas McAgy, whose dedication to the arts is memorialized in his contribution to the design of this sculpture garden. The precise placement of each work was critical from the standpoints of both design and engineering. Throughout the hot, humid summer of 1974, staff members worked long hours with painstaking haste under the guidance of Director Abram Lerner to prepare for the splendiferous October opening of the Museum and Sculpture Garden.

Other museums have organized temporary outdoor exhibitions. In the summer of 1972 the DeCordova Museum installed on its lovely old estate grounds in Lincoln, Massachusetts, an exceptional exhibit of contemporary sculpture, selected and placed by the director of the museum. The grounds of the Albright-Knox Museum in Buffalo, New York, provided the setting for another outstanding exhibit in the summer of 1973.

Perhaps the major permanent collection of large-scale outdoor sculpture in the United States is found at the Storm King Art Center in Mountainville, New York, the first public institution committed to outdoor sculpture. The spacious rural setting of rolling meadows and wooded hills, with its backdrop of low mountains, provides a "gallery space" that challenges the impact of even the largest works.

Right: Bill Barrett, Ann Arbor, Michigan. Lantern Gallery (now the Alice Simsar Gallery) of Ann Arbor, Michigan was involved in the selection and placement of this work by Bill Barrett at the University of Michigan Dental School. Photo by Claudia R. Capos, courtesy of Lantern Gallery.

Below: Charles Ginnever, *Fayette: In Memory of Charles and Medgar Evers,* Storm King Art Center, Mountainville, New York. Storm King Art Center's spacious rural setting provides a challenging stage for the display of monumental sculptures.

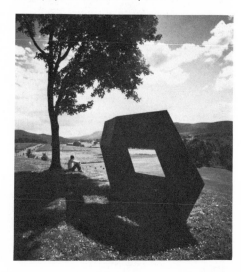

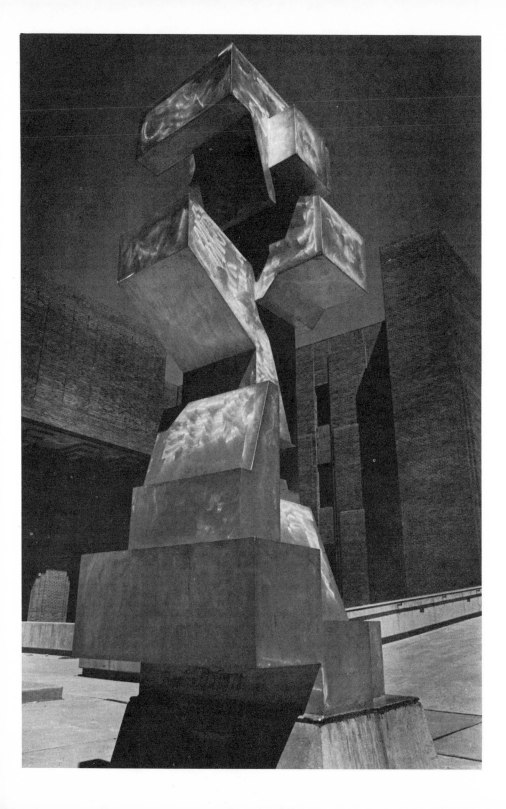

74

Individuals

The accomplishments of individuals in the realm of outdoor sculpture must be assessed according to different criteria. Often they are inseparably involved with those of business and industry or other institutions of our society. But there are also some exquisite private sculpture gardens. Joseph Hirshhorn's was one of them. Although he eventually opened it to the public on a limited basis, perhaps the true measure of his achievement is that now the same collection is available to a much larger public every day of the week.

Others have followed similar pathways. The magnificent setting of a southern plantation is the site of a sculpture garden that began as the private collection of Archer Milton Huntington and Anna Hyatt Huntington, the late animal sculptor. Open to the public for a nominal admission charge, the Brookgreen Gardens near Myrtle Beach, South Carolina, contain what is probably the largest collection of representational late 19th- to early 20th-century American sculpture in the country. Both the overall and the individual settings, utilizing the indigenous flora of the area, are particularly compatible with this type of outdoor sculpture.

Today a more common and effective means of individual patronage is the donation of a work or the donation toward a work that has been or will be selected as part of a community program. The Carl Milles work, *The Spirit of Transportation,* created for Detroit's Cobo Hall Convention Center, was given to the city by the family of an automotive pioneer. In Phoenix, Arizona, individuals played a significant part in funding the sculpture program in the Phoenix Civic Plaza. Although not a community project in the same sense, the giant concrete Picasso *Bust of Sylvette* that stands in the plaza of the University Plaza apartment complex in New York City is nevertheless the result of an individual's concern for art in the environment. The idea for its placement originated with the architect of the project, while its funding came from an attorney and his wife.[11]

Sometimes the sculptor may actually become a donor or patron, contributing either a complete work or a total design concept for a work as Picasso did for Chicago. An extraordinary case is that of Korczak Ziolkowski, a sculptor who has dedicated his life to carving the gigantic Crazy Horse Memorial on the face of Thunderhead Mountain in the Black Hills of South Dakota. The scale of the project, far larger than that of either Mt. Rushmore or Stone Mountain, is in keeping with the ultimate goal of this determined man, who by the way owns Thunderhead Mountain. Ziolkowski plans to create a $50,000,000 "North American Indian Center complete with university, hospital, airfield and a museum to preserve the Indian traditions and cultural heritage."[12]

Community and Joint Efforts

Although all the foregoing accomplishments in outdoor sculpture have come about through the efforts of more than one person or agency, some projects are even more appropriately credited to community efforts or to the joint cooperation of many people and agencies. There have been many such programs in recent years, and new ones are constantly being initiated. The following accounts cover only a few examples.

The 1968 and 1971 Vermont International Symposia

Unique among programs for sculpture in the exterior environment were the two Vermont International Symposia of

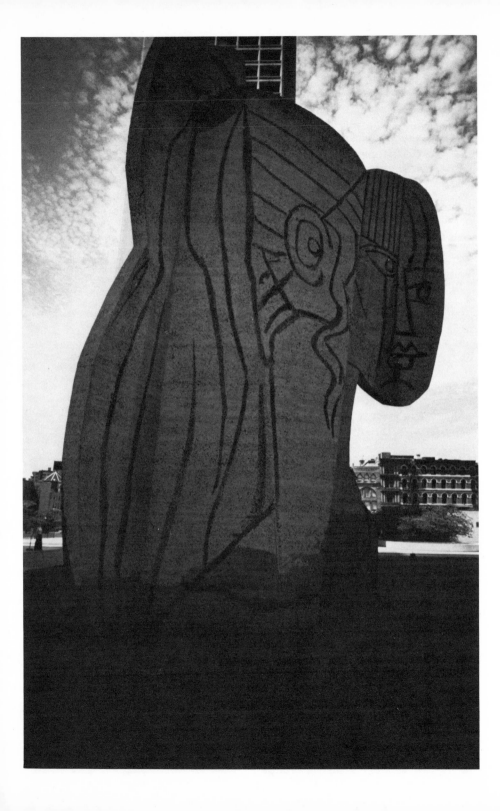

1968 and 1971, which culminated in Vermont's "Sculpture on the Highway" program. Although the initial impetus for the symposia began with a university faculty member, the entire program was completed through the combined efforts of a number of different people and agencies both within and outside the university community.

The international sculpture symposium, first introduced in 1959 at St. Margarethen, Austria, under the direction of sculptor Karl Prantl, has since been organized with varying degrees of success in Germany, Italy, Yugoslavia, Israel, Japan, Mexico, Canada, and the United States.[13] The international sculpture symposium provides an opportunity for sculptors from various countries to create monumental works that their personal facilities, equipment, and budgets do not otherwise permit. If a university is involved in the project, a singular learning experience is afforded the students who are selected to work with the sculptors, as was the case in both the Vermont and the 1965 California State University at Long Beach symposia. If industry is involved, it builds its own image as a valuable contributor to public art and gains knowledge of how to assist artists with specific problems. The works of sculpture themselves stand as reminders that sculpture is a universal language, capable of expanding the world of artist and spectator alike.

Supplying materials, equipment, and technical advice is industry's primary contribution. The artist contributes his or her time and ability and either donates the completed work or loans it for a certain amount of time to the country or jurisdiction where it was created. The sculptor receives transportation to and from the symposium, as well as housing, meals, and usually an additional honorarium or stipend. Funding for those as well as other miscellaneous expenses are provided by sponsoring agencies or institutions.

In the Vermont symposia the originating and guiding spirit was Paul Aschenbach, sculptor and faculty member in the University of Vermont Art Department. Aschenbach believes that "art is for people to look at and live with and touch and walk around and enjoy."[14] In 1968 he initiated and coordinated a marble symposium hosted by the Vermont Marble Company and in 1971 a concrete symposium hosted by S. T. Griswold and Co., Inc. Today seventeen of the resulting sculptures are part of Vermont's "Sculpture on the Highway," a project through which sculpture was placed in the rest areas along Vermont's Interstates 89 and 91.[15] The works are owned by the sculptors and are on loan to the state of Vermont for use along its highways. The project was funded in part by the National Endowment for the Arts and the Vermont Council on the Arts. In addition to the host industries previously cited, support was provided by Dayton Sure-Grip East, Inc.; the University of Vermont; the Episcopal Diocese of Vermont; and the Vermont State Department of Highways, which was responsible for installing the sculptures. An excellent publication, *Vermont International Sculpture Symposium*,[16] provides further information as well as outstanding photographs. (For further discussion, see Chapter 7, page 144.)

Grand Rapids, Michigan, Projects

Grand Rapids, Michigan, has developed a reputation as a community with a vital interest in public art. It was the first community in the country to take advantage of the National Endowment for the Arts program offering matching grants for art in public places. The outcome of this venture was the magnificent Calder stabile, *La Grande Vitesse*, which stands in the downtown Vandenberg Plaza and which has become the insignia or symbol of the city. In the years since its installation in 1969—both in spite of and because of the reaction it stimulated—this work of public art has been accepted by the people of Grand Rapids, who now refer to it as "our Calder." Its image has

Top: Isaac Witkin, Vermont Interstate 89 South. Witkin, created this work of concrete during the 1971 Vermont symposium.

Bottom left: Erich Reische, Vermont Interstate 89 South. One of the works created during the 1968 symposium was this one by Erich Reische, who used Vermont Danby Imperial marble.

Bottom right: Alexander Calder, *La Grande Vitesse*, Grand Rapids, Michigan. Alexander Calder's *La Grande Vitesse* has become the insignia of Grand Rapids, Michigan.

Below: The image of the Grand Rapids Calder identifies city trucks.

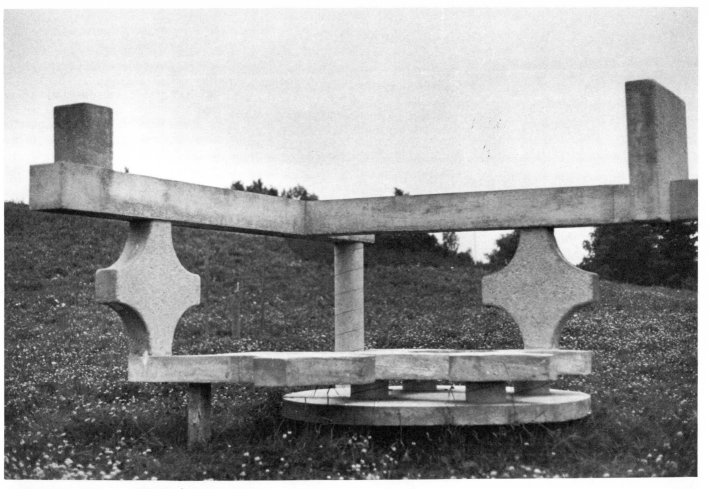

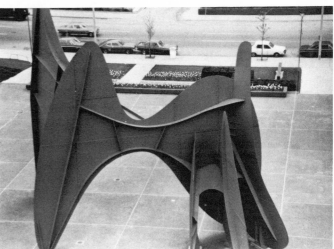

John Henry, Grand Rapids, Michigan. An extended area of turf along a sidewalk accommodated this sprawling work by John Henry.

been two-dimensionally reproduced and reduced and now appears on city hall brochures as well as city trucks.

More recently in 1973–1974 downtown Grand Rapids was the setting for a remarkably successful exhibition of monumental sculpture in the out-of-doors. The show, "Sculpture Off the Pedestal," was the result of a most enthusiastically and effectively pursued program of research, selection, funding, and publicity, powered primarily by the Women's Committee of the Grand Rapids Art Museum. The National Endowment for the Arts supplied an original grant of $8,900, which was matched nearly five times over before the end of the project.

The Women's Committee began by matching the federal funds. Next a research committee was selected, and individuals were assigned to investigate various media. The researchers used the facilities of several art libraries and consulted various area authorities in order to arrive at a list of internationally known sculptors from which the final selections were made. Letters were then sent to the artists, thirteen of whom agreed to participate in the show. There was no fee or honorarium; the completed works were to remain the property of the artists, to be sold or returned to them as they wished.

From one to three members of the Women's Committee were then assigned to each sculptor to act as liaison between him and the community. Their task was to secure all materials, equipment, and technical assistance needed by each artist. They were advised by Fred Myers, director of the museum; by Ronald Watson, chairman of the Art Department of Aquinas College, who acted as consultant particularly on site selection and installation; and by Michael Hall of the Sculpture Department at Cranbrook Academy of Art, who not only participated in the show but acted in an advisory capacity.

A relatively limited area in the vicinity of the Calder was chosen as the general site for the show so that all the works would be the most accessible to the most people. The downtown area was also selected to give the center of the city that excitement, meaning, and lift inherent in a major exhibition of this type.[17]

As quickly as possible it was established what sculpture would go on what site, so that the necessary permission for installation—either public or private —could be secured. To ensure credibility from a legal and mechanical point of view, the safety of each proposed work was determined and certified in writing by a structural engineer, whose service was donated by a local engineering firm. When the women representing the artists approached businesses and industrial firms for materials and technical assistance, they were able to be very specific about what was needed, when, and where. The overwhelming response of the business community is obvious from the contributors listed under the name of each artist and his work in the show's catalog.[18] Of the thirteen works in the show, six were fully or partially constructed on the site by the artist. Some of the works were fabricated in Grand Rapids by local industry, while those produced elsewhere were transported to Grand Rapids free of charge by local trucking firms. The thirteenth work, an earth sculpture by Robert Morris, was still in the planning stages when the rest of the show was dismantled in the spring of 1974. Completed and dedicated that October, it makes use of a hill on the site of a new park constructed by the Grand Rapids Park Department. With the completion of the Robert Morris work, the show's total budget came to over $139,000.

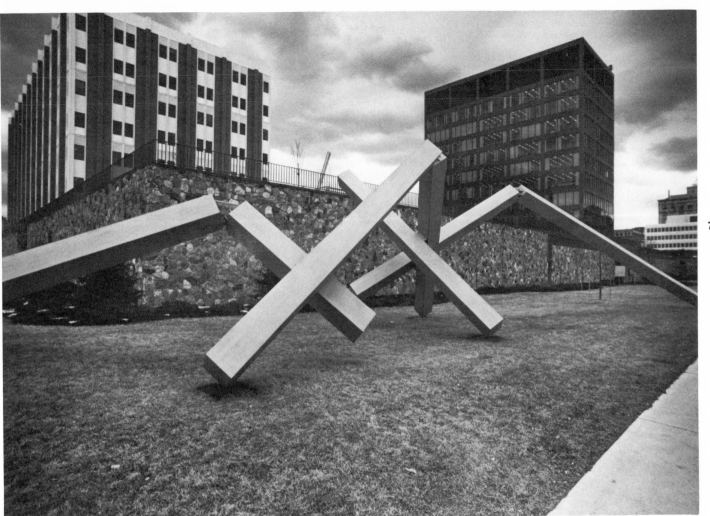

The artists themselves demonstrated an enthusiasm and personal involvement that have probably bridged forever the so called communications gap between artist and layperson, at least for a number of Grand Rapids citizens. All but one artist who was living in Europe made "at least one trip to Grand Rapids to select a site, meet Museum personnel, Women's Committee members, and the Show advisor, and to work out details for their part in the Show."[19] The artists were guests in the homes of Women's Committee members, and judging from the comments of the hostesses, this was one of the most rewarding experiences of the entire project. Almost all the artists were able to attend the opening of the show on September 8, 1973, designated "Sculpture Day" in Grand Rapids, when Mayor Lyman Parks presented each sculptor with a key to the city.

Public reaction was of course varied, but most of the shock generally produced by a monumental work of abstract or nonrepresentational sculpture had long since been dissipated by the presence of the Calder. In fact many people used the Calder as a standard of measure or point of reference for assessing the newer works. Generally there was a spirit of objectivity and at least a measure of acceptance. No one heard the comment, "What is it?" Instead, it was, "Some of them are quite interesting, aren't they?" (an elderly man). Or at least, "Well, I'll withhold judgment." An additional indication of public reaction was that a stranger in the city did not receive a blank stare but specific directions upon asking, "Where is the sculpture show?"

By October 1974 three of the works from the show had been purchased for installation in the Grand Rapids area—one by a commercial institution, one by a small college, and one by a nearby community. The remaining works were returned to the artists or sold to out-of-state purchasers. From the purchase price of one of the works bought for a regional retail shopping mall, a significant amount was contributed by the purchaser at the request of the artist to the Women's Committee of the Grand Rapids Art Museum.

Also, Mark di Suvero, one of the artists who participated in the show, was commissioned by the General Services Administration to do a sculpture for the plaza of the new federal building in Grand Rapids.

The impact of such a project upon a Midwestern community is difficult to assess, but there is no doubt about its reality and vitality. An additional value lies in the implications it poses for similar communities where its example, one hopes, will be instructive and challenging.

Safeway's Fountain Sculpture in Monterey, California

Impressive as was the Grand Rapids accomplishment, its monetary scale need not be matched in order to implement a worthwhile project. Dissatisfied with the appearance of a fountain in the small plaza on the edge of a Safeway supermarket parking lot in Monterey, California, the Monterey Committee on City Appearance suggested that Safeway Stores, Inc. sponsor a competition for the design of a new fountain sculpture. A cash award of $2,500 was given by Safeway for the winning design, which was selected by a special subcommittee chosen by the Committee on City Appearance. The winning design, a welded copper wild boar representing a species native to that part of California, was the work of a southern California sculptor, Jo Hudson. It was unveiled in 1973 in a brief ceremony attended by a national representative of Safeway, the local store

manager, the mayor of Monterey, members of the city council, and the Committee on City Appearance. An item in a local newspaper applauded the event:

To its everlasting credit, Safeway discreetly refrained from taking advantage of the occasion with signs proclaiming specials on pork chops, or ham, or anything like that. (Let's hear it for Safeway!)[20]

Lutheran Center Sculpture in Cedar Falls, Iowa

Just across the street from the campus of the University of North Iowa in Cedar Falls, Iowa, stands a large frame house that serves as the campus Lutheran Center. On a part of what is now its lawn grew and flourished for over one hundred years a magnificent elm tree that eventually died from Dutch elm disease in 1973. Unwilling to see the remains of the venerable tree cut down, carted away, and forgotten, the pastor of the Lutheran Center consulted with the university Art Department, where he was referred to a student sculptor, John Faust. For Faust, the gigantic trunk presented an opportunity to work on a scale he had not previously attempted. At his suggestion the trunk was cut off 20 feet above the ground. Assisted by student volunteers, Faust erected a scaffold, climbed to the top, and began translating a small-scale sketch into the dimensions of the huge tree trunk. For the duration of the project the young sculptor and his wife were given free lodging in the Lutheran Center student apartment. All assistance was volunteered and all materials donated.

The result is a human figure, reaching in anguish toward the sky. No, it isn't a crucifixion, but a personified "memorial to the tragedy of Dutch elm disease," says Faust. For the Midwesterner whose Main Street was once a

cathedral-like space—whose columns were the trunks and whose arches were the branches of elm trees — the tragedy of Dutch elm disease is worth memorializing, and the subject matter of this work of public outdoor sculpture is indeed appropriate.

San Diego's "The City Is for People" Exhibition

"The City Is for People" exhibition was held in San Diego from midsummer to early fall in 1973. As the title implies, its purpose was to promote community awareness and enjoyment of the arts in a nonmuseum environment. Sponsored by the Fine Arts Gallery of San Diego and partially funded by a $10,000 matching grant from the National Endowment for the Arts, it was an attempt to "offer a series of correlated programs and exhibitions to encourage the community to explore ways to improve the community."[21] The assistance and cooperation of the city government was enlisted through the mayor, who acted as honorary chairman of the entire exhibition, and the assistant city manager, who acted as city hall's liaison and coordinator.

Sculpture and wall paintings were used to animate empty spaces in the city and "add a new dimension to the life of a city-dweller or worker."[22] At the Fine Arts Gallery were other correlated exhibitions, one of which was a multimedia presentation of public art in major cities throughout the United States. The sculpture for the exhibition, which included the work of some local as well as nationally known artists, was selected and placed throughout the city by Henry Gardiner, Director of the San Diego Fine Arts Gallery, and his staff. Other than some permanently placed works at the Fine Arts Gallery, the LaJolla Museum of Contemporary

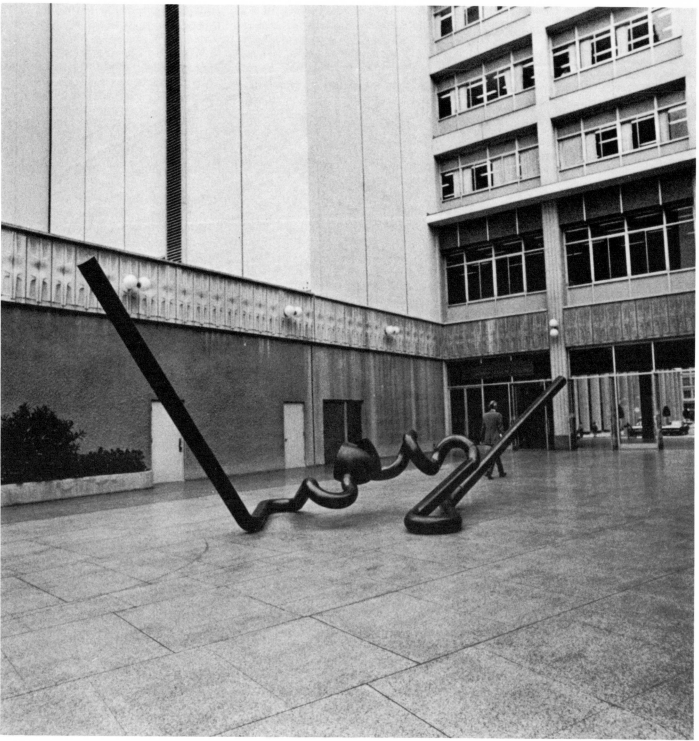

84

Art, and Grossmont College in El Cajon, all the sculpture in the exhibition was on loan, and the expense involved was primarily that of shipping, insurance, and installation. Eighteen works were located in exterior settings such as parks, urban plazas, and courtyards.

Mary McLeod Bethune Monument in Washington, D.C.

Sometimes the implementation of a successful outdoor sculpture program requires not only a considerable sum of money, but a sustained drive over several years. The combined efforts of some 60,000 women resulted in a work of monumental outdoor sculpture that in today's world of the antihero recaptures something of the spirit that must have stirred in the hearts of viewers at the unveiling of the seated statue of Abraham Lincoln at the Lincoln Memorial. For over thirteen years members of the National Council of Negro Women labored to erect a monument to Mary McLeod Bethune that would honor the memory of this great educator who lived her life so beautifully for her people. The artist, Robert Berks, was selected through the recommendation of the National Fine Arts Commission and several other authorities in the arts. Through the years the women "held bake sales, washed cars, put on garage sales and a myriad of other benefits to raise money for the statue. Like others, they were hit by inflation. They had to reassess their original cost figure by 20 percent."[23] Persistence triumphed, however, and on July 10, 1974, the bronze figure group portraying Mary McLeod Bethune handing her legacy to two eager young children was unveiled before a crowd of some 100,000 people at Lincoln Park in Washington, D.C. (For further discussion, see Chapter 7, page 144.)

Donations Involving Private and Public Agencies in New York City

In New York City a group of business executives known as the Association for a Better New York presented the city in 1971–1972 with six large-scale works of contemporary outdoor sculpture. The program was carried out in cooperation with the New York City Department of Cultural Affairs of the Parks Administration. At first the sculptures were placed at key locations throughout Manhattan and Brooklyn; later they were moved to selected sites that also included the Bronx, Queens, and Staten Island. All the sculptures were engineered so that they could be moved easily. One of the works, *Cubed Curve* by William Crovello, was purchased from the city by the Rockefeller Center Corporation and remains permanently in its original location in front of the Time-Life Building on Sixth Avenue. The purchase funds will be used by the cultural council's Visual Arts Committee to obtain other sculpture for public display, thus involving both private and public agencies in a joint project for public art.

Civic Plaza in Phoenix, Arizona

Like many other cities, Phoenix, Arizona, became aware of the desperate plight of its downtown area in the late 1950s and began plotting a course to save it from irreversible deterioration. Today Phoenix boasts a handsome new Civic Plaza that includes a cultural-convention center with outstanding architecture and a carefully planned art enrichment program containing outdoor sculpture. Individuals, architects, and community agencies were involved in selecting and funding these works. The Phoenix Civic Plaza publicity director noted that the design director of the project "suggested many of the pieces so that appropriateness, proportion, visual appeal . . .

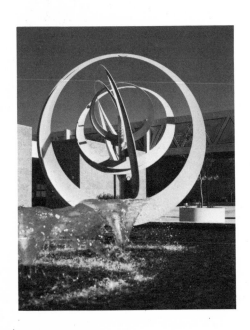

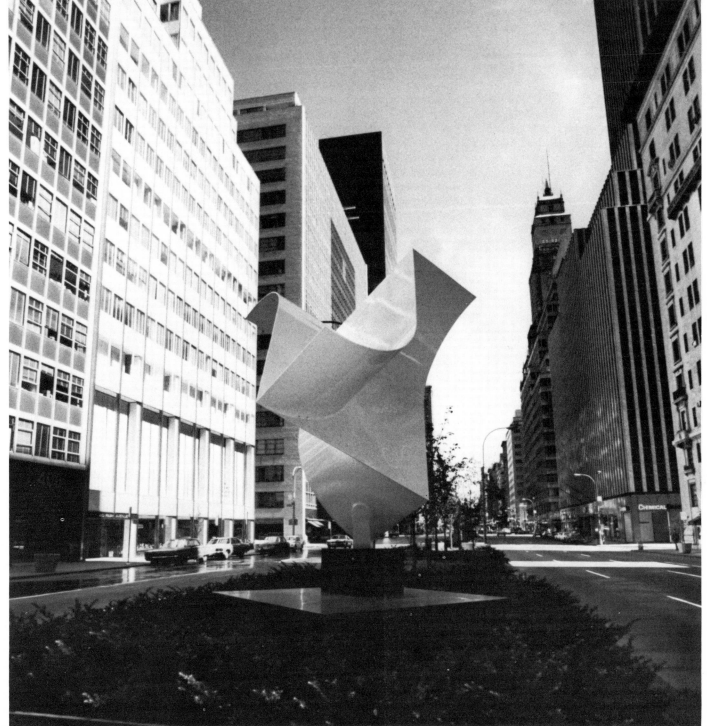

were taken into account relative to the architecture."[24] The method used for handling funds is also worth noting:

A special trust account was set up under the Civic Plaza controller's jurisdiction to receive and disburse the donated funds as the contracts for the art objects progressed. This kept the funds out of the city's general funds, protected the interests of the donors, and permitted disbursement under close surveillance, but with minimal record keeping.[25]

Since the opening of the Phoenix Civic Plaza additional interest in and support for the arts program has been generated, and it is anticipated that the collection will continue to grow.

Sculpture in the Park in Paramus, New Jersey

Often the energizing catalysts in the inception and implementation of outdoor sculpture programs are the various regional and community arts organizations known as arts councils, cultural councils, or arts committees. In 1971 the North Jersey Cultural Council in cooperation with the Bergen County Parks Commission presented the first exhibit of outdoor sculpture in a county park setting in Van Saun Park, Paramus, New Jersey. A second "Sculpture in the Park" exhibit on the same site was held from June 15 to October 20, 1974, and was presented by the North Jersey Cultural Council, the Bergen County Parks Commission, and the Board of Chosen Freeholders. The benefits of the informal outdoor museum through which people leisurely strolled while observing a wide variety of contemporary sculptures were expanded since they could also watch a number of different works actually being constructed on site by the artists. Twenty of the sculptors received grants for this purpose, with the resulting works becoming part of a permanent collection of the North Jersey Cultural Council that are made

available for display in public places in Bergen County. (For further discussion, see Chapter 7, page 142.)

Monumenta in Newport, Rhode Island

Under the sponsorship of the Newport County Arts Council, and supported by the Department of Natural Resources of the state of Rhode Island and a grant from the National Endowment for the Arts, an exhibition of large-scale outdoor sculpture was held August 17 through October 13, 1974, at Newport, Rhode Island. As in the Paramus project, there was also substantial support from a good many private and community organizations, individuals, and local businesses. "Monumenta," as the exhibition was named, was organized by art historian Sam Hunter of Princeton University, who served as director of the exhibition. The sculptures were located throughout Newport in a downtown mall, in the oceanside public parks and along the oceanside drive, and on the grounds of the Elms and the Château-sur-Mer, two of Newport's famous historic mansions. A map of Newport showing the location of the sculptures as well as a listing of all the works at a given site was available for visitors. In spite of the name, not all the works in the show were monumental in scale, but an attempt was made to suit the sculpture to the site, the smaller works being displayed in the more intimate settings of the estate gardens. (For further discussion, see Chapter 7, pages 132–134.)

Nebraska Interstate 80 Bicentennial Sculpture Program

A significant and exciting program has been initiated under the sponsorship of the Nebraska Interstate 80 Bicentennial Sculpture Corporation. The project involves commissioning ten American

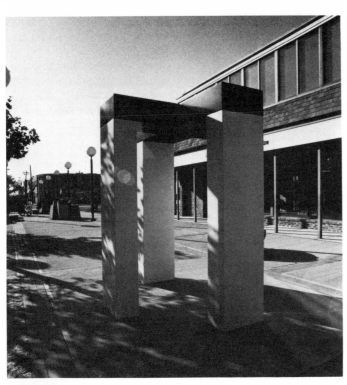

Possible steps in the implementation of an outdoor sculpture program (in order of complexity).

What or who are the organizations or people involved in exterior sculpture selection, procurement, placement, implementation, administration, and maintenance? A varying cast of characters play a substantial number of roles that appear consistently in the total production of an outdoor sculpture program. Sometimes a character (a person or group) may play a number of roles; sometimes the various roles are performed individually by specific characters. The following is a listing of essential roles:

A Sculptor/creator — the person who creates or originates the works of art

D Space designer — the person or group responsible for designing the space or area in which a piece of sculpture is placed

$ Donor — the person or group responsible for acquiring or financing the purchase or acquisition of individual pieces or groups of sculpture (procurement)

B Administrator — the person or organization responsible for the administration and management of an exterior sculpture program

S Sculpture selector — the person or group responsible for the selection of the piece or pieces of sculpture

I Implementor — the person or group responsible for initiating, coordinating, and following through to the completion of a given outdoor sculpture program, whether permanent or temporary, involving a single work or a collection

M Maintainer — the person or group responsible for maintaining or preserving the individual work or a collection of outdoor sculpture

P Sculpture placer — the person or group responsible for the selection of the specific site where the sculpture is to be placed

C Coordinator — the person or group responsible for the harmonious integration of an outdoor sculpture program within a given community

artists to create monumental pieces of outdoor sculpture to be placed at ten roadside park rest areas across 455 miles of Interstate 80 in Nebraska by July 4, 1976, in honor of the Bicentennial. The sculptors will become artists-in-residence in the communities along Interstate 80 while they create their works. The results of this program should produce positive reactions from the public and should foster better communications between laypeople and artists.

The preceding survey of achievements in outdoor sculpture by government agencies, educational institutions, business and industry, museums, private individuals, and a variety of community and joint efforts indicates the complexity possible in the implementation of outdoor sculpture programs. The chart on this page diagrammatically illustrates the numerous steps and individuals or groups that may be involved in carrying a given outdoor sculpture project to completion. The process may be as simple as that of a sculptor/donor placing his or her own work in an outdoor space that the artist controls. Or it may be as complex as a community project involving local arts people; government officials and/or agencies, both local and federal; a number of artists from whom a selection is made; architects and contractors; local business and industry; national arts experts; and community service organizations. The complexity is determined by a number of variables, such as the nature and purpose of the project; the size of the budget; and the setting, both general and specific.

It should be emphasized that there is no guaranteed formula for success. However, experience seems to indicate that no matter what the nature of the program, or how few or how many people and processes are involved,

planning for sculpture should occur as early as possible in the design phase of an architectural project. Securing the best available professional guidance and consultation is absolutely essential to the success of any program, whether permanent or temporary.

The term "successful" is applied with some misgivings to outdoor sculpture programs. It is difficult and probably unwise to make hasty value judgments. Does "successful" refer to esthetic and design quality? Does it connote compatibility with the setting? Does it mean enduring? Does it mean popular? Its meaning could include any, all, or none of these. The term is a source of controversy. Although the creative product that is art cannot be regulated or determined by popular taste, there is always a relationship between a work of art and its audience.

Outdoor sculpture, however, is usually also *public* art, in that it is available to a large and varied audience. Chapter 5 will deal with a limited and tentative attempt to determine the public audience reaction to outdoor sculpture.

5 Public Response to Outdoor Sculpture

Outdoor sculpture, by virtue of its setting, is probably the most people oriented of all urban art. Commenting on the show, "New York City Public Sculpture" at the Metropolitan Museum of Art during midsummer to early fall in 1974, Ada Louise Huxtable stated:

The use of space and sculpture is traditionally one of man's most creative contributions where it counts most: as a three-dimensional part of the functioning city scene and of the activity of life. More people experience art here than in galleries and museums. The art of the city is the most pervasive art of all.[1]

The purpose of this chapter is to present and illustrate one way of determining people's response to outdoor sculpture. Determining public response to the arts has recently gained new importance. As Amy Goldin, art critic and contributing editor to *Art in America*, urges:

We must inquire into public art's relationship to its audience, because the investigative techniques available to contemporary critics — iconography, style, formal analysis — do not help us account for it. . . . We see art as ultimately bound up with the inner life of both the artist and the viewer. True art thus becomes basically a personal and individual response.[2]

The role of the public as audience for contemporary outdoor sculpture is a vital one in the total art experience. The artist is the sine qua non—he creates—but it is the viewer who responds—accepts, rejects, interprets.

Although this chapter deals primarily with the use of the sample survey, there are other ways for determining viewer response to sculpture in the environment. Information could be gathered via the hidden camera, through casual photography, by direct observation and person-to-person interviews, and through distribution of self-addressed postal cards eliciting comments. In certain situations information could be obtained from physical evidence, such as wear and tear or even vandalism on sculpture or the surrounding areas, how pathways are worn in turf, or from indentations or hollows in paving surfaces. These last methods are obviously less dependable and thus less desirable. However, there is a more sophisticated device, the *hodometer*, which has been developed for use in museums or other indoor settings. The hodometer involves a sensor installed under the floor covering, which when activated by the pressure of a person, identifies the individual's location. The information is electronically recorded in an adjacent room, and the participant is totally unaware of the entire procedure. Perhaps there will be future adaptation or development of a device similar to the hodometer that can be used in the outdoor setting.

The sample survey using questionnaires is becoming an increasingly popular tool for determining public needs and desires in all areas of environmental planning, and most certainly promises to be of use in evaluating and planning public art programs. A nationwide survey of public attitudes toward the arts in general was conducted in 1973 by the National Research Center of the Arts, an affiliate of Louis Harris & Associates, Inc. A total of 3,005 people sixteen years and older, representatives of all major demographic groups in the country, were interviewed. This is considered an unusually large statistical sample, providing a high degree of reliability for study results. Among the findings, the survey revealed that "almost 9 of 10 American adults (89 percent) feel that the arts 'are important to the quality of life in their communities.'"[3] Harris made the comment, "Our survey shows that when the arts are brought to the people, the people do respond. . . ."[4]

The survey was based on 90-minute interviews using a questionnaire containing hundreds of questions. Al-

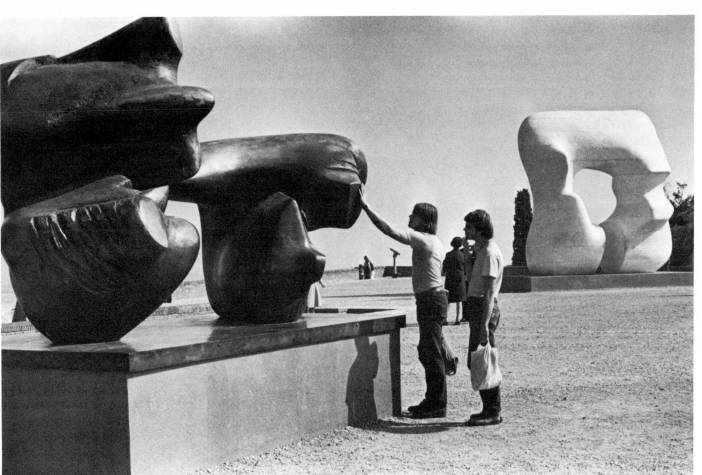

though questionnaires are simply forms for securing information, there are a number of kinds that can be used. They may employ adjective or activity checklists, rating scales, semantic differential, or questions aimed at determining attitudes. Questions are generally of two types: structured or unstructured. The structured or closed question provides responses from which the respondent may choose, while the unstructured or open-ended question asks the respondent to compose his or her own answer. The structured question is of course the more efficient and less time-consuming. The following checklist of the major steps in a sample survey is taken from material provided by Don Conway, Director of Research Programs, The American Institute of Architects, Washington, D.C.:

Designing and planning the survey

Preparing the sampling frame and selecting the sample

Developing, pretesting, and reproducing the questionnaire or interview schedule

Developing and reproducing interviewer training materials

Recruiting and training the interviewers

Conducting and supervising the fieldwork

Editing, coding, and keypunching the responses

Tabulating and analyzing the data

Preparing and reproducing the report[5]

The Public Opinion Survey

With the listing of what is involved in the proper development and utilization of a survey questionnaire, it must be noted that the study of outdoor sculpture discussed here does not meet all these standards. Because of limitations imposed by time, money, and available personnel and because it was merely a segment of a larger study, this public opinion survey conducted throughout 1972 and 1973 must be regarded primarily as a pilot study or "prestudy study" to provide guidelines for the development and implementation of further research in this area. At the inception of this study there had been no similar survey undertaken in the area of outdoor sculpture, nor has there been any as this book goes to press. Therefore this effort is experimental, and it certainly provides information not previously available.

The purpose of the questionnaire (see page 93), developed with the assistance of Dr. Charles S. Harris, Senior Associate of Roy Littlejohn Associates of Washington, D.C., was to elicit subjective response from the casual observer of a given work or works of outdoor sculpture. Such response, it was hoped, would indicate awareness of and attitudes toward outdoor sculpture. Surveys were conducted in fifteen specific locations in eight cities in the United States. As with all pilot projects, once the surveys were underway, it became apparent that the questionnaire needed to be revised, particularly to make it more usable to evaluate collections, as opposed to individual works. However, for the sake of continuity and uniformity it was necessary to continue using the original form throughout the project.

The procedure followed in conducting the surveys was to hand out twenty-five questionnaires at random to the people lounging, lunching, or passing through the public area immediately surrounding a work. Pencils were provided and the respondents requested to fill out the questionnaire on the spot. Since the questions were structured and the number fairly limited (twenty), the form could easily be completed within two to five minutes, after which it was collected by the interviewer. The total operation in each instance took approximately 1½ hours.

Results of the Survey

Of the total of 375 people surveyed, 53 percent were male, 47 percent female (Table 6, Appendix A); 68 percent were in the 18 to 35 age group (Table 2, Appendix A); 65 percent had completed at least one year of college (Table 1, Appendix A). Although vocations have been condensed for the sake of classification, they varied considerably (Table 3, Appendix A); often there were nearly twenty-five recorded for each set of questionnaires. The largest group represented was the professional, with 39 percent of the respondents in that category. An overwhelming 93 percent of the people surveyed were consciously aware of the works of sculpture about which they were questioned (Table 1, Appendix A). The educational level of the respondent appeared to have little bearing on that awareness.

In spite of occasional strong individual negative reactions, 60 percent of the respondents indicated that they liked the particular work or works in question (Table 2, Appendix A), while 12 percent registered dislike and 28 percent were neutral in their response. The highest percentage of favorable responses came from those under 18, the lowest from those over 55, while the reverse was true for negative responses. The next highest percentage of favorable responses came from those in the 18 to 25 category. There seems to be an indication that age, which determines to some extent the individual's awareness and attitudes, is a factor influencing response to sculpture in the outdoor environment.

Evaluation Sheet

Statistical information

1 Age: under 18 ☐, 18 to 25 ☐, 26 to 35 ☐, 36 to 55 ☐, over 55 ☐

2 Sex: male ☐ female ☐

3 Educational background (under high school or technical, please indicate subject preference; under college &/or graduate or professional, indicate major)

 High school Technical training College Graduate or professional

 _____ _____ _____ _____

4 What is your occupation? _____

5 Are you a resident of this community? ☐ yes ☐ no

Information about this particular piece of sculpture or collection of works

1 Are you aware of it? Do you notice it? ☐ yes ☐ no

2 How do you feel about this work? ☐ I like it. ☐ I dislike it. ☐ I am neutral towards it.

3 Is the work: too large ☐, too small ☐, approximately the right size ☐

4 Does its form suit the setting and subject matter (if any)? ☐ yes ☐ no ☐ no opinion

5 Does the material from which it is made suit the setting and subject matter?
☐ yes ☐ no ☐ no opinion

6 Does the color suit the setting and subject matter? ☐ yes ☐ no ☐ no opinion

7 Does the work (or do most of the works, if this is a collection) generally fit its setting?
☐ fairly well ☐ extremely well ☐ not at all

8 Would you say that the work is (or works are) generally esthetically pleasing? ☐ yes ☐ no

9 Given the opportunity, would you:
☐ replace it with another work ☐ remove any sculpture from this particular setting ☐ leave it as it is

10 Does this particular work have a message or purpose other than an esthetic one?
☐ yes ☐ no ☐ not sure

11 Do you think that most people understand the message? ☐ yes ☐ no

12 If there is a message, and if you think most people understand it, do you think it is valid?
☐ yes ☐ no ☐ not sure

 Do you think it is in any way offensive? ☐ yes ☐ no

13 Do you feel that exterior sculpture in our urban environment is a worthwhile means of maintaining and improving our quality of life? ☐ yes ☐ no ☐ not sure

14 Who do you think should be responsible for selecting and placing exterior sculpture?
☐ a public or governmental officials
☐ b creative professionals such as artists, architects, landscape architects
☐ c laypeople representing the community in which the work is to be placed
☐ d a committee composed of the following combination of the above _____

15 How should such a program be funded?
☐ a public funds
☐ b private endowment
☐ c public solicitation and fund raising
☐ d the following combination of the above _____
☐ e other _____

Probably the most difficult questions to answer were those dealing with the message of a work of sculpture (questions 10 – 12). Of the 375 people surveyed, 24 percent felt the work or works had a message or purpose other than an esthetic one, 30 percent felt they did not, 35 percent were uncertain, and 11 percent did not answer the question (Table 3, Appendix A). The "yes" answers were fairly evenly divided among the vocational classifications, while the largest percentage, 39 percent, of "no's" came from those in the professional category. This could possibly be because the largest proportion of respondents fell into this group. One young man observed that the message of a work of sculpture could well be different for each viewer.

One of the most important questions was who should be responsible for the selection and placement of outdoor sculpture. The breakdown by age (Table 4, Appendix A) indicates little difference of opinion between the 25 and under and the over 25 age groups. Of the total number surveyed, 37 percent felt that selection and placement of outdoor sculpture should be the responsibility of creative professionals such as artists, architects, and landscape architects; 33 percent agreed that selection and placement should be done by a group composed of public or governmental officials, creative professionals, and laypeople representing the community; 13.5 percent favored selection by a committee composed of creative professionals and laypeople; 5 percent thought that laypeople from the community should be the decision makers; 3 percent were of the opinion that it should be the responsibility of public officials; 2 percent felt it should be done by public officials and creative professionals; 0.5 percent felt that a committee of public officials and laypeople should make the choices; 6 percent did not answer the question.

All in all, creative professionals were included in the choices of 85.5 percent of the people surveyed. The category receiving the smallest percentage of votes was that of public or governmental officials and laypeople representing the community.

Another critical question was on preferred methods of funding for outdoor sculpture programs (Table 5, Appendix A). The item receiving the highest percentage of votes — 29 percent — was the combination of public funds, private endowment, and public solicitation and fund raising. The next highest was public funds — 17 percent — while public solicitation and fund raising as well as private endowment each received 13 percent. It is significant that in 56 percent of the answers public funding was at least one of the choices.

Perhaps the most fundamental question rated the value of outdoor sculpture as a worthwhile means of maintaining and improving the quality of life (Table 6, Appendix A). A substantial 78 percent of the respondents felt that the use of exterior sculpture in our urban environment does indeed contribute positively to the quality of life. The reliability of this percentage is supported by the findings of the much larger survey conducted by the National Research Center of the Arts that was cited previously. It showed that 89 percent of American adults feel that the arts are important to the quality of life in their communities. In the survey on outdoor sculpture 8 percent felt that it is not a worthwhile means for maintaining and improving our quality of life, 10 percent were not sure, and 4 percent did not answer the question. Interestingly, the same percentage — 78 percent — of both men and women agreed on the positive value of outdoor sculpture.

Although the findings of this experimental survey cannot be regarded as conclusive, they do provide indicative evidence that the American public is most certainly aware of sculpture in the outdoor environment; that subjective response to contemporary works is relatively favorable; that public opinion strongly favors using artists, architects, and other creative professionals in the selection and placement of sculpture; that public funding of such programs is generally favored; and that outdoor sculpture is recognized as an important, positive element in our urban environment.

The surveys were conducted at fifteen sites in eight cities — Boston, New York, Washington, D.C., Atlanta, Chicago, San Francisco, Los Angeles, and San Diego. Whenever possible they were carried out on weekdays during midday hours. Classified according to the kinds of setting, the surveys fall into the categories of urban/commercial, urban/cultural, urban/governmental, and urban/educational. The individual tabulations for all the surveys are included in Appendix B.

Urban/Commercial Settings

Embarcadero Center
San Francisco
Sculpture by Willi Gutmann

This work, entitled *Two Columns with Wedge*, is located in a semienclosed, open-to-the-sky courtyard in San Francisco's magnificent Embarcadero Center. Specifically designed for this site by the artist, the sculpture was fabricated in stainless steel by the Robert Yick Company, a San Francisco manufacturer of stainless steel ovens and kitchen equipment. It consists of three pieces: a cylindrical column 82 feet

Right: Willi Gutmann, *Two Columns with Wedge*, San Francisco. Willi Gutmann's *Two Columns with Wedge* was specifically designed for its site in Embarcadero Center, San Francisco.

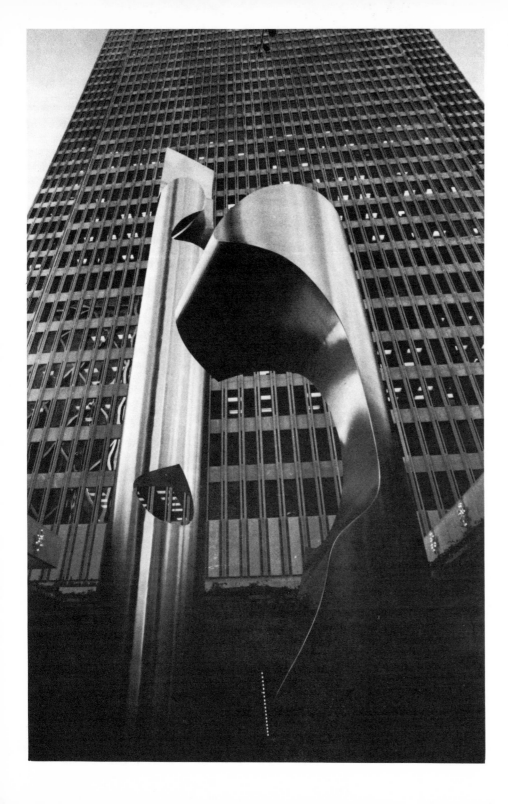

96

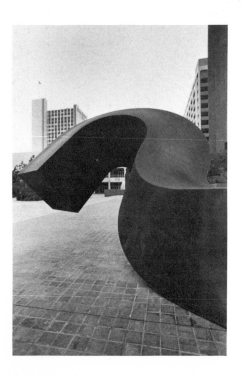

high, another column 36 feet high, and an 8-foot high wedge. The cylinders and wedge rise from a shallow rectangular pool, the tallest cylinder extending beyond the opening of the second level of the courtyard and rising eight stories against the backdrop of the Security Pacific Bank skyscraper.

The general response to this work was favorable. Fifteen out of twenty-five people indicated that they liked the work. Eighteen thought its form compatible with its setting, while twenty and twenty-one approved of the material and color, respectively. At the time the survey was conducted, a crafts fair was taking place in the open plaza areas of both lower levels.

Chase Manhattan Plaza
New York
Sculpture by Jean Dubuffet

Selected and placed by the Chase Manhattan Art Committee under the personal guidance of David Rockefeller, this striking work was provided "for the enjoyment of the downtown community"[6] of Lower Manhattan. Standing 42 feet or three stories high, *Group of Four Trees* is constructed of painted fiberglass resin skin over a core of cellular aluminum, which in turn is mounted on a steel framework anchored to the plaza structure. Because of its scale, form, and silver-gray and black color, this is scarcely a work of which one could be unaware. Although only twelve out of the twenty-five people surveyed indicated that they liked it, seventeen felt that it was generally esthetically pleasing, and only eight, if given the opportunity, would have replaced it with another work. Fifteen felt that it had no message other than an esthetic one. In light of this, it is interesting to consider the feeling that the artist, Jean Dubuffet, expressed at the unveiling of his work:

Obviously, the work stands in full view of everyone here and each one of us must now look at it with his own eyes and bring it his own associations. My own belief is that a work of art fails in its function if its meaning is too limited. I believe that the meaning, or rather the *meanings* of any work of art should be wide open so that each one of us can absorb it into our own particular universe (I am referring, of course, to our mental universe).[7]

Chase Manhattan Plaza
New York
Sunken Sculpture Garden
by Isamu Noguchi

A much different kind of sculptural work in the same setting as Dubuffet's piece, this one was designed by the sculptor to be viewed at eye level by people on the lower floor inside the building, as well as from above by those looking down from the plaza. It utilizes several different materials, including water, to create a sort of minienvironment for viewing. Fifteen of the respondents expressed a favorable reaction to the work, while twenty-two judged it esthetically pleasing.

Security Pacific Plaza, San Diego
Sculpture by Clement Meadmore

The bank plaza seems to be one of the most common examples of the urban/commercial setting. One of several works by major artists exhibited at various locations throughout San Diego during the show, "The City Is for People" (sponsored by the Fine Arts Gallery of San Diego, July 14 through September 23, 1973), this large-scale work of cor-ten steel received the most negative reaction of any included in the survey. Only eight people stated that they liked it, while nine said they disliked it, and eight were neutral. In contrast, fifteen felt that the size, material, and color were suitable to the setting, and twelve thought that the form was also acceptable. Twelve respondents thought the work generally pleasing esthetically; thirteen did not. Twelve would have replaced it with another work; twelve would have left it on the site; one did not answer. While there

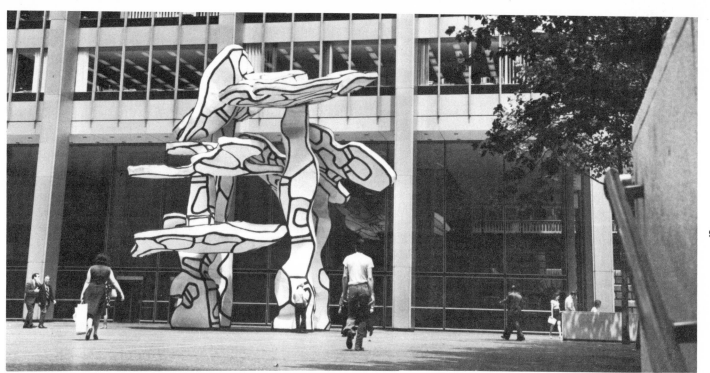

are a number of possible theories that could explain the reaction to this work in this site, it seems obvious that failure on the part of the work itself is not one of them. Lack of harmony between the spaces and solids created by the architecture and the sculpture might be one. First selecting and then securing permission to use temporary sites for a number of different large sculptures in an exhibition of this type is an extremely difficult task.

Time-Life Plaza, New York
Sculpture by William Crovello

Placed directly over a subway entrance at 50th Street and Sixth Avenue in New York City, this painted steel work, entitled *Cubed Curve*, was the first of six large-scale sculptures given to the city by the Association for a Better New York. Subsequently the work was purchased from the city by the Rockefeller Center Corporation, and the purchase funds designated for use by the Cultural Council's Visual Arts Committee to purchase other sculpture for public display. While most repondents felt that the size, form, color, and material of this work were appropriate, eleven of them would have replaced it with another work if given the opportunity.

Peachtree Center, Atlanta
Sculpture by Willi Gutmann

One of several large-scale works of sculpture placed throughout this gigantic commercial complex in downtown Atlanta, *The Big One* in anodized aluminum rises from the central court of a restaurant to the pedestrian/ shopping level above. Architectural elements, plants, water, and sculpture have been harmoniously combined in this setting designed with the pedestrian in mind. Of the twenty-five people surveyed, fourteen felt that the work suited its setting fairly well; and

seven thought that it did so extremely well.

Urban/Cultural Settings

Smithsonian Museum of History and Technology, Washington, D.C.
Sculpture by Alexander Calder

Because of the nature of this setting— the kind of museum and its location—it should be noted that the age of the majority of respondents was under 18 and their occupation high school student. Furthermore, most considered themselves nonresidents of the metropolitan community. The gigantic black Calder stabile, entitled *The Gwenfritz*, stands out in striking contrast to the white walls of the museum. The normal spectator view of the work is from a distance. It requires a certain amount of walking out of one's way and of climbing down a turf bank to view the sculpture up close. There is also a somewhat limited view from inside a glass-walled restaurant into the court-

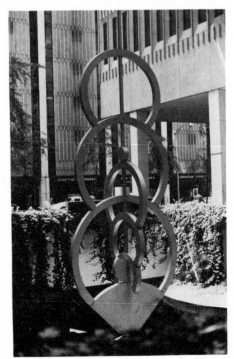

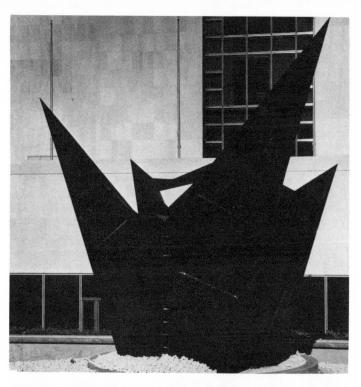

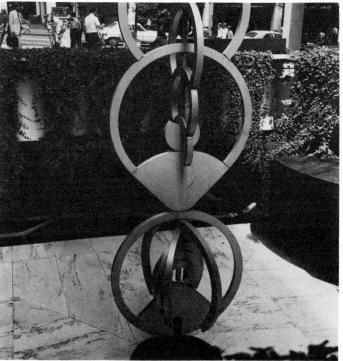

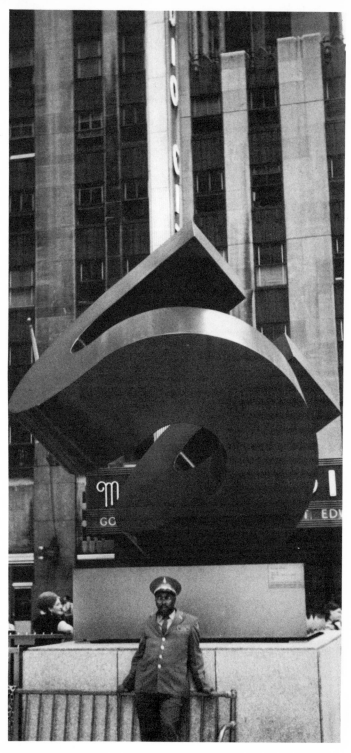

Top left: Auguste Rodin, *Balzac* (work in center foreground), New York. In the Museum of Modern Art's sculpture garden most of the viewers come there out of personal choice.

Top right: Pablo Picasso, Chicago. Pablo Picasso's giant weathered steel sculpture in Chicago's Civic Center Plaza is a distinctive feature of that cityscape.

Bottom: Jurgen Weber, *America*, Washington, D.C. Jurgen Weber's relief panel, *America*, is one of two that stand opposite the main entrances to the John F. Kennedy Center for the Performing Arts in Washington, D.C.

Below: José de Rivera, *Infinity,* Washington, D.C. José de Rivera's graceful *Infinity* stands at the mall entrance to the Smithsonian Museum of History and Technology.

100

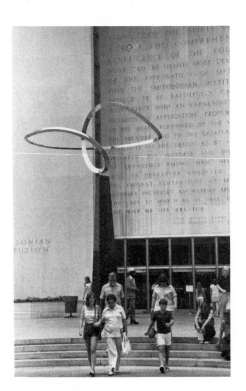

yard where the sculpture stands. Fourteen of the respondents indicated that they liked this work, three disliked it, and eight were neutral. The evaluative judgments regarding its size, form, color, and material were substantially more favorable.

Smithsonian Museum of History and Technology, Washington, D.C. Sculpture by José de Rivera

Respondents had the same make up as in the above survey, and this sculpture appeared in approximately the same location. The base of this relatively delicate stainless steel work, *Infinity*, because of its height, form, and color, makes the work more visible to the spectator and also enhances its lyrical elegance. Twenty of the twenty-five respondents indicated that they liked this work, none disliked it, and five were neutral.

John F. Kennedy Center for the Performing Arts Washington, D.C. Sculpture Panels by Jurgen Weber

These two large bronze relief panels, Germany's gift to the Kennedy Center, stand directly across from the main entrance doors. One is entitled, *America*; the other, *War and Peace*. They are not abstract; the figures are clearly readable and express some rather unsettling commentary on the state of the present world. James M. Goode's book, *The Outdoor Sculpture of Washington, D.C.*, provides an excellent, brief explanation of the works. Contrary to the response in all but one of the other surveys, a relatively large proportion—fourteen out of twenty-five—felt that these works do have a message or purpose beyond the esthetic one. Strangely, only eight felt that most people understand the message. Five thought it was offensive, and one retired school teacher wrote the additional comment: "If the artist ever vis-

ited America, he missed its purpose and meaning."

The Museum of Modern Art Sculpture Garden New York

Here of course the difficulty with the questionnaire becomes apparent. Specific questions about scale, color, form, and material are impossible to answer in relation to an entire collection. As a result some respondents considered only one work within the collection. Another distinctive feature of this survey is that the audience was composed primarily of people who were purposely there to enjoy the artwork. In addition the Museum of Modern Art must be classified as semipublic, in that there is a nominal admission charge, except for certain weekend evenings during the summer. As might be expected, the response to this collection of outdoor sculpture was generally positive.Twenty-four of the twenty-five respondents felt that the works (or in some cases an individual work) suited the setting either extremely or fairly well and also that they were esthetically pleasing.

Civic Center Plaza, Chicago Sculpture by Pablo Picasso

In this setting that might also be called urban/commercial or governmental the scale, color, and durability of the 50-foot high work in cor-ten steel enable it to hold its own admirably within the canyons of the Windy City. Although the artist left it untitled, it has a certain mysterious lifelike quality — a presence — that has prompted some Chicagoans to call it "The Sphinx," or others to identify it as the contemporary counterpart of the famous "Lions on Michigan Avenue" that guard the entrance to the Art Institute. Nineteen respondents indicated that they liked this work, while the same number thought it esthetically pleasing.

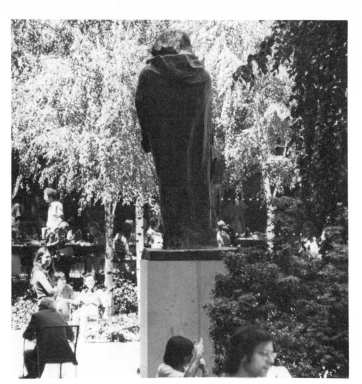

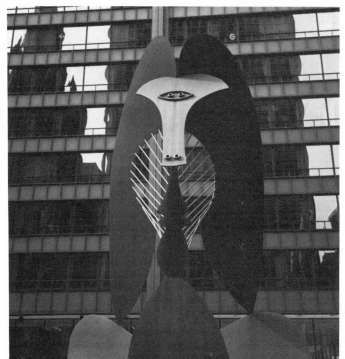

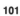

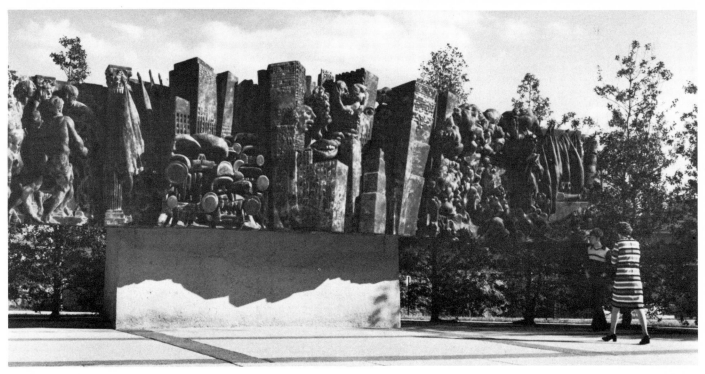

102

Urban/Governmental Settings

Lafayette Square, Washington, D.C.
Sculpture by Clark Mills

Since it is a park, this setting could be classified as cultural, but because it's located across the street from the White House and the Executive Office Building and because of the many government offices in the immediate vicinity, the governmental category seems the most appropriate. Because this park has such amenities as fountains, flower beds, trees, turf, and benches in addition to sculpture, it is probably one of the most heavily used public places in that part of the city. The 19th-century equestrian monument of Andrew Jackson is centrally located at a point where traversing walkways meet. Although this study is primarily concerned with contemporary outdoor sculpture, it's worth remembering that many works of another era are still focal points in urban public spaces. There was no particularly enthusiastic reaction to this work, either positive or negative. Eleven of the twenty-five people questioned liked the work, two disliked it, and twelve were neutral. Twenty thought it suited its setting fairly well.

John F. Kennedy Federal Center
Boston
Sculpture by Dimitri Hadzi

Abstract but strongly suggestive of some sort of powerful living force, this monumental bronze work stands in the entrance plaza of the John F. Kennedy Federal Center. It also overlooks the vast Government Center Plaza, on the other side of which rises the renowned Boston City Hall. This space can, and on occasion does, accommodate great crowds of people. The areas around the water, as well as those places to sit that are shaded by trees, are well occupied during weekday lunch hours. Eighteen of the twenty-five respon-

dents felt that the work suited its setting fairly well; four thought it did so extremely well. One lawyer offered the criticism: "This work is too complicated and confusing to be associated with a federal office building. The public is generally confused by bureaucracy anyway. The ideal piece should be more ordered and understandable."

Urban/Educational Settings

The Franklin D. Murphy
Sculpture Garden
The University of California
at Los Angeles

Because this setting has a collection of works, it was again difficult to use the questionnaire to gather reactions. The respondents, most of whom — nineteen — were students, were unusually cooperative and enthusiastic, although some expressed strong personal feelings about specific works of sculpture. One young woman whose field was theater arts thought that Gaston Lachaise's *Standing Woman* was "obscene." A particularly enthusiastic young man wrote in large green letters across the foot of his questionnaire, "More sculpture surrounded by greenery, trees, grass, etc." and on the back, "Get more art into the environment." Nineteen of those questioned liked the works, while twenty-two approved of the esthetic quality of the collection. (For further discussion, see Chapter 7, pages 140–142.)

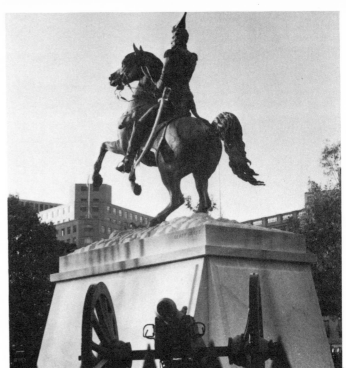

**Cloyd Heck Marvin Student Center
The George Washington University
Washington, D.C.
Sculpture by Rudolph Heintze**

Constructed of welded stainless steel, this 20-foot high work is located in the lower entrance court of the student center of a city university campus. The spatial quality and quantity as well as the surrounding elements that are part of the setting are considerably different from those found on the UCLA campus. Although four of the works (or collections) surveyed received fewer "like" votes, only one—the Meadmore work in San Diego with nine—received more "dislike" votes. Fourteen people indicated that they liked the work, seven disliked it, and four were neutral.

The entire question of the importance of obtaining the general public's reaction to public art has currently received critical consideration. Esthetic quality obviously cannot be controlled by public opinion, nor can works of art be selected and effectively placed solely through the efforts of a committee. Nevertheless the significance of the viewer's role in the art experience cannot be disregarded in the society in which we live, and the need for communication in the public art process is an urgent one. The questionnaire used in this study of outdoor sculpture was developed and implemented as an experimental tool. It will prove its value if it suggests new approaches and better methods for future research.

6 The Future of Outdoor Sculpture

108

I WOULD LIKE TO HEAR SOME DISCUSSION REGARDING THE DIFFERENCES BETWEEN (PRIVATE) IMAGE AND (PUBLIC) SPACE, THE POTENTIAL OF WELL FUNDED PUBLIC ART TO MAKE OUR MESSY AND DREARY URBAN ENVIRONMENT MORE LIVABLE AND LIVELY WITHOUT, AT THE SAME TIME CREATING NEW ENVIRONMENTAL PROBLEMS BY CONFUSING PRIVATE AND PUBLIC PURPOSE, WHICH MANY ARTISTS AND ARCHITECTS AND THEIR SPONSORS MANAGE TO DO.
Who set up the original Dicotomy?
HOW DOES THE GENERAL CHARACTER OF MODERN ART — HOW IT'S MADE, THE PATRONS OF IT, WHAT IT MEANS — RELATE TO THE QUESTION OF PUBLIC ART? The MASTERS make the rules for the wise men and the Public

The current renewal of interest in and enthusiasm for monumental outdoor sculpture appears to have taken hold throughout the country in places as diverse as New York City; Newport, Rhode Island; Chicago; Paramus, New Jersey; Denver, Colorado; and Grand Rapids, Michigan. The future promises a proliferation of outdoor sculpture in many American communities where programs involving contemporary works would not have received serious consideration less than a decade ago.

Problems for Concern

There is beginning to be widespread concern among artists, architects, funding agencies, and those who have already struggled with the multitudinous problems of implementing outdoor sculpture programs. This concern focuses upon such matters as the nature or definition of public art, the relative merits of private and public funding, and the relationships and responsibilities of artists, architects, clients, and the public.

The Nature or Definition of Public Art

In May 1974 the Boston Institute of Contemporary Art sponsored a symposium on public art. Participating as speakers and panelists were outstanding artists, architects, members of the business world, and art administrators. Among several topics discussed were "Public Art: An American Phenomenon"; "Artists and Architects: Competitors or Collaborators?" and "Business and Government: What Is Their Role?"

Throughout the four-day period of the symposium there was a debate about the nature or definition of public art. Reflecting the growing influence and participation of minority groups in the cultural fabric of our society, Robert Sommer of the University of California

at Davis argued the validity of what he termed "street art," "guerrilla art," and "ethnic art," as truly representative of contemporary public art. Topper Carew — film maker, producer, musician, graphic artist, and former director of *The New Thing* in Washington, D.C. — felt that the definition of what public art is should come from the public. He also made the comment that "object art is dead" and that "people are more interested in process art." This last drew strong protest from some of the artists in the audience. And of course such a view ignores the enthusiastic public response to such recent exhibitions of object art as those in Grand Rapids, Michigan; Paramus, New Jersey; and Newport, Rhode Island, not to mention the opening of the Hirshhorn Museum and Sculpture Garden in Washington, D.C., in October 1974. However, Carew may have been intentionally overstating the case to make the point that art forms are indeed changing and that object art must now share the stage of the public art scene with other, newer forms.

Somewhat broad yet comprehensible is the view of the Boston Institute of Contemporary Art that "the definition of public art hinges on accessibility" and that "this generally means art which is outside."[1] To this might be added two criteria suggested by art critic Amy Goldin in *Art in America:*

First, it [public art] solicits a wide audience, usually on the basis of its size and setting. Second, it deals with subject matter of recognizable social import. (Recognizability means that style and subject matter can't be obscure or "personal.")[2]

Another set of criteria has been formulated by Doris Freedman, also a participant in the Boston symposium and head of the Public Arts Council of New York City's Municipal Art Society. They are "(1) esthetically high standards, (2) scale, (3) human relationships."[3] Adapting those criteria to outdoor public sculpture, one would say that it must

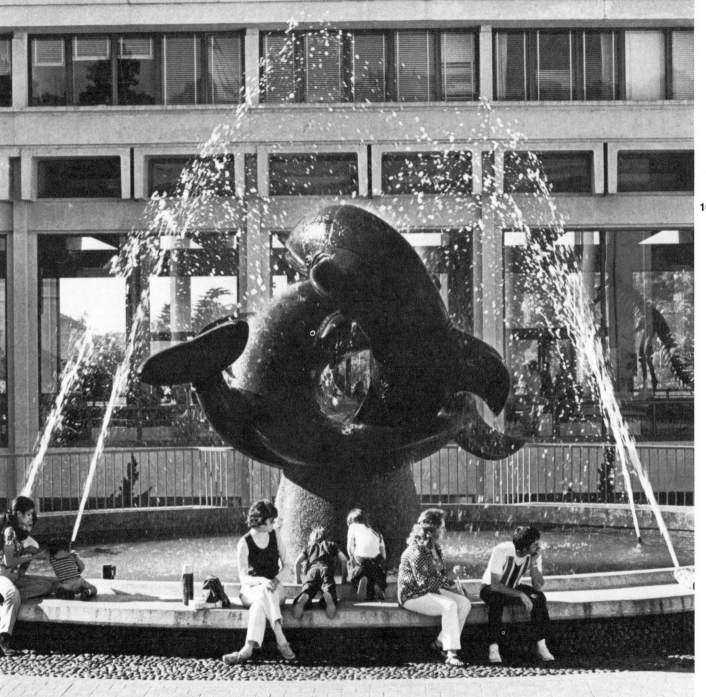

be accessible to people, comprehensible by people, and related to people. Comprehensibility actually involves scale and form as well as subject matter.

Private and Public Funding

At the Boston symposium the discussions on the role of government and business with regard to public art centered primarily on how to get funding for public art from those areas and on how much funding it is reasonable to expect. Business leaders pointed out the need for zoning and tax incentives to persuade developers, architects, and business executives of the value of public art. One prominent business leader and expert in the field of land planning and development suggested that since most corporation art comes "from the top," a small group of competent arts-interested and sensitive people are needed to act as advisors and sales representatives to corporation heads. Someone else pointed out that public art — that is, public art sponsored by business — is recognized by the public as a valid means by which business demonstrates its accountability to the people.

Funding by government agencies seemed to be considered more reliable by the artists participating in the symposium. Bennard Perlman of Baltimore presented the case for 1 percent for art in architecture legislation (see also Chapter 4, pages 64, 66), similar to that implemented in Baltimore, Philadelphia, San Francisco, Seattle, and the state of Hawaii. In Boston the 1 percent for art in architecture program is administered by the Boston Redevelopment Authority (BRA) and applies only to the construction of new buildings by developers on land taken by the BRA through eminent domain and turned over to the developer by the BRA. Several people at the symposium felt that often the funds from the 1 percent programs, in other cities as well as in Boston, tend to get siphoned off for purposes other than artworks. Richard Saul Wurman of Murphy, Levy, & Wurman of Philadelphia stated that he is opposed to 1 percent for art laws because art cannot be legislated. Perlman responded with a number of statistics, both numerical and monetary, on how many works of art had been placed and how much had been spent by various jurisdictions under the law. Artists at the symposium tended to oppose such legislation because of the dangers inherent in the selection of artists and/or artworks by people whose choices could be determined by a rigid or conservative viewpoint. An architect concluded that 1 percent for art legislation was *an* answer, but not *the* answer to government funding of public art.

Some other sources and methods of government funding for the arts were mentioned in Chapter 4 (pages 64, 66). In Chapter 5 (page 94) it was noted that 56 percent of 375 respondents to the questionnaire on outdoor sculpture included public or government funding as an acceptable means of supporting such programs. It seems then that government funding, whether municipal, state, or federal, is considered the most dependable means of supporting all kinds of public art. However, the enhancement of the corporate image promoted by increased publicity and better media coverage should in the future make substantial support for public art continually more attractive to the business world. An excellent presentation urging a greater commitment by business to the support of the arts is Gideon Chagy's *The New Patrons of the Arts*. In reality, both public and private support, enlisting also the participation and contribution of the general public, appears to provide the most successful funding methodology.

The Relationships and Responsibilities of Artists, Architects, Clients, and the Public

Implied in the title of the Boston symposium session on "Architects and Artists: Competitors or Collaborators?" is the perennial problem of lack of communication, understanding, and empathy between members of these two disciplines. The symposium discussion aired some new and some old aspects of the problem, but did not seem to produce any workable solutions. Two architects and one artist concurred that the artist commissioned to create a work of public art bears a responsibility beyond that of an artist creating a private work of art. Others argued that the ultimate responsibility for what is created lies with the architect in charge of the total project and that the architect should therefore control what is created. A young Boston artist suggested that a partial cause of the architect's isolation from the artist is the economic restrictions placed upon the architect. Repeatedly it was brought out that one of the greatest errors is the failure to involve the artist early in the design phase of the project.

The need for early involvement of the artist has been particularly well articulated by Anita Margrill, a sculptor and architect working in New York City:

I feel that sculptors must be initiators in people-oriented urban design. We . . . know sculpture should be used to humanize environment . . . but there are much better ways to integrate sculpture and sculptural thinking into the urban-scape than is currently being done. . . . I don't think artists should be called in at the end of a project to provide the icing on the cake.[4]

Karel Yasko, Counselor to the GSA Administrator on Fine Arts and Historic Preservation, has for years worked to encourage *early* participation by the sculptor (or painter, muralist, or graphic designer) in federal architecture projects.

There have been a number of studies and proposals dealing with the architect-artist communications/role problem. Two of them — one by Paul Damaz and another by Art Brenner — offer some constructive suggestions.

In a study done for the American Institute of Architects (AIA), Paul Damaz explored the problems inherent in commissioning works of art for public buildings in New York City.[5] In his report Damaz points out problems and makes recommendations. His study is an excellent reference source for those concerned with funding, selection, the actual installation of the work, and the problems of communication and cooperation among architect, artist, client, and contractor. Of the recommendations made by Damaz, one of the most significant is that the artist, after selection has been finalized, be retained by the architect as a special consultant. Damaz lists the following advantages of such procedure:

1 The artist can be retained early in the design process. The architect will be inclined to call on the artist as he calls on other consultants, thereby intensifying architect-artist cooperation and increasing the artist's impact on the architectural environment.

2 Since the architect becomes part of the contract, he will be more interested in the artist's work. The responsibilities of both parties will be legally defined, thereby reducing the chances of problems and misunderstandings.

3 Technical information and advice concerning installation will be readily available to the artist.

4 Overall timing and coordination will be improved.

5 The artist will be given the consideration he [or she] deserves as a

professional. Artwork will not be treated as building material.

6 The smoothing of relations among artist, architect, owner, and contractor will result in better working conditions and more successful results.[6]

In an article dealing with sculpture and architecture (see Chapter 2, pages 28–32) Art Brenner, an American sculptor living in Paris, discusses the highly complex problem of integrating the two art forms.[7] He suggests two principles, the one functional and the other psychological, which interact in the process and which encompass such factors as structure, utility, and space control, as well as definition of purpose and esthetic appreciation. (1) The functional aspect of integrating sculpture with architecture is concerned with incorporating the sculpture into the structure of the building, with designing it to serve some utilitarian function, or with organizing and articulating space. (2) The psychological aspect, which is by no means divorced from the functional, has to do with expressive or symbolic purposes of sculpture — the message — and with its effect upon the viewer as well as its meaning for the sculptor.

Brenner suggests a solution to the problem of selecting a sculptor or sculpture, which is related to Damaz's proposal for making the status of the sculptor that of a consultant to the architect. Damaz's study of course deals primarily with a civic governmental organization whose machinery already includes a special commission for selecting artists. However, it is interesting to note that according to Damaz's study, "in an overwhelming majority of cases, the selection of the artist is made by the architect"[8] for public as well as for private buildings.

Brenner too draws inspiration from the common practice of hiring consultants to the architect in various fields. He proposes that architectural firms create a new position, that of consultant-sculptor or collaborating sculptor. Brenner's concept of the function of the consultant-sculptor bears a relationship to, but is somewhat broader than, Damaz's proposal for the sculptor to work as a consultant to the architect while carrying out his or her commission. This is clear in the following description by Brenner:

The role of consultant-sculptor needs a clear job definition. This position would be filled by a practicing sculptor who could contribute to the design process at selected stages. He would at least review preliminary architectural drawings for the possible incorporation of sculpture and suggest qualified artists. He should not have easy access to all the sculptural commissions from that firm—in fact, there should be severe limitations. Rather his function here would be to keep abreast of works by other sculptors through visits to studios and exhibitions, keeping in mind their possible use in connection with architecture. Lastly, he would follow through by checking progress of a commissioned piece, aid in installation details, etc. The consultant-sculptor would, then, perform a valuable professional service as well as serving as a sympathetic sounding-board to the architect. It strikes me as an exciting and stimulating position that would require but a few hours each week and thus would neither take the artist away from his regular work nor be beyond the means of even the smallest architectural firm.[9]

The ideas of both Damaz and Brenner offer reasonable solutions to the problems of selection and successful integration of sculpture in our urban environment. Even small communities as well as small architectural offices could adopt similar methods with no great increase in cost and surely with increased effectiveness. Perhaps an artist-in-residence at a local university or college might serve as an area consultant-sculptor. Often in smaller communities or in situations where the budget for art is limited, the work of local or area artists could be used as effectively and knowledgeably as that of nationally or internationally known name artists. This serves the double function of encouraging these artists and of giving the community a greater pride in and awareness of its own cultural contributions.

On the national level, the National Endowment for the Arts already provides expert counseling services in connection with the various matching grants programs for art in public places. The visual arts division also maintains a slide file of artists' work that is appropriate for use in exterior public spaces. Similar consulting and information programs have been initiated by some state arts agencies and by local communities as well. One example is the Public Art Council of Peoria, Illinois, whose members are assembling a file of artists' names, biographical data, and photographs of representative works, with the emphasis particularly on artists whose work is suitable for outdoor use.

The point is that there exist workable means to encourage greater communication between artist and architect and ways to permit the artist to play a more meaningful role in the design of our environment.

Other concerns arise out of the changing role of the sculptor with regard to the scale and the materials of works created for today's and tomorrow's outdoor environment. A perceptive discussion of the artist's needs with respect to these problems is found in critic Barbara Rose's article, "Shall We Have a Renaissance?" published in the March/April 1967 issue of *Art in America*. Rose writes:

A change in the scale of the work has been the single most important factor motivating artists to seek new alternatives to traditional media and ways of working. Because new work is frequently so large that it must be displayed outdoors, a variety of weatherproof surfaces such as enamels, epoxies, stainless steel and fiberglass, have had to be investigated. Large scale has meant that the individual sculptor often cannot execute his own work but is forced to have it commercially fabricated.[10]

Constantino Nivola, New York City. A sculptural wall
with seating has functional as well as esthetic value.

Right: Piotr Kowalski, Long Beach, California. Collaboration between sculptor Piotr Kowalski and North American Aviation resulted in this monumental work in metal for California State University at Long Beach.

Since Rose's article was published, new works of large-scale sculpture, usually nonrepresentational, have appeared in city plazas and parks, on campuses and malls, in public and semipublic gardens, on street corners, and literally — if you consider the 1973 San Diego exhibition and the 1974 Newport exhibition — from sea to shining sea. The need for suitable exhibition space for large-scale works is probably the most generally recognized and most nearly met. The needs for adequate working space, for technical assistance and tools, and for economic support to defray the greater cost of monumental works in today's expensive materials are still urgent, particularly for younger and less well-known artists. In her article Rose proposes a number of solutions to these problems. Some of them are:

An information exchange [which] might publish a bulletin on new techniques and materials available to artists and the health hazards involved in using them . . . [and] compile a directory of shops and factories willing to work with artists, along with a price list of their services. . . .

Another directory of consulting specialists — engineers, chemists, physicists, etc. — along with a description of their services. . . .

A lending library for tools.

A depot for materials: Such a stockpile could accumulate industrial surplus for the use of artists, offer materials at wholesale costs or dispense free materials to qualified professional artists.[11]

Although it is true that in instances such as the symposia at California State University at Long Beach (Chapter 4, page 66) and in Vermont (Chapter 4, pages 74 – 76) as well as in the 1973 – 1974 sculpture exhibition in Grand Rapids, Michigan (Chapter 4, pages 76 – 80) there was substantial participation and contribution on the part of industry, this sort of involvement is still relatively rare. There remains a need for some kind of coordinated, concentrated effort to provide the necessary contact and cooperation between artists and industry. A step in this direction was the founding of Experiments in Art and Technology in New York City in 1967, with its purpose of encouraging and facilitating collaboration between artists and engineers.

This discussion touches briefly on some problems and concerns that will affect the future of outdoor sculpture. It is hoped that there will be material progress toward solutions, because the new possibilities for kinds and functions of outdoor sculpture are not only exciting and challenging, but will very likely present new and different problems to be solved. Most kinds of outdoor sculpture programs included in the following listing have already been the subject of experiments. Some have been used with relative success in more than one instance, others have been once-only pilot projects, while still others have existed thus far only on paper.

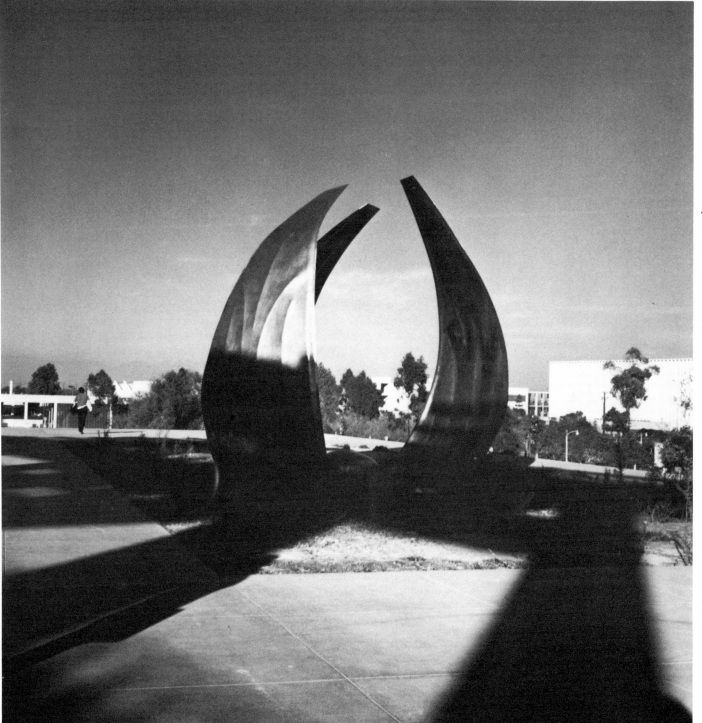

Possibilities for Consideration

Highway Sculpture

Among the new kinds of outdoor sculpture programs, one with exciting possibilities is using sculpture along highways. In the Vermont highway program (Chapter 4, pages 74 – 76) works of sculpture have been placed in the rest areas adjacent to the highway. This makes them accessible to travelers using the rest stops and permits a closer as well as more leisurely view of the works. Since the sculptures are of either marble or concrete, they are generally capable of withstanding the climate as well as being climbed on by children. Some of the works are particularly well sited and seem to harmonize very well with their surroundings. Not many of the sculptures are of sufficient scale nor are they so placed as to be clearly visible from the highway.

Such is not the case with the monumental works placed along the Olympic Highway ("Route of Friendship") outside Mexico City. The gigantic works are the result of the International Sculpture Symposium held in conjunction with the 1968 Olympic Games. All the works are visible from the highway, some much more so than others. Some indeed exert a tremendous impact up close. Because of their gigantic scale, however, they are visible far enough in the distance to prevent the automobile traveler from being startled by coming upon them unexpectedly.

Dropping down to a much smaller scale and to an urban rather than a rural or suburban setting, a very interesting experiment was tried in Overland Park, Kansas, a suburb of Kansas City. As one approach to solving the problem of how to improve the appearance and simplify the maintenance of median strips on major urban thoroughfares, an abstract metal sculpture, 6 inches high and 35 to 40 feet long, was installed on an intersection median. The work was designed, constructed, and donated by a local junior high school art class.[12]

Archaeological/Historical Sculpture

It may seem more than a bit strange to include such a category under *new* kinds of outdoor sculpture. In this case, as in most of the examples listed, the newness derives not from the works themselves, but from the way in which they are used — as exhibits in an outdoor historical museum. This illustrates the educational purpose or function served by outdoor sculpture (see Chapter 1, page 16). Probably the foremost example is Mexico City's Archaeological Park, which opened in December 1972. A large, existing city park was redesigned to accommodate the permanent exhibition of fifty-one pieces of sculpture, each of which is an exact replica of representative work from one of the principal pre-Hispanic cultures, the originals being in museums or archaeological areas of the Mexican provinces. Special features include night lighting designed to enhance the beauty of the works and informational tablets that comment on the esthetic and historical significance of each work. The total project was a joint effort of the Federal District and the National Museum of Anthropology and History. The selection of the works was the responsibility of the latter.

A related project on a much smaller scale is the collection of restorations and replications of Indian totem poles maintained throughout the community of Prince Rupert in British Columbia.

There is some justification for the creation of historical sculpture gardens, particularly in areas or regions of the United States where so much American history took place. The sculpture

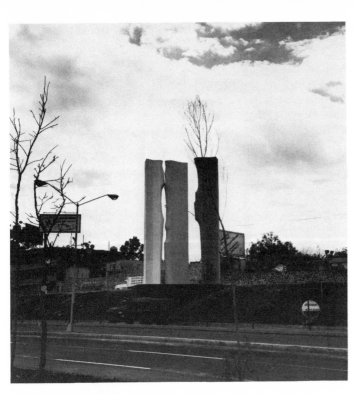

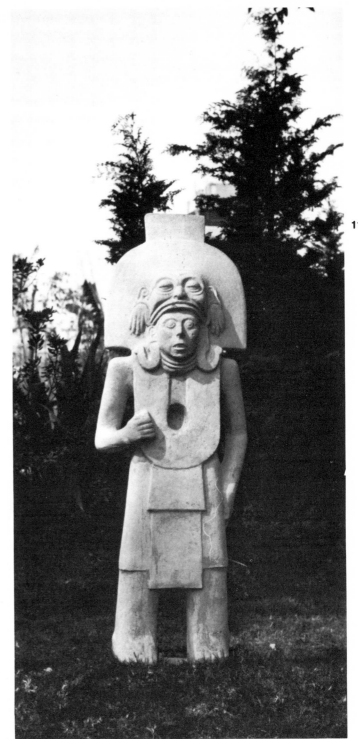

118

already exists and not only in museums. There are very likely many weary bronze soldiers, statesmen, pioneers, and other heroes, bedecked with pigeon droppings and marred by pollution, who could happily exchange their virtually invisible urban niches, corners, and intersections for a nice spot in an open park or garden where the importance of the characters they represent would be "plainly writ" on an accompanying tablet. Such a "sculpture garden of American history" would require extensive research and meticulous selection and placement. Its value as an educational tool, however, might prove well worth the effort.

Outdoor Sculpture for the Handicapped

There are no examples of public outdoor sculpture installations where the selection and siting of the work or works have been determined by the needs of the handicapped viewer. Some museums, however, have provided interior exhibits of sculpture for the blind. There now exist in the United States a few gardens designed for either the visually or otherwise physically handicapped, but for the most part they do not include sculpture. Significant progress has been made in the design and construction of playgrounds for handicapped children, and these often include some form of playground sculpture.

Although it's simply not fair to deny handicapped people the opportunity to enrich their lives through experiencing sculpture in the outdoor environment, little or no effort has been made, even in our most modern contemporary sculpture gardens, for it to be possible for people with severe physical handicaps — those using leg braces or wheelchairs — to get to the area where the sculpture is displayed. Outdoor sculpture for the handicapped may well

be one of the most challenging future possibilities.

Participatory Sculpture

Of course the viewer participates in the total art experience by her or his own subjective response to works of outdoor sculpture. Beyond this basic involvement, there are two kinds of participatory outdoor sculpture: that which the viewer, by the design and intent of the artist, may physically operate, manipulate, or climb on and that in whose creation one or more nonprofessional laypeople have actually played a contributing role. For the purposes of this discussion commercially produced play or playground sculpture is not included in the first category.

The value of outdoor sculpture that the viewer is allowed or even encouraged to touch, move, or climb on is that it permits the viewer a more intimate acquaintance with the artwork, reduces or eliminates feelings of alienation, and broadens the channels of communication between artist and public.

Mark di Suvero is an example of a sculptor working on a monumental scale with industrial material who has always encouraged his audience to participate in or with his sculpture in a physical as well as an esthetic sense. Elizabeth C. Baker, editor of *Art in America*, writes of di Suvero:

He has always built his work to entice people into climbing on it, lying on it, swinging from it. . . . DiSuvero seems to assume that his work has, quite naturally, a social and public dimension. He wants it to be *used* in every sense—physically, socially, esthetically—the last encompassing all the rest.[13]

Another artist who creates participatory outdoor sculpture is Anita Margrill of New York City. Her works — water sculptures involving the use of coiled metal tubing and sometimes pumps — are on a considerably smaller scale than Di Suvero's and are intended for

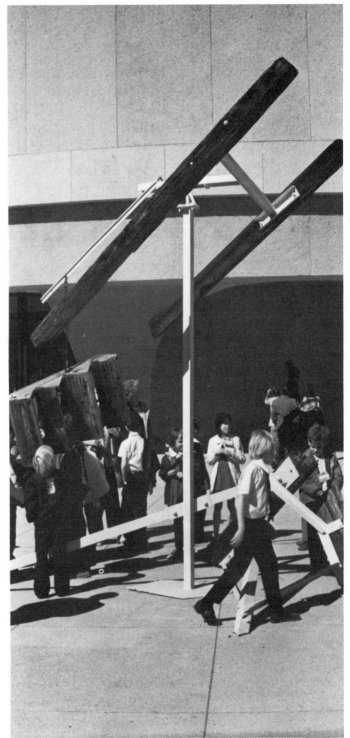

Top: Ruth Asawa, San Francisco. One hundred people were involved in creating the sculptured vignettes of San Francisco that cover the surface of Ruth Asawa's fountain. Detail of fountain.

Bottom: Perhaps an innovation in environmental/functional sculpture was the trash-consuming goat at the Spokane, Washington, Expo '74.

use as play sculptures on crowded city streets.[14] Margrill is typical of what she refers to as "a whole new breed of socially aware artist. Through their work these artists seek to involve their audience in a physical, creative way."[15]

The second kind of participatory sculpture, where members of the nonprofessional public are actually involved in the creation process, is perhaps more controversial than the first. This kind of participation can and often does, however, make an important contribution to community involvement in and support of the arts. A notable example is Ruth Asawa's fountain, a 14-foot diameter bronze drum whose surface is embellished with myriad scenes and symbols of San Francisco and which is a feature of the Hyatt House Hotel plaza on Union Square. The creation of this work involved the participation of some 100 people — family and friends — from all over the city of San Francisco, each of whom reproduced in a material called *baker's clay*, invented by Asawa, some element — a house, a school, a street, a figure — for the final panoramic fantasy of San Francisco that was eventually cast into the bronze relief surface of the fountain.

Perhaps under this second category of participatory sculpture should be added that work which is fabricated without professional guidance or supervision by people who feel constrained to make some sort of personal impact on their environment. This does not of course include amateur sculptors who place their own creations in their own yards. It does encompass works like those that have appeared with intermittent regularity, constructed from an assortment of "found" materials, on the Emeryville, California, mud flats. Such works, argues Robert Sommer of the University of California at Davis, are undeniable evidence that

"man must be more than a consumer, even a tasteful one, of other people's products."[16]

Environmental/Functional Sculpture

The term "environmental/functional sculpture" brings to mind such mundane sculptural elements as fountains, light fixtures of various kinds, benches, and walls. Perhaps one of the more unique and humorous works of what conceivably could be labeled environmental/functional sculpture was the trash-consuming goat that performed its utilitarian function at the 1973 – 1974 Expo in Spokane, Washington.

Gyorgy Kepes of Massachusetts Institute of Technology has suggested some appealing ideas for future urban sculptural works that would incorporate esthetic quality with environmental utility.[17] One type of dual-purpose sculpture involves using water purification processes as a potential display feature. Kepes proposes that water purification plants be designed to serve as contemporary "public monuments directed toward the future and not the past."[18] As historical precedents he cites the fountains of Rome, which were the triumphant, climactic celebrations of the arrival of water in the Eternal City. He speaks of such things as water purification kinetic sculpture set in water gardens or water parks and of the combination of simple mechanical devices with the water power of city fire hydrants that through the ingenuity of artists would create sculptures which would enrich urban life by both their usefulness and their esthetic quality.[19] That these are more than futuristic fantasies is evident from what has already been undertaken in these or related areas. For example, the Genesee County, Michigan Parks and Recreation Commission was responsible for the design and construc-

tion of a utilitarian dam that incorporates sculptural form and night lighting to make it an esthetic focal point for the entire area.[20]

Harold Lehr, a young New York City artist, has designed and fabricated water-borne sculptures that, powered by electricity produced by wind, sunlight, and water currents, operate as water purification units while floating and bobbing like abstract sailboats or buoys. This is of course not a total solution to water purification, but it's certainly a positive approach and an exciting possibility for artists with qualifications and motivations similar to Lehr's.[21]

In the summer of 1971 Anita Margrill began a cooperative project with New York City's mayor's office and the Department of Parks, Recreation, and Cultural Affairs in which her portable water sculptures were placed on designated play streets for alternating periods throughout the summer months. These sculptures were designed by the artist to attach to fire hydrants. For Margrill, "Building water [sculptures] to be used for play was a logical way . . . to bring the excitement and beauty of water to everyday city life."[22] As Gyorgy Kepes suggests in his discussion of similar works, "The quality of these [sculptures] would not escape the children's sensibilities, and would educate them to an awareness of such things."[23]

Top: This project by SITE, Inc. for Best Products Retail Center, Richmond, Virginia, illustrates the development of sculptural elements as an intrinsic part of the building. Photograph courtesy of SITE, Inc., New York.

Bottom: The work of SITE, Inc. is "conceptually realized to involve a total site," such as in this project for Intermediate School 25, New York. Photograph courtesy of SITE, Inc., New York.

Below: This work of sculpture by Nicolas Schöffer moves about the city streets on a specially designed automobile chassis. Photograph courtesy of Galerie Denise René, New York.

Perhaps the most provocative and stimulating concept suggested by Kepes is that of a huge sculptural display tower that—utilizing today's technical and multimedia tools — could supply environmental information to an urban community. Kepes elaborates briefly on the possibilities of such a socially oriented work of *techno-sculpture*:

> There are potent technical ways of utilizing sophisticated instrumentation to bring into a single spatial focus the widest range of data relevant to common urban life. Distant sensors coupled to transmitters and monitoring data to a central display device may report conditions of air, noise, water, heat, pollution and traffic congestion. . . . The possibility of bringing into a single display focus all the interdependent data of the changing characteristics of the environmental "common" could be instrumental in developing a civic consciousness of problems that concern everyone.[24]

Such a sculptural work placed in an appropriate urban space would function also as a "display landmark for the urban body "[25] and would help create a responsive environment. Its design, fabrication, and placement would require the collaboration of artists, multimedia experts, telecommunication engineers, scientists, sociologists, as well as architects and landscape architects. It is not inconceivable. The automated information band atop the Allied Chemical Building in New York City and the weather ball of Northwestern National Bank in Minneapolis are prototypal evidence that such a structure is feasible.

Another approach to environmental sculpture as well as to public art and to the problems of communication and collaboration among architects, artists, and designers of the urban environment is practiced by a group of artists, writers, and technicians known as SITE, Inc.[26] SITE, or Sculpture In The Environment, has been responsible for some innovative design solutions that might be called "sculptural environments" or — a more familiar term —

"environmental sculpture." Among the most commented-upon projects are an apartment complex in Peekskill, New York, in which the lower part of the buildings appear to "melt" into rolling, sculptural sidewalks; a store in Richmond, Virginia, whose walls appear to "peel" away from the structure; and a plaza at the University of Northern Iowa in Cedar Falls, Iowa, that is floored by an undulating grid with movable, interchangeable parts incorporating sculptural elements. SITE was organized to explore and develop new concepts for using art in the urban environment. James Wines, president of the organization and a sculptor himself, explains that "the works of SITE are not 'exhibitable' in the conventional sense; but rather, conceived as an intrinsic part of a given context." Thus the art of SITE is site oriented, or conceived and developed with a specific site in mind.

People are traditionally, perhaps even intrinsically, object oriented when it comes to art. That is, the very "objectness" of an artwork helps to identify it as something to be viewed as having special significance. An art object may also be possessed by an individual or even by a community and people are by nature possessive. It may be difficult if not impossible to completely reject the sculptural object as a valid element in the environment. However, there is considerable force in SITE's proposition that "sculpture, conceptually realized to involve a total site, is preferable to the decorative placement of object art in public circumstances."[27] Some object sculpture is indeed badly chosen and placed. Site-oriented sculpture becomes something other than an object in the environment; it becomes simply *the environment*. It seems reasonable to assume that a sculptural environment would exert a powerful, positive influence on the quality of life.

Members of SITE, Inc. also feel that "urban art should be an act of inclusion wherein the informational reservoirs of city life and structure become the means, the fabric, and the message of a new category of art." Basically this somewhat McLuhanistic proposition concurs with Gyorgy Kepes's proposals about using today's technical and multimedia tools to supply various kinds of environmental information via a sculptural element.

Movable/Portable Sculpture

Some participatory and some environmental sculpture, such as that of Anita Margrill, is also movable or portable. Perhaps one of the greatest appeals of portable sculpture is its economic practicality. For example, the works of Margrill can be transported from neighborhood to neighborhood, permitting wider use and enjoyment of a given work. This concept was probably part of the philosophy behind the program sponsored by the Association for a Better New York, in which several large-scale sculptures, engineered so that they could be moved with relative ease, were temporarily installed at key locations throughout all five boroughs.

There are other approaches to portable sculpture. Sculptor Nicolas Schöffer has long been concerned with getting his art out "into the environment itself."[28] In 1972 Schöffer combined one of his "chronodynamic" sculptures, which in itself consists of movable elements, with a specially designed automobile chassis (the result of collaboration with Regie Renault). Thus he created a nonstationary work of sculpture that moves about through the streets of the city, bringing art to the public environment in a unique way.[29]

123

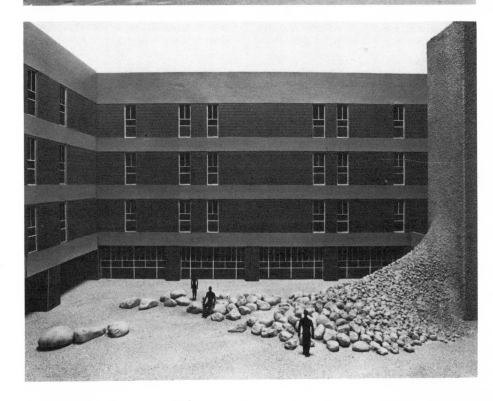

Temporary Sculpture

Perhaps equally suitable terms for this kind of sculpture would be "temporal," "transitory," or "impermanent." Traditionally and even currently one tends to think of outdoor sculpture in terms of durable structures created to last for generations. Some works have endured both physically and esthetically for centuries. Even in temporary installations such as exhibitions, the works themselves are usually either relocated permanent sculptures or models, constructed especially for the exhibition in a less expensive and more easily transportable material, of works intended to be eventually fabricated in a permanent, durable material. There is something to be said in favor of less permanent works that allow for experimentation and expression of new ideas in materials that are not only less expensive than most used for permanent outdoor sculpture, but that in some cases can be reused or recycled. Most of us are well aware that the rapidly accelerating rate at which changes occur in contemporary life demands adjustment in lifestyles. Literature advocating such things as disposable houses, automobiles (if they do not become obsolete), and clothing is controversial but not uncommon. Since many believe that the idea or the essence of a work of art is more important than its physical existence, it is possible that the value of an artwork could be sustained by the imprint of its idea or essence on the mind of the viewer. Very likely the brilliance of the colors and the appealing shapes of the fabric informational towers or signs at Spokane's Expo '74 will remain clearly in the memories of those who saw them, long after the originals have faded and disappeared.

Anne Healy creates gigantic and colorful sculptures in fabric that are anchored by ropes or cables and allowed to billow in the wind like sails. One of her works, "Hot Lips," was exhibited in a natural setting, strung between rocks over water in a cove at Newport, Rhode Island, Monumenta show in the summer of 1974. Another work — two gigantic yellow arrows — was displayed against the unfinished upper stories of a New York City office building under construction. When questioned about the permanence or impermanence of her sculpture, Healy replied: "I don't think that is an important consideration — the question of how long something is going to last."[30]

Another attractive possibility for using fabric or even paper is creating "air sculpture" or more specifically, kite sculpture. The creating and flying of kites is an ancient esthetic/philosophical profession in Japan. Kite building and flying may also be considered folk art, as in a celebration that takes place annually in Guatemala. Brilliantly colored circular kites of all sizes are painstakingly constructed by village households to be flown on All Saints Day over flower-decorated graves of family and friends. At the close of the celebration — one is tempted to call it a happening — the kites are burned by their creators.[31] Today the creating and flying of kites is gaining a new appreciation in the Western world. The United States boasts three annual kite festivals, one in New York City, one in Washington, D.C., and one in Boston. Air sculpture is of course not limited to kites, but also includes such things as balloons and banners.

Outdoor sculpture created with light may be temporary or permanent, or permanently temporary, since it can be viewed only at night. Because of the nature and scale of the outdoor setting, laser light, which is relatively new since its introduction to the commercial market in the mid-1960s, is particularly suited as a material for outdoor sculpture. It can span great distances, and it has been used successfully by artist Rockne Krebs in Los Angeles, Minneapolis, New Orleans, Philadelphia,[32] and Washington, D.C. Laser light is especially effective in the urban setting where its appeal stems not only from the sculpture itself, but from the way in which it emphasizes features of the city.

Some pioneer experiments have been launched to create settings or programs for outdoor sculpture that emphasize the process and thus the impermanence of creation rather than the finished product. One such effort was the artist in residence program initiated and carried out during the summer of 1974 at Artpark in Lewiston, New York, near Niagara Falls.[33] As part of a richly varied program, a number of sculptors were invited to actually construct their works in the rural setting of the park and to encourage the participation and interaction of the children and townspeople who came to watch. This is also a form of participatory sculpture.

A similar project was undertaken during the same period by the Boston Institute of Contemporary Art. Only in this case the setting was urban. Ten artists, some of them sculptors and many of them working outdoors, were paid weekly salaries to work in public spaces in downtown Boston. As indicated by the title of the project, Works in Progress, the emphasis was on the creative process rather than on the finished product. The purpose of the project was to encourage a dialogue between artist and public.

124

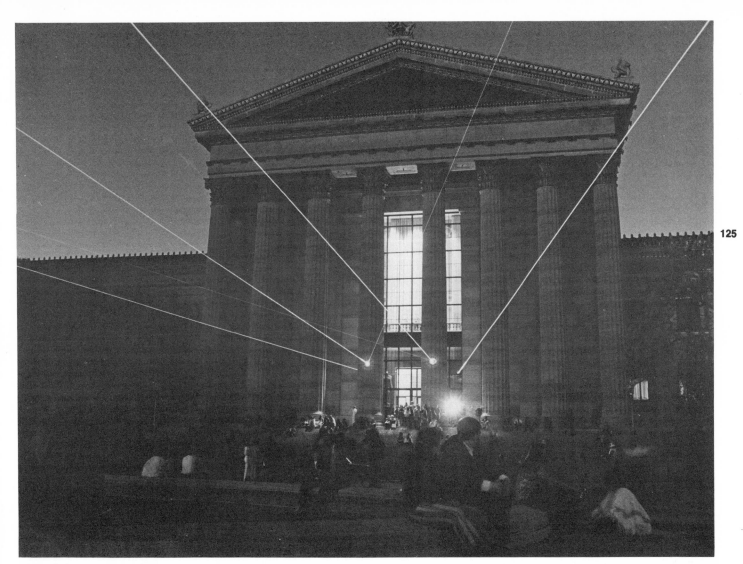

Rockne Krebs, *Sky Pie*, Philadelphia Museum of Art, Philadelphia. Using laser beams, Rockne Krebs creates immense works for outdoor display. This work adorned the Philadelphia Museum of Art in May 1973. Photographer unknown.

Earth Sculpture

Also referred to as "landscape sculpture" or "earthworks," earth sculpture is a form of environmental art that has been practiced since the days before the Druids. Traditional and contemporary earth sculpture has been and is practiced by landscape architects and architects, and contemporary earth sculpture is being created more recently by artists like Michael Heizer, Robert Smithson, and Robert Morris. Earth sculpture may range from unimaginative parking-lot berms and "mouse-under-the-rug" mounds scattered here and there for effect, to sensitively designed forms such as those of the Jardin Sculpté, which was a major feature of the French Floralies Internationales exhibition of 1969 and which today is part of a well-used Paris park. Here an attempt was made to animate space "solely by the play of shapes."[34]

It also encompasses works such as the late Robert Smithson's[35] "Spiral Jetty," whose name is succinctly descriptive of the 10-acre earthwork that extends into Utah's Great Salt Lake. Smithson and other "earth artists" felt that earth sculpture or earthworks not only permit the artist a greatly expanded scale, but by nature provides a means of artistic expression that cannot be bought, sold, or collected. For those who may have some reservations about the validity of earthworks — and this discussion merely offers a brief introduction to the subject — they may have a utilitarian purpose in addition to an esthetic one. Smithson at the time of his death was working on plans for a sculptural reclamation of depleted strip mining sites. In Grand Rapids, Michigan, an earth sculpture by Robert Morris completed in the fall of 1974 makes up a major portion of a city park. Of somewhat mind-boggling scale when considered as sculpture, it makes use of an existing hill and is traversed by two diagonal ramps whose intersection provides a secondary viewing platform from which to observe events on the field below. Here again is a unique example of participatory sculpture.

Projections for the Future

This presentation of problems and possibilities for the future of outdoor sculpture is obviously not an exhaustive treatment. Doubtless other problems and, hopefully, other possibilities will have already occurred to the reader. That is one purpose of the discussion. It should also be clear that although it may sometimes sound as though these future possibilities are being set forth as *new kinds* and *new approaches* to the art of sculpture, few of them are newer than the 1920s, and some are centuries old. What is new are the possibilities for their use in the contemporary and future outdoor environment. More than simply presenting a list of possibilities for kinds of outdoor sculpture for the future, it is hoped that this discussion will provide fuel for new fires, and that the conviction that the end result is worth the effort has been strengthened or renewed.

Aside from all the pragmatic reasons for the use of outdoor sculpture, there is a very basic one that ought never to be forgotten. It is expressed in a few brief lines by Mohammed:

If of thy mortal goods thou art bereft,
And from thy slender store
Two loaves alone to thee are left;
Sell one, and with the dole,
Buy hyacinths to feed thy soul.

It is after all the enrichment of the individual human spirit with which we are concerned.

7 Case Studies

The following case studies are presented to supply additional information about how sculpture can be included in the contemporary environment. Although the studies may have been discussed in previous chapters, it is hoped that these more detailed accounts will offer valuable insights as well as methodologies adaptable for future projects.

Atlanta, Georgia

The city of Atlanta, Georgia, has included outdoor sculpture to a greater extent than most cities in the United States in a variety of ways in urban spaces throughout the metropolitan region.

Peachtree Center

In downtown Atlanta the architectural firm of John Portman & Associates has been responsible for the development of Peachtree Center, which incorporates office buildings, a shopping arcade, hotels, and other urban amenities. Throughout Peachtree Center there are several pieces of large-scale public sculpture. Among these, a monumental fiberglass work, *Renaissance of the City* by Robert Helsmoortel, is located on Peachtree Street and dominates the entrances to a clothing store and a large office building. *The Blue One,* a sculpture by Willi Gutmann, is on the upper level of a pedestrian plaza in the same general area, while *Early Mace*, a striking work in curved stainless steel bars by Charles O. Perry, is almost directly across the street from the Helsmoortel work. *Untitled* by Hans and Gerritt van de Bovenkamp is incorporated in a small pool of water only a few steps down the street from the Perry work. In the October 1970 issue of *Atlanta* magazine were the following comments concerning the use of outdoor sculpture in Atlanta:

Where once the sculptor's art stood shadowed in dim corners of hushed museums, Atlanta's horizon is increasingly broken by pieces shaped in stone, steel, aluminum, wood, fiberglass.

In the last few years, glens of sculpture have mushroomed, thanks largely to the enlightened stimulus of corporations which, like Renaissance patrons, have encouraged the creation of communicative art.

Now, like citizens silent in the sun, sculpture sentinels abound, becoming part of our everywhere environment, watching the people as the people have watched them.[1]

Architect John Portman has personally selected the works of sculpture in Peachtree Center. Says Lee C. Hiers, research associate for the Atlanta Chamber of Commerce, "Mr. Portman prefers art pieces that encourage personal involvement; i.e., those that revolve, contain parts that can be manipulated, or have a surface that encourages one to touch."[2] Portman's philosophy about the role of architecture today is that it must meet the needs of people to feel close to nature, to experience variety and spaciousness, and to relate in a positive way to the scale of architecture (see Chapter 4, page 70). Obviously having sculpture in the outdoor environment is one very effective way of ensuring that today's architecture can achieve these goals. And Peachtree Center's developers have recognized and made good use of this means.

Colony Square

Colony Square, one of Atlanta's most striking office-residential-hotel-retail developments boasts a 29-foot weathered steel sculpture by Dorothy Berge. This work was also selected by the architects of the development, who plan to place additional works of sculpture on the grounds and open plazas of the development.

The First National Bank

Another outstanding work of outdoor sculpture in the downtown area of At-

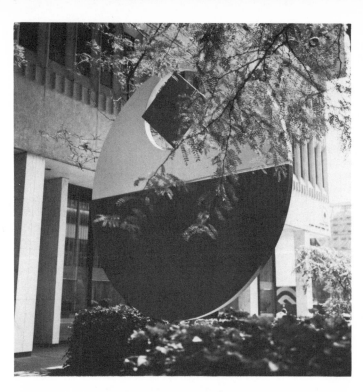

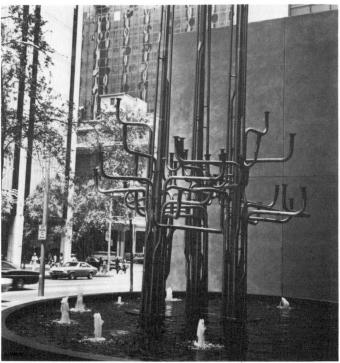

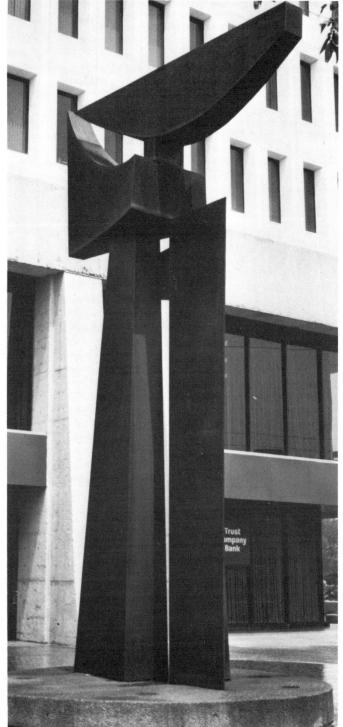

132

lanta is the First National Bank's *Phoenix* by Francesco Somaini. A huge abstract bronze, *Phoenix* symbolizes the resurgence of the South in general and of Atlanta specifically from the ashes of wartime destruction.

Lenox Square Shopping Center

Within the enclosed mall area of Lenox Square are two major works of contemporary abstract sculpture. In the surrounding exterior courtyard area are two works in cast stone that demonstrate both the adherence to a theme and the selection of works in a lighter, even humorous vein that can be very well suited to shopping center settings. *The Owl and the Pussy Cat* and *The Traveling Musicians* are representational works with appeal for children — who make up a large portion of the shopping center "audience" — and adults.

The High Museum of Art

The High Museum of Art in Atlanta has at its entrances and on the surrounding grounds some significant works of outdoor sculpture. Among these are *Untitled* by John Rietta in weathered steel, and *Two Lines Oblique* by George Rickey in stainless steel. Other pieces are rotated and changed from time to time. One end of *Red*, a 60 by 40 foot painted steel construction, extends into the air atop a high bank, while the other end descends from the bank toward the museum entrance. It definitely attracts physical participation on the part of viewers. This work by Tal Streeter was sponsored by the museum in November 1973.

Atlanta Gateway Park
(Great Southwest Industrial Park)

In this industrial park on the outskirts of Atlanta, monumental outdoor sculpture has been used as in no other industrial area in the United States. The original developer of the Great South-

west Industrial Park, which was later renamed the Atlanta Gateway Park, placed throughout the park, on the boulevards, and in grassy spaces adjacent to buildings, a series of significant works by such prominent sculptors as Anthony Magar, Beverly Pepper, and Peter Forakis. Throughout the total design of the park an attempt was made to create a setting where industry, production, and enjoyment of the arts are simultaneous activities.

The outdoor sculpture in Atlanta is more than a series of isolated cases. It is indicative of an active concern on the part of business, industry, and community organizations for the importance of including the arts in the contemporary environment.

Monumenta
Newport, Rhode Island

During the summer of 1974, Newport, Rhode Island, became the setting for one of the most exciting exhibitions of contemporary outdoor sculpture in America. Entitled "Monumenta," the show included fifty-four large-scale works by forty artists — many of them well known, some not so well known. The works were placed throughout Newport's malls and plazas, along harbor and wharf sites, on the spacious grounds of two of Newport's famous mansions, and in the larger open spaces along Ocean Drive.

The idea for the exhibition originated with Newport resident William A. Crimmins, who states in the foreword to the Monumenta catalog: "I think that the great traditions of art start with the people, and monumental sculpture in public places is a good way of encouraging a vital sensibility which is the basis of understanding."[3]

In her article "Sculpture Out in the Open" in the December 1974 issue of *House & Garden*, Patricia Corbin pro-

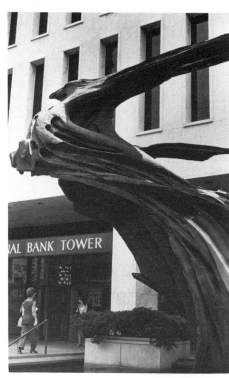

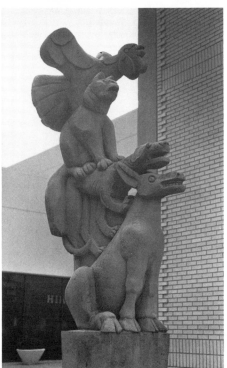

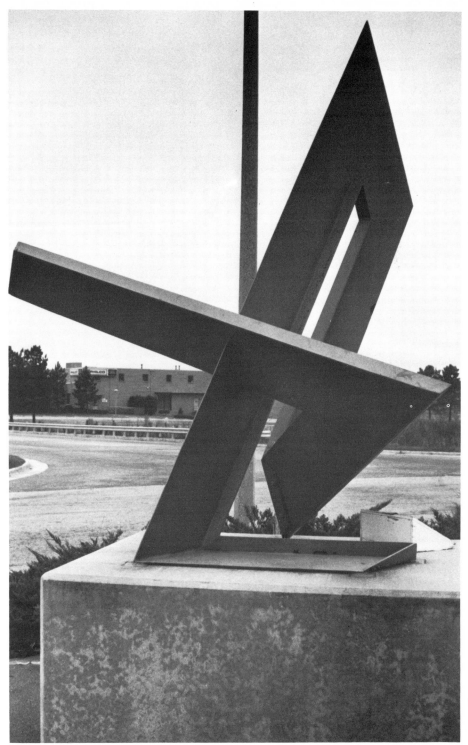

vides a step-by-step summary of how it happened.

How did a whole town open its spaces to Monumenta? Mr. Crimmins says, "First, there had to be permission to use the territories needed for sites. We asked the Department of Natural Resources for the state's properties. The Preservation Society of Newport County for the use of its lawns, the Mayor for the downtown plazas and malls. Everyone was immediately enthusiastic about the project—having 20th century sculpture in old Newport was a great idea for boosting the town, and coming at the end of summer, a great way to extend the tourist season."

After securing a grant from the Visual Arts Program of the National Endowment for the Arts, and soliciting private monies, Mr. Crimmins contacted Professor Sam Hunter of Princeton University, well-known art critic and former museum director, to guide the project. Professor Hunter conceived the exhibition with two primary objectives in mind, "to match sculpture and site and to provide a balanced reading of large-scale sculpture today in a variety of mediums." Because of the nature of the show, artists, galleries, and private owners were happy to cooperate in lending their works. The major costs for the exhibition were the transportation, installation, insurance, and security charges.[4]

For visitors to Newport throughout the duration of the exhibition, August 17 through October 13, 1974, a free map and tour guide was provided listing the locations of all the works of sculpture. An excellent catalog could also be purchased.

While the more or less urban space of the Brick Market Mall proved a very complimentary setting for the less than monumental works of Kosso Eloul, Lyman Kipp, Tony Rosenthal, and Lucas Samaras, perhaps the most exhilarating experience of the exhibition was driving along Ocean Drive and coming suddenly upon the gigantic bright red version of Claes Oldenberg's *Geometric Mouse* or seeing on a distant rise the pristine white forms of Alexander Liberman's *Argo* against a backdrop of sea and sky.

Robert Hughes, writing in the September 2, 1974, issue of *Time*, points out quite accurately that the enormity of the natural landscape setting does sometimes annihilate the sculpture. Even the garden settings, with their extensive rolling lawns, out-scaled many of the smaller works, but not all of them. The work of David Smith, as Hughes points out, "was always conceived in terms of landscape or, more exactly, the heroic domination of landscape by icon."[5] Hughes also concludes that Alexander Liberman, "along with Mark di Suvero and Clement Meadmore, is one of the three U.S. sculptors best fitted to handle large outdoor projects."[6]

5-in-1 by Tony Rosenthal
Municipal Building,
Police Headquarters
New York

In the open tree-lined plaza between the New York City Police Headquarters and the Municipal Building in Lower Manhattan stands Tony Rosenthal's monumental sculpture in weathering steel, *5-in-1*, the winner of the 1974 Art in Steel Award of the Iron and Steel Institute. The sculpture was commissioned by the Department of Public Works, and the sculptor, Tony Rosenthal, was chosen from a selection of five sculptors by a committee made up of members of the architectural firm of Gruzen and Partners; M. Paul Friedberg, landscape architect; and the Fine Arts Commission.

The cost of the sculpture — $80,000 plus $20,000 for installation — was provided out of $150,000 (half of 1 percent of the total cost of the building) set aside by executive order for artworks for the new Police Headquarters.

The work itself, weighing 75,000 pounds, was fabricated in a factory in the Bronx under the supervision of Bruce Gitlin of Milgo Art Systems of Brooklyn, who has had extensive experience in the fabrication of large-scale sculpture. Each of the 20-foot diameter discs was brought to the site individually on large flat-bed trucks. The interior structure of the sculpture and its placement on the plaza are designed to give the work stability in winds up to 100 miles per hour.

Rosenthal, whose works have been installed in public spaces throughout the country, has two other works in Manhattan: the black steel cube *Alamo* in Astor Place near Cooper Union and the 11-foot bronze disk *Rondo* in front of the 58th Street branch of the New York Public Library. Of the work *5-in-1*, Rosenthal says: "What really excites me is the scale of this. I've finally made something that seems big enough for out-of-doors."

Top left: Tony Rosenthal, *5-in-1*, New York. This sculpture was commissioned by New York City's Department of Public works for the plaza of the Police Headquarters.

Top right: Kosso Eloul, Newport, Rhode Island. The Brick Market Mall in Newport proved an excellent setting for works of such a scale as this one by Kosso Eloul.

Bottom: Alexander Liberman, *Argo*, Newport, Rhode Island. One of the greatest visual treats of the Monumenta exhibition was Alexander Liberman's *Argo* in its magnificent oceanside setting.

Below: Tony Rosenthal, *5-in-1*, New York. The interior structure of *5-in-1* as well as its placement on the plaza are designed to give it stability in winds up to 100 miles per hour. Photograph by Bethlehem Steel, courtesy of Tony Rosenthal.

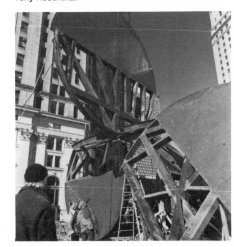

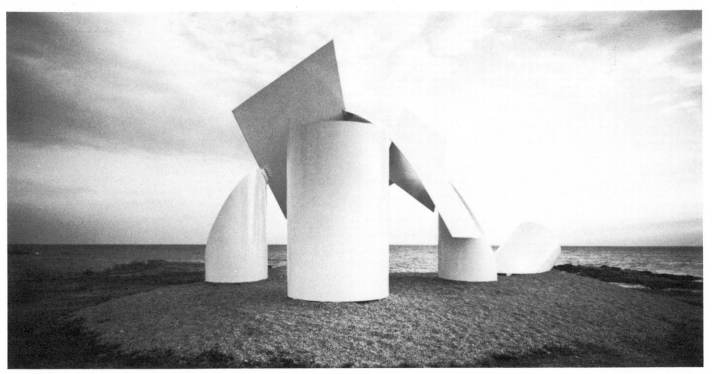

Right: Pablo Picasso, *Bather*, Chicago. Using a powerful sandblasting gun, Norwegian artist Carl Nesjar engraves the features of *Bather*. Photograph courtesy of Gould, Inc., Rolling Meadows, Illinois.

Picasso's Bather
Gould Center
Chicago

A unique partnership was formed when Gould, Inc., a Chicago-based, worldwide, technology-oriented corporation that develops and manufactures electronic, electrical, and industrial products, joined together with the late Pablo Picasso and Carl Nesjar, who has been a fine arts fellow at Massachusetts Institute of Technology, to develop the only corporately purchased Picasso sculpture in the world. The completed work, entitled *The Bather*, is a 28-foot high, sandblasted, cast-in-place concrete sculpture. The original design had been approved by Picasso for placement at the Louisiana Museum in Denmark. Since the Louisiana Museum did not have the funds to construct the work, Gould, Inc. through a series of negotiations obtained the rights and began arrangements for placing the sculpture on the grounds of the new company headquarters in Rolling Meadows, Illinois, a northwestern suburb of Chicago.

The black granite and concrete sculpture weighs more than 50 tons and was executed under a contract with Carl Nesjar, the prominent Norwegian artist who collaborated with Picasso on sixteen similar concrete sculptures through a process known as "beton-gravure," or concrete engraving.

The entire project illustrates what can be accomplished through the cooperative efforts of private enterprise as the patron and the artist or creator. In this instance the patron Gould, Inc., the artist Carl Nesjar, and art consultant Sally Fairweather of Fairweather-Hardin Gallery all served as implementors.

In an article entitled "Picasso as a Spur to Productivity" in the July 1974 issue of *Nation's Business*, Associate Editor Vernon Louviere quotes William T. Ylvisaker, Chairman of Gould, Inc.:

Business generally has been good for art . . . both for the artist and for the public. . . . And it is certainly good for business if the art purchased is a contribution to the environment of its employees and neighbors. . . .

There simply is no reason to spend half your waking hours in joyless, beautyless surroundings. . . . Art should enrich one's daily life and stimulate one's imagination and creativity . . . and, not, I think, only on occasional visits to museums and rare trips through the galleries.[7]

In his article "Chicago's New Picasso" in the March 1975 issue of *The Art Gallery*, Jon Borgzinner summarizes the role of business as patron of the arts:

Business support for the visual arts is based on the instinct of past princes and popes, and it still contains the sound impulses of proper patronage. . . . The Gould Picasso is a perfect instance of how to do it well. The *Bather* took determination stretched between continents. It took the forthright consent of a museum director in Denmark, the labor of Norwegian craftsmen, the skilled services of a Chicago art dealer, the informed patronage of a Midwest businessman—and, of course, a glint in the eye of our century's most protean artist.[8]

At the dedication of the completed sculpture on March 10, 1975, Ylvisaker made the following significant comments about the relationship of industry, the arts, and the public, and about Gould's philosophy regarding the role of a work such as *The Bather* in this relationship:

During the construction, we have made every effort to share the excitement of this event with the public. Rather than await a traditional unveiling, the work has been carried out for the most part in the open. More than 1,000 school children have already visited the site and participated in guided tours which have explained the concrete engraving step-by-step.

In addition, slide presentations to local libraries, schools, civic organizations and senior citizens' groups have provided a background on Picasso to increase the community's understanding and appreciation for the work. A documentary film is also being produced to bring the story of Picasso's *Bather* to an even wider audience. . . .

138

Our purpose in sharing the creation of this work from the very beginning was motivated by Picasso's intention that his sculptures be for the enjoyment of the public. In keeping with his wishes for an open landscape scheme, we changed the original plans for a formal landscape to a rambling, woodlawn setting. It is what Picasso would have wanted for the gentle serenity of his *Bather*, and we believe it will provide an idyllic environment in which to view his work.

We believe also that great art such as *The Bather* can be a functional contributor to a productive environment, supporting and enriching the daily experiences of our own employees as well as the cultural climate of the community.[9]

Storm King Art Center
Mountainville, New York

The Storm King Art Center in Mountainville, New York, boasts what is probably the largest collection of monumental contemporary sculpture exhibited in a natural setting in the United States, or perhaps in the world. Storm King Art Center came into being in 1957 when the Ralph E. Ogden family of Mountainville rededicated their private collection of outdoor sculpture as a public institution — the first of its kind. In 1967 the center acquired the David Smith collection. Today the Storm King Art Center Sculpture Gardens contain over ninety-five large-scale works in the permanent collection. Among them are thirteen works by David Smith, as well as works by Isaac Witkin, David von Schlegell, Charles Ginnever, Anthony Caro, Henry Moore, Barbara Hepworth, Alexander Calder, Herbert Ferber, Richard Stankiewicz, Sol Lewitt, Mark di Suvero, Alexander Liberman, George Rickey, Max Bill, Sorel Ertrog, Fritz Wotruba, Kenneth Campbell, Joseph Konzal, Robert Grosvenor, and others.

"Sculpture in the Fields," an outdoor loan exhibition, presents over 100 works by many of today's outstanding artists, among whom are William King, Lyman Kipp, Tal Streeter, Joseph Goto, Roger Bolomey, Warren Owens,

Marjorie Strider, Mike Todd, Bill Barrett, Jay Wholley, Jene Highstein, Peter Gourfain, Bernard Kirschenbaum, Andre Volten, Gary Wojcik, Jackie Ferrara, Peter Forakis, Grace Knowlton, John Chamberlain, Lila Katzen, George Kuehn, Richard Nonas, Anthony Padovano, William Pye, Arthur Weyhe, Manual Bromberg, Dorothy Dehner, Josefa Filkowski, Ann Gillen, Betty Klavun, Joseph Kurhajec, Gilbert Hawkins, Jack Massey, George Mittendorf, Joel Perlman, and Peter Reginato.

The Storm King collection provides an excellent opportunity for assessing the impact on and interaction with the natural setting of an extremely broad selection of outdoor sculpture.

Grace Borgenicht Gallery
New York

Commercial galleries are becoming increasingly involved in outdoor sculpture projects. Because some of them represent a number of sculptors whose work is particularly suited to the outdoor environment, they are able to arrange exhibitions that include the work of several sculptors. One such gallery is the Grace Borgenicht Gallery of New York City. A show entitled "Sculpture for Architecture" and including the work of José de Rivera, Roy Gussow, and David Lee Brown ran from April 27 through May 30, 1974. Among the works featured in this exhibition was De Rivera's *Construction #150* commissioned by the city of Lansing, Michigan, to stand in its Washington Square Mall. Half of the purchase funds for this work were provided through the Art in Public Places program of the Visual Arts Program of the National Endowment for the Arts.

Sculptor Roy Gussow, also represented by Borgenicht Gallery, works currently in stainless steel. A number of

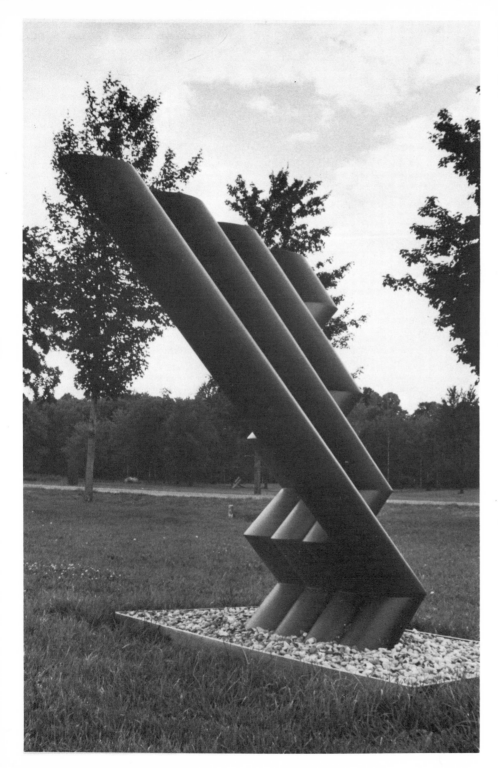

140

his works have been placed in outdoor urban settings:

Three Forms (1972), New York City Family Court Building

Flight, Cooperative Savings and Loan Association, Wilmington, North Carolina

Mutual, Phoenix Mutual Life Insurance Company, Hartford, Connecticut

Amity, Civic Center Plaza, Tulsa, Oklahoma

Three Forms (1969), Xerox Square, Xerox Corporation, Rochester, New York

From October 27 through November 24, 1973, Borgenicht Gallery held an exhibition of the work of Martin Chirino. In the catalog published in conjunction with this show is a statement by the artist, extracted from "El Paso" manifesto, that indicates his strong feelings about the role of his works in linking humanity to the natural environment:

> I try to conceive my sculpture as both Equilibrium and as Serenity. It is from these points that my work emerges: upon the unsteady earth on which I stand, sculpture is the only firm referent. I place it in the infinite landscape just as a tree or stone is set. In this metaphor my work is not a superficial gesture, but a fixed presence . . . my sculpture tries to achieve simplicity without embellishment. It tries to flow from itself into the open space. It grows organically into its forms. It shows itself simply as it is, because of necessity and inner impulse. With a minimum of material the sculpture wills itself into a maximum of space.
>
> In its inspiration, the sculpture derives from forms relating to tools, humble and useful implements, such as plows and plowshares, which have nothing to do with decoration. Such ordinary instruments, in themselves human extensions, bind man to the soil as he is bound in all necessary and harmonious tasks. The sculpture interlocks with the human spirit in its most extreme dimension, as implements join man with the earth. The exquisiteness and superficiality of a "still-life" finds no similarity with my sculpture. Definitely it claims a place apart from all frivolous consideration, a place closest to human beings. I am not bothered that my sculptures can be considered as objects. They are rooted in the useful,

but transformed into the symbolic. I have found my sculpture *en el pueblo* (among the people).[10]

Franklin D. Murphy Sculpture Garden University of California at Los Angeles, Los Angeles

As mentioned in Chapter 3, the Franklin D. Murphy Sculpture Garden at UCLA is one of the outstanding sculpture gardens in the United States. Designed by the landscape architectural firm of Cornell, Birdgers, Troller & Hazlett of Los Angeles, it is located near the Sunset Boulevard and Hilgard Avenue approach to the university and is a heavily used area of the campus.

The development of the sculpture garden has continued through the efforts of the UCLA Art Council and the gifts of alumni, students, artists, and friends of the university. Soon after the first sculpture, *Song of the Vowels* by Jacques Lipchitz, was placed in the garden in 1963, David E. Bright donated an outstanding collection of twelve works from his sculpture garden. This was augmented by Jean Arp's *Pagoda Fruit*, given by Mrs. Bright. Among the more than forty sculptures located throughout the garden are works by Alexander Calder, Sorel Etrog, Gaston Lachaise, Barbara Hepworth, Gerhard Marcks, Francesco Somaini, Isamu Noguchi, William Tucker, Auguste Rodin, and Henry Moore.

The grounds of the sculpture garden are used extensively by students and faculty members and are frequently visited by many friends and alumni of the university. A letter from Mrs. Eugene Strand of Pasadena, California, to William Bridgers of Cornell, Bridgers, Troller & Hazlett is indicative of the human response to this integration of sculpture with the outdoor environment.

This is to tell you how grateful I am that the very special place known as The Murphy Sculpture

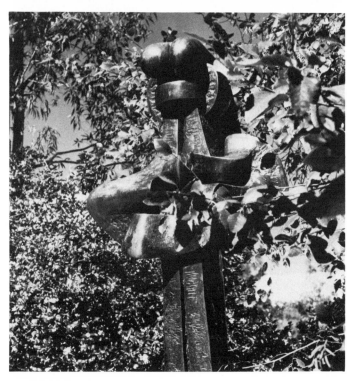

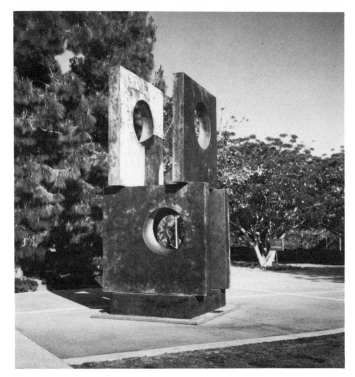

142

Garden exists. Many people have had a hand in its creation, I know, but I am impelled to say this thanks to its architect. Would you like to know how and why it has enriched me?

Our two oldest sons have both graduated from UCLA after very different experiences, both very positive. On many occasions, scheduled and unscheduled, involving their activities, I have walked through, met, spent time in, waited in, celebrated in that space. Each time it had something supportive and exhilarating to offer as a setting, and, of greater importance, was obviously providing the same kind of variety to others there at the same time. A design that functions well for a specific reason is one thing: a space that admits of as many necessary and delightful uses as I have witnessed and experienced suggests another qualitative dimension.[11]

Sculpture in the Park, 1974 Paramus, New Jersey

Sculpture in the Park, 1974, the second exhibition of outdoor sculpture in a county park setting presented by the North Jersey Cultural Council and the Bergen County Parks Commission, took place in Van Saun Park, Paramus, New Jersey, from June 15 to October 20, 1974. The first was held on the same site in 1971. Of the forty-one sculptors who participated in the second show, twenty were specially commissioned to create pieces on site, with the resulting sculptures becoming a permanent collection of the North Jersey Cultural Council available for display in public areas of Bergen County.

This exhibition was exceptional not only in the wide range and variety of contemporary sculpture exhibited, but in its easy accessibility to the citizens of the community. Van Saun Park is a pleasant and heavily used recreational area, and provided a variety of settings for the individual works. Perhaps most significant was the opportunity afforded the public to observe artists absorbed in the labor of creation and fabrication of their works, a most enlightening experience for many who may have harbored the misconception that there is "nothing to 'modern art'" or

that "anyone can do that." There were even opportunities to converse with the artists, to learn what they felt about their work, and to find out why they were creating for a public audience.

In the catalog for the exhibition, available from the council in Paramus, Constantine G. Vasiliadis, Executive Director of the exhibition, makes some perceptive observations on the significance of outdoor sculpture:

Art in public places is no contemporary phenomenon. It was there in ancient Athens, in the medieval public squares, and in the 19th century and early 20th century American parks. Many of us reared in now decaying cities fondly recall bronze statues of mounted figures blown to heroic proportions on their super-real chargers. The extension of reality, the suggestion of the abstract, even then formed the basis of what we see today in contemporary sculpture.

Commenting briefly on the developing 20th-century practice of placing contemporary sculpture in the urban settings of plazas and parks, as well as in rural parks and on estate grounds, Vasiliadis continues:

After sculpture on city plazas and in public parks, where does it go next? The answer is simple. Sculpture must go where people are, on main streets, in shopping centers, in front of town halls, school buildings, and where people work. But there is another place where sculpture can go—along the highways and access routes to airports, bridges and tunnels. . . .

Most important, the dissemination of art in our surroundings might serve as a constant reminder that our values, physical and moral, must extend beyond the purely material and functional, that we are in need of the food of aesthetic fulfillment. Outdoor sculpture is one step in achieving such a sense of well-being.[12]

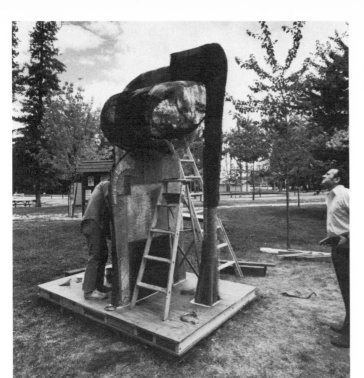

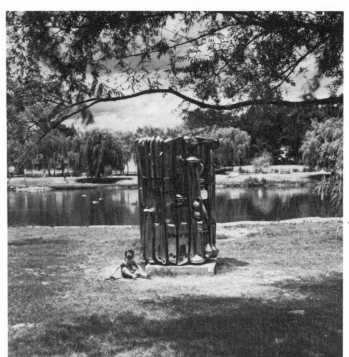

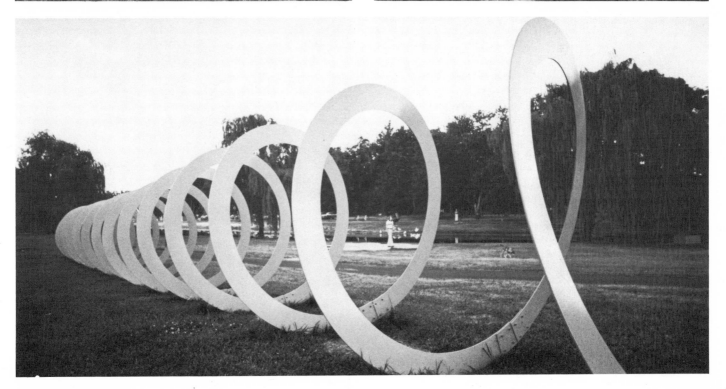

144

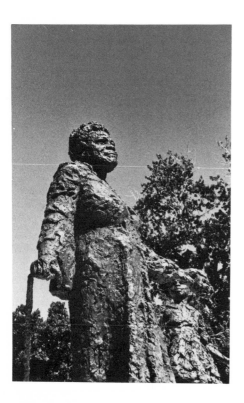

Mary McLeod Bethune Memorial
Lincoln Park
Washington, D.C.

It has often been noted by contemporary critics and observers that American monumental public sculpture today no longer commemorates heroes and is abstract rather than representational. As a generalization this is true, but the demand for this kind of commemorative public sculpture, though greatly diminished, will probably never cease completely.

On July 10, 1974, somewhere around 100,000 people converged on Lincoln Park in the District of Columbia to participate in the dedication of the bronze monument honoring Mary McLeod Bethune by sculptor Robert Berks. The event was sponsored by the National Council of Negro Women and the National Park Service, together with 120 organizations across the country. Funds for the sculpture, costing nearly $400,000, were raised over a thirteen-year period by the dedicated efforts of the 60,000 members of the National Council of Negro Women.

The representational bronze group, raised on the traditional pedestal, is intended to embody the legacy of the remarkable educator, Mary McLeod Bethune, who was born of slave parents, but who eventually served as advisor to four presidents. Bethune was both a leader and a symbol for blacks throughout her life, personifying the image of pride, self-confidence, and faith in the future. Her legacy is briefly summarized in an article by Angela Terrell in the *Washington Post*, July 8, 1974.:

I leave you love . . . hope . . . the challenge of developing confidence in one another . . . thirst for education . . . respect for the use of power . . . faith . . . racial dignity . . . desire to live harmoniously with your fellow man . . . finally, responsibility to our young people.[13]

Vermont International Sculpture Symposiums and Vermont Sculpture on the Highway

The state of Vermont, working with the Vermont International Sculpture Symposium of the University of Vermont, has developed a program entitled, "Sculpture on the Highway." Works of sculpture are located in the rest areas of Vermont's Interstate 89 and 91 between the borders of Canada and Massachusetts. A brochure that includes a diagrammatic map showing the sculptures' locations presents the following description of the program:

The eighteen sculptures in marble and concrete were designed and fabricated by sculptors from nine countries during International Sculpture Symposiums held in Vermont during the summers of 1968 and 1971.

Sculptures were, in many cases, designed for specific rest areas and with the Vermont landscape in mind. In most cases, they are placed away from the highway, out of the vision of the passing motorist, inviting the traveler to become a pedestrian and suggesting a fuller involvement with the sculpture and the spaces it creates. The rest area locations of the sculptures are indicated on the accompanying "map" of the highway.

The sculptures were created by artists who believe that art should be not only in museums and galleries, visited by the special few; but it should be in public places where its unique qualities can be enjoyed by many.[14]

CANADA

↓Southbound

1. Highgate
 Meadmore ~~Removed~~

2. St. Albans
 Uher

3. Williston
 Ramirez

4. Waterbury
 Trantenroth

5. Randolph
 Witkin
 Reischke

6. Sharon
 Ruddick

7. Hartland
 Baumann

8. Putney
 Lenassi

17. St. Albans
 Floyd

16. Williston
 Graves

15. Waterbury
 Aschenbach

14. Randolph
 Mizui

13. Sharon
 Kishida

12. Hartland
 Niizuma

11. Springfield
 Prantl

10. Putney
 Silva

9. Guilford
 Rogy

Northbound ↑
MASSACHUSETTS

145

Southbound

1. *Clement Meadmore,* born Melbourne, Australia, 1929, lives New York City. "Swing", Ferro-Crete, 10'x20'x10'. ~~Removed~~

2. *Rudolf Uher,* born Lubina, Czechoslovakia, 1913, lives Bratislava. Concrete, 9'x12'x9'.

3. *Eduardo Ramirez,* born Pamplona, Colombia, 1923, lives New York City. Concrete, 9'x12'x9'.

4. *A. Dieter Trantenroth,* born Bochum, Germany, 1940, lives Wunsiedel, BRD. Concrete, 4'x8'x12'.

5. *Isaac Witkin,* born Johannesburg, South Africa, 1936, lives Bennington, Vermont. Concrete, 12'x8'x8'.

 Erich Reischke, born Berlin, Germany, 1927, lives Berlin. Vermont Danby White Marble, 13'6"x7'x12'6".

6. *Peter Ruddick,* born Sunderfield, England, 1939, lives Plainfield, Vermont. Concrete, 30'x8'x8'.

7. *Herbert Baumann,* born Blumberg Baden, Germany, 1921, lives Stuttgart. Vermont Danby White Marble, 9'x4'x9'.

8. *Janez Lenassi,* born Opatija, Yugoslavia, 1927. Vermont Danby White Marble, 7'x9'6"x5'.

17. *Carl Floyd,* born Kentucky, 1936, lives Cleveland, Ohio. Concrete, 40'x8'x8'.

16. *Bradford Graves,* born Dallas, Texas, 1939, lives New York City. Concrete, 10'x4'x4'.

15. *Paul Aschenbach,* born Poughkeepsie, New York, 1921, lives Charlotte, Vermont. Concrete, 12'x4'x4'.

14. *Yasuo Mizui,* born Kyoto, Japan, 1925, lives Paris, France. Vermont West Rutland Marble, 3 pieces, 13'x8'x3'; 11'x7'x4'; 10'x7'x3'6".

13. *Katsuji Kishida,* born Tokyo, Japan, 1937, lives Paris, France. Concrete, 52'x8'x6'.

12. *Minoru Niizuma,* born Tokyo, Japan, 1930, lives New York City. Vermont Radio Black Marble, 4'6"x5'6"x8'6".

11. *Karl Prantl,* born Pottsching, Austria, 1923, lives Vienna, Austria. Vermont West Rutland Marble, 2 pieces, 21'x3'6"x3' and 5'6"x3'6"x3'.

10. *James Silva,* born New York, 1943, lives Brooklyn, New York. Ferro-Crete, 8'3"x9'x8'10".

9. *Viktor Rogy,* born Austria, 1924, lives Elidenhausen, Austria. Vermont Danby White Marble 2'6"x8'x4'.

Northbound

Notes

Chapter 1

1 Harold Osborne, gen. ed., *The Appreciation of the Arts,* 3 vols. (London: Oxford University Press, 1969), vol. 2, *Sculpture,* ed. L. R. Rogers, p. 3.
2 Ibid.
3 Ibid.
4 James Earle Fraser, "Why Sculpture?" (1938), in the James Earle and Laura Gardin Fraser Collection in the George Arents Research Library for Special Collections in the Syracuse University Libraries, Syracuse, N.Y.
5 F. A. Gutheim, "Civic Monumental Sculpture," *Magazine of Art,* August 1933, pp. 371–378.
6 Ibid.
7 Ibid.
8 Ibid.
9 Ibid.
10 Wayne Craven, *Sculpture in America* (New York: Thomas Y. Crowell Co., 1968), p. 614. Copyright 1968 by Wayne Craven.
11 Ibid., p. 615.
12 Rockne Krebs created a laser beam sculpture entitled *Sky Pie* for the Philadelphia Museum of Art, which was displayed in May 1973.
13 Craven, *Sculpture in America,* p. 568.
14 Gutheim, "Civic Monumental Sculpture."
15 Douglas Davis, *Art and the Future* (New York: Praeger, 1973), p. 16. Reprinted by permission from Praeger Publishers, Inc. Copyright 1973 by Douglas Davis.
16 Charles Blessing, as quoted by Louis G. Redstone, *Art in Architecture* (New York: McGraw-Hill, 1968), p. 87. Copyright 1968 by McGraw-Hill, Inc. Used with permission of McGraw-Hill Book Company.

Chapter 2

1 James M. Goode, "Outdoor Sculpture: Washington's Overlooked Monuments," *Historic Preservation* (January–March 1973), pp. 4–14.
2 Art Brenner, "Sculpture and Architecture," article based in part on a previous article appearing in *Leonardo,* vol. 4 (1971), published by Pergamon Press, April 1972.
3 Ibid.
4 Ibid.
5 Maryland Arts Council, *1% Art in Civic Architecture,* prepared by RTKL Associates, Inc., architects and planners, and text written by Bennard B. Perlman, p. 18. Project supported by a grant from the National Endowment for the Arts.
6 Barbara Rose, "Shall We Have a Renaissance?," *Art in America,* March–April 1967.

Chapter 3

1 John Canaday, *Culture Gulch: Notes on Art and Its Public in the 1960's* (New York: Farrar, Straus & Giroux, 1969), p. 190. Copyright 1969 by The New York Times Co. Reprinted by permission.
2 Ibid., p. 190.
3 Art Brenner, letter, Feb. 12, 1973.
4 Ivor de Wolfe, *The Italian Townscape* (New York: Braziller, 1966), pp. 134–142.

Chapter 4

1 *National Endowment for the Arts: Guide to Programs,* July 1974, p. 88.
2 *AIA Journal* 60 (September 1973), p. 8.
3 *Franklin D. Murphy Sculpture Garden,* catalog (Los Angeles: University of California at Los Angeles, printed by Anderson, Ritchie & Simon), n.d.
4 Ibid.
5 Ibid.
6 Collins, DuTot & Associates, "University of Pennsylvania Campus Fine Arts Study," unpublished study done for the University of Pennsylvania, Philadelphia, April 1970.
7 Ibid.
8 "Peachtree Center," brochure, Atlanta, Ga., April 1973.
9 Ibid.
10 Elizabeth B. Kassler, *Modern Gardens and the Landscape* (New York: The Museum of Modern Art, 1964), p. 58.
11 "Picasso's Prestressed Sculpture," *Engineering News-Record,* Aug. 8, 1968, pp. 20–21.
12 Henry A. Pohs, "One Man against the Mountain," *National Sculpture Review,* Winter 1967–1968, pp. 23–26.
13 California State University at Long Beach was the site of the first International Sculpture Symposium held in the United States in 1965.
14 Ruth Page and Sanders Milens, "Roadside Sculpture," *Parks and Recreation,* April 1972, pp. 34–37.
15 Lois Ingram, *Vermont International Sculpture Symposium* (Vermont: George Little Press, 1973).
16 Copyright 1973 by Vermont International Sculpture Symposium, Charlotte, Vt.
17 Comments attributed to Watson are from telephone conversations and personal interviews, March–May 1974.

18 *Sculpture Off the Pedestal,* catalog, Grand Rapids Art Museum, 1973.
19 Ibid.
20 This quotation was obtained from mimeographed material supplied by Safeway Stores, Inc.
21 Press release, The Fine Arts Gallery of San Diego, June 7, 1973.
22 Henry Gardiner, "The City Is for People," brochure, San Diego, Calif., July 1973.
23 Erwin Washington, "Bethune Dedication to Draw 100,000," *Washington Post,* July 10, 1974, p. C15.
24 David M. Krigbaum, Publicity Director, Phoenix Civic Plaza, letter, Feb. 6, 1973.
25 Ibid.

Chapter 5

1 Ada Louise Huxtable, "Public Sculpture—A City's Most Pervasive Art," *New York Times,* Sept. 15, 1974. Copyright 1974 by The New York Times Co. Reprinted by permission.
2 Amy Goldin, "The Esthetic Ghetto: Some Thoughts about Public Art," *Art in America,* May–June 1974, pp. 30–35.
3 Alan M. Kriegsman, "A Closer Look at How Americans View Culture," *Washington Post,* Apr. 4, 1974, p. B5.
4 George Gent, "Survey Finds Many Would Pay $25 Tax for Culture," *New York Times,* Apr. 4, 1974. Copyright 1974 by The New York Times Co. Reprinted by permission.
5 "Sample Survey Check List," Research Programs, The American Institute of Architects, Washington, D.C. (Mimeographed.)
6 "'Group of Four Trees': An Engineering As Well As Artistic Feat," The Chase Manhattan Bank, press release.
7 Jean Dubuffet, "Text of M. Dubuffet's Remarks," Oct. 24, 1972, The Chase Manhattan Bank, press release.

Chapter 6

1 Institute of Contemporary Art, Boston, Mass., "Arts Renewal: Boston's Visual Environment, 1874 – 1974," Symposium, Boston, May 1–4, 1974. (Mimeographed.)
2 Amy Goldin, "The Esthetic Ghetto: Some Thoughts about Public Art," *Art in America,* May–June 1974, pp. 30–35. Brackets added.
3 Doris Freedman, "Public Sculpture," *Design and Environment,* Summer 1974, p. 19.
4 Anita Margrill, letter, May 27, 1973.
5 Paul Damaz, "National Survey on Legal Contracts Covering Architectural Works of Art," including additional memos and recommendations regarding the New York City Ordinance, study done for AIA, December 1971. Paul Damaz, AIA,

Architect and Public Consultant, Director of the Fine Arts Federation of New York.

6 Ibid.

7 Art Brenner, "Sculpture and Architecture," article based in part on a previous article appearing in *Leonardo,* vol. 4 (1971), published by Pergamon Press, April 1972. Except where otherwise indicated, references in this chapter to Brenner's ideas as well as quotations from him are derived from this article. Brenner has requested that it be stressed that he does not here suggest the use of existing *pieces* of sculpture for architectural spaces, but rather the use of specially qualified sculptors to create works for specific settings.

8 Ibid.

9 Art Brenner, "The Humanizing Role of Sculpture," *AIA Journal* 60 (September 1973), pp. 24–27.

10 Barbara Rose, "Shall We Have a Renaissance?," *Art in America,* March–April 1967.

11 Ibid. Brackets added.

12 "Medians," *Grounds Maintenance* magazine, July 1972, pp. 14–16.

13 Elizabeth C. Baker, "Mark di Suvero's Burgundian Season," *Art in America,* May–June 1974, pp. 59–62.

14 Margrill's sculptures are individually designed and constructed by the artist and are therefore not in the category of commercial play sculpture.

15 Anita Margrill, "On Manhattan's Streets for Fun and Clout," *Landscape Architecture,* July 1972, pp. 315, 353.

16 Robert Sommer, "People's Art," *AIA Journal* 58 (December 1972), pp. 29–34. Reprinted with permission from the *AIA Journal,* December 1972. Copyright 1972 the American Institute of Architects.

17 Gyorgy Kepes, "The Artist as Environmentalist: A Proposal," *Ekistics* 34, no. 204 (November 1972), pp. 372–374. Published by the Athens Center of Ekistics, Athens, Greece.

18 Ibid.

19 Ibid.

20 For more information, see "A Different Dam," *Parks and Recreation* (NRPA), May 1972, pp. 39, 64.

21 Lehr has continued to pursue the creation of sculpture that participates positively with the environment. His education (B.A. in art history, M.F.A. in sculpture), plus his ability to master scientific and technical disciplines, make him uniquely qualified for the creation of environmental sculpture.

22 Margrill, "On Manhattan's Streets for Fun and Clout." Brackets added.

23 Kepes, "The Artist as Environmentalist." Brackets added.

24 Ibid.

25 Ibid.

26 James Wines. Except where otherwise indicated, the information regarding SITE, Inc., including quotations, was obtained from a personal interview with Wines, president of SITE, Inc., on Feb. 19, 1974, or from mimeographed material obtained from SITE, Inc.

27 James Wines, "The Case for Site Oriented Art," *Landscape Architecture,* July 1971, pp. 317–319.

28 Douglas Davis, *Art and the Future* (New York: Praeger, 1973), p. 120. Reprinted by permission from Praeger Publishers, Inc. Copyright 1973 by Douglas Davis.

29 Information on Scam I, the first automobile sculpture, was supplied by Galerie Denise René, New York and Paris, representing Nicolas Schöffer.

30 Anne Healy, as quoted by Hugh M. Davies, "Interview with Anne Healy," *Monumenta* catalog, Newport, R.I., 1974.

31 Hans Namuth, "The Kites of Guatemala," *Architecture Plus,* July–August 1974, pp. 64–69.

32 "Rockne Krebs at the Philadelphia Museum of Art," in "Review of Exhibitions," *Art in America,* September–October 1973, pp. 118–119.

33 Lucy R. Lippard, "A Is for Artpark," *Art in America,* November–December 1974, pp. 37–38.

34 Anna Dolanyi and Zoltan Fejes, "Jardin Sculpte: A Rich, Sensory Universe," *Landscape Architecture,* July 1971, pp. 320–323.

35 A good source for information on Robert Smithson, including a bibliography of his writings and a listing of his earthworks is Lawrence Alloway's "Robert Smithson's Development," *Artforum,* November 1972, pp. 53–61.

Chapter 7

1 "The People Watchers," *Atlanta* magazine, October 1970, pp. 58–61. Copyright 1970. Reprinted by permission.

2 Lee C. Hiers, Research Associate, Atlanta Chamber of Commerce, letter, Aug. 8, 1973.

3 W. A. Crimmins, Foreword to *Monumenta* catalog, Monumenta Newport, Inc.

4 Patricia Corbin, "Sculpture Out in the Open," *House and Garden,* December 1974.

5 Robert Hughes, "Sea with Monuments," *Time,* Sept. 2, 1974. Reprinted by permission from TIME, The Weekly Newsmagazine. Copyright Time, Inc.

6 Ibid.

7 Vernon Louviere, "Picasso as a Spur to Productivity," under "Panorama of the Nation's Business," *Nation's Business,* July 1974, p. 39. Reprinted by permission from *Nation's Business,* July 1974. Copyright 1974 by *Nation's Business,* Chamber of Commerce of the United States.

8 Jon Borgzinner, "Chicago's New Picasso," *The Art Gallery,* March 1975, pp. 18–22.

9 William T. Ylvisaker, Chairman, Gould Inc., "Opening Remarks: Pablo Picasso's *Bather,*" Mar. 10, 1975. (Mimeographed.)

10 Martin Chirino, extract from "El Paso" manifesto, as it appears in the exhibition catalog, *Martin Chirino,* 1973. Reprinted by permission from the Grace Borgenicht Gallery, New York.

11 Mrs. Eugene Strand, Pasadena, Calif., letter to William Bridgers of Cornell, Bridgers, Troller & Hazlett, Oct. 13, 1972.

12 Constantine G. Vasiliadis, Foreword to the catalog *Sculpture in the Park 1974,* North Jersey Cultural Council, Paramus, N.J.

13 Mary McLeod Bethune, as quoted by Angela Terrell, *Washington Post,* July 8, 1974.

14 *Sculpture on the Highway,* brochure, Vermont International Sculpture Symposium, University of Vermont, Burlington, Vt.

148

Appendix A
Evaluation Tables for
Public Opinion Surveys

Table 1 Educational Level by Awareness of Sculpture

Educational level	Aware		Unaware		No answer		Total	
	%	No.	%	No.	%	No.	%	No.
High school	94	99	5	5	1	1	100	105
High school and technical training	88	23	12	3	0	0	100	26
Some college	93	139	6	9	1	1	100	149
College plus graduate study	92	87	7	7	1	1	100	95
Total	93	348	6	24	1	3	100	375

Table 2 Subjective Reaction by Age Group to a Given Work or Works of Outdoor Sculpture

Age group	Like		Dislike		Neutral		Total	
	%	No.	%	No.	%	No.	%	No.
Under 18	75	32	2	1	23	10	100	43
18–25	66	105	9	15	25	40	100	160
26–35	51	49	19	18	30	29	100	96
36–55	58	33	9	5	33	19	100	57
Over 55	42	8	26	5	32	6	100	19
Total	60	227	12	44	28	104	100	375

Table 3 Public Opinion Regarding Whether a Given Work or Works Has a Message Other Than an Esthetic One

Vocation*	Yes		No		Not sure		No answer		Total	
	%	No.	%	No.	%	No.	%	No.	%	No.
Academic	26	23	17	15	34	30	23	21	100	89
Clerical	19	14	34	25	40	29	7	5	100	73
Technical	22	11	26	13	40	20	12	6	100	50
Professional	26	34	39	52	30	39	5	7	100	132
Domestic	23	2	33	3	33	3	11	1	100	9
None indicated	27	6	14	3	45	10	14	3	100	22
Total	24	90	30	111	35	131	11	43	100	375

*The following descriptions explain the various categories:

Academic includes all full-time students ranging from junior high through graduate school.

Clerical includes all nonprofessional white-collar vocations.

Technical includes all blue-collar vocations as well as others requiring specialized skills acquired through trade schools or apprenticeships.

Professional includes the usual fields of law, medicine, architecture and related arts, fine arts, education, as well as areas of business and management involving advanced education and long-term commitment in a given field.

Domestic was included to cover housewives, who could just as well have been placed in the professional or technical categories, depending upon one's viewpoint. Obviously many people included in other categories are housewives or "domestic engineers" as well.

150

Table 4 Public Preference Categorized by Age Group Regarding Who Should Be Responsible for Selection and Placement of Outdoor Sculpture

Those responsible for selection and placement of outdoor sculpture	25 years and under		Over 25		Total	
	%	No.	%	No.	%	No.
Creative professionals such as artists, architects, landscape architects	37	76	36	61	37	140*
A committee composed of creative professionals, public or governmental officials, and laypeople representing the community in which the work is to be placed	34	69	31	53	33	122
Creative professionals and laypeople representing the community	13	26	15	25	14	51
Laypeople representing the community	5	10	6	10	5	20
Public or governmental officials	2½	5	3	5	2½	10
Public or governmental officials and creative professionals	2	4	2	4	2	8
Public or governmental officials and laypeople representing the community	½	1	1	1	½	2
No answer	6	12	6	10	6	22
Total	100	203	100	169	100	375*

*Three individuals who did not indicate their age selected the category of creative professionals.

Table 5 Public Preference for Methods of Funding Outdoor Sculpture Programs

	%	No.
A combination of public funds, private endowment, and public solicitation and fund raising	29	108
Public funds	17	65
Public solicitation and fund raising	13	49
Private endowment	13	48
A combination of private endowment and public solicitation and fund raising	11	43
A combination of public funds and private endowment	7	25
A combination of public funds and public solicitation and fund raising	3	10
Other*	2	7
No answer	5	20
Total	100	375

*Individual answers given under Other:

"Any way possible."

"I believe they should cut the board of supervisors for S.D. back to previous level and use the money saved plus public funds to fund outdoor art — within reason of course."

"Whoever's land it's on should pick and pay."

"Ability to pay of local arts council."

"Use of surplus materials donated by government agencies and applied to the needs of community by artist volunteers."

"It depends on the area and purpose of the sculpture."

"Depends on the amount and who wanted it."

Table 6 Public Opinion Categorized by Sex Regarding Whether Exterior Sculpture in Our Urban Environment Is a Worthwhile Means for Maintaining and Improving Our Quality of Life

Sex	Yes		No		Not sure		No answer		Total	
	%	No.	%	No.	%	No.	%	No.	%	No.
Male	78	155	8	16	10	19	4	8	100	198
Female	78	135	8	13	9	16	5	9	100	173
Not indicated	75	3			25	1			100	4
Total	78	293	8	29	10	36	4	17	100	375

Appendix B
Tabulations of
Public Opinion Surveys

Embarcadero Center
San Francisco
Sculpture by Willi Gutmann

Statistical Information

1	Under 18	0
	18–25	5
	26–35	14
	36–55	6
2	Male	12
	Female	13
3	High school	5
	High school and technical training	1
	Some college plus technical training	1
	Some college or degree	9
	Undergraduate degree plus graduate study	8
	No answer	1
4	Accountant	1
	Artist	2
	Clerk	2
	Computer operator	1
	Craftsman	5
	Credit collector	1
	Data processing supervisor	1
	Economist	1
	Insurance	3
	Researcher	1
	Salesperson	2
	Secretary	3
	Tax lawyer	1
	Teletype operator	1
5	Yes	15
	No	10

Information about Sculpture

1	Yes	23
	No	2
2	Like	15
	Dislike	4
	Neutral	6
3	Too large	3
	Too small	0
	Right size	15
	No answer	7
4	Yes	18
	No	4
	No opinion	3
5	Yes	20
	No	3
	No opinion	2
6	Yes	21
	No	3
	No opinion	1
7	Fairly well	12
	Extremely	7
	Not at all	5
	No answer	1
8	Yes	18
	No	5
	No answer	2
9	Replace	9
	Remove	1
	Leave	14
	No answer	1
10	Yes	14
	No	13
	Not sure	7
	No answer	1

11	Yes	1
	No	19
	No answer	5
12	Yes	4
	No	3
	Not sure	10
	No answer	8
	Offensive:	
	Yes	1
	No	21
	No answer	3
13	Yes	21
	No	2
	Not sure	0
	No answer	2
14	a	0
	b	9
	c	3
	d (1) b & c	2
	(2) a, b, & c	10
	No answer	1
15	a	3
	b	2
	c	5
	d (1) a & b	3
	(2) b & c	5
	(3) a & c	1
	(4) a, b, & c	4
	No answer	2

Chase Manhattan Plaza
New York
Sculpture by Jean Dubuffet

Statistical Information

1	Under 18	0
	18–25	13
	26–35	8
	36–55	2
	Over 55	2

2	Male	13
	Female	12

3	High school	4
	High school and technical training	2
	Some college and technical training	1
	Some college or degree	10
	Undergraduate degree and graduate study	8

4	Accountant	1
	Auditor	3
	Clerk	3
	College student	1
	Graduate student	1
	International banker	1
	International insurance underwriter	3
	Locksmith	1
	Masseur	1
	MT/ST operator	1
	Payroll assistant	1
	Programmer	1
	Sculptor	1
	Secretary	5
	Travel agent	1

5	Yes	7
	No	17
	No answer	1

Information about Sculpture

1	Yes	25
	No	0
	No answer	0

2	Like	12
	Dislike	5
	Neutral	8
	No answer	0

3	Too large	5
	Too small	1
	Right size	17
	No answer	2

4	Yes	8
	No	11
	No opinion	6
	No answer	0

5	Yes	11
	No	11
	No opinion	3
	No answer	0

6	Yes	17
	No	8
	No opinion	0
	No answer	0

7	Fairly well	13
	Extremely	2
	Not at all	9
	No answer	1

8	Yes	17
	No	8
	No answer	0

9	Replace	8
	Remove	2
	Leave	15
	No answer	0

10	Yes	5
	No	15
	Not sure	5
	No answer	0

11	Yes	1
	No	20
	No answer	4

12	Yes	4
	No	3
	Not sure	10
	No answer	8
	Offensive:	
	Yes	1
	No	21
	No answer	3

13	Yes	21
	No	3
	Not sure	1
	No answer	0

14	b	9
	c	2
	a & b	1
	b & c	4
	a, b, & c	8
	No answer	1

15	a	2
	b	6
	c	1
	e	2
	a & b	2
	b & c	7
	a, b, & c	4
	e (government surplus and volunteered time of artists)	1

154

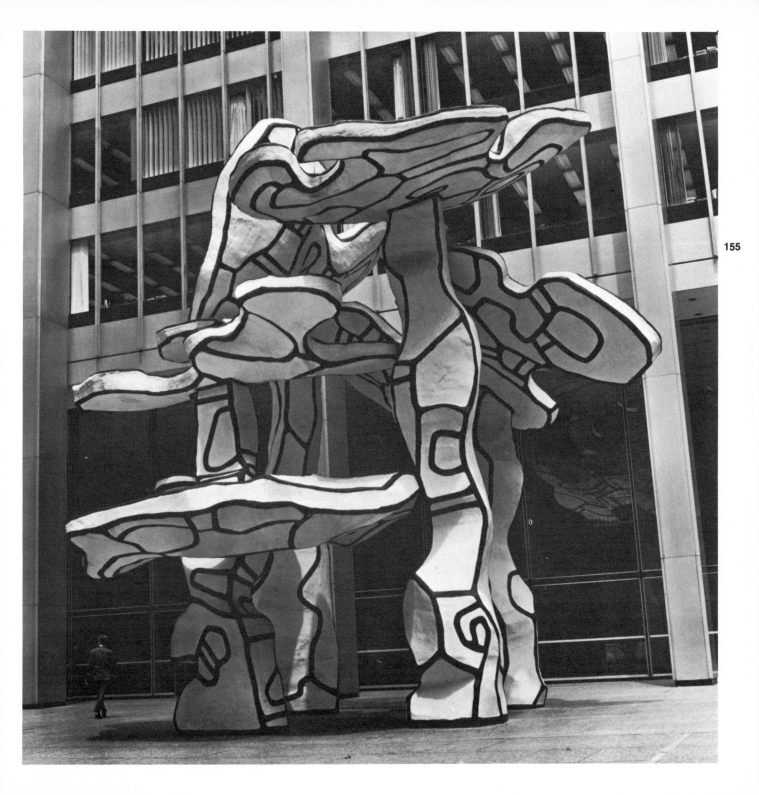

Chase Manhattan Plaza
New York
Sculpture by Isamu Noguchi

Statistical Information

1	Under 18	1
	18–25	14
	26–35	6
	36–55	3
	Over 55	1
2	Male	15
	Female	9
	No answer	1
3	High school	8
	High school and technical training	1
	Some college and technical training	0
	Some college or degree	10
	Undergraduate degree and graduate study	5
	No answer	1
4	Auditor	1
	Bank clerk	3
	Bank officer	2
	Clerk	1
	Commissions analyst	1
	CPA	2
	Environmental engineer	1
	Real estate broker	2
	Secretary	7
	Security analyst	1
	U.S. Merchant Marine officer	1
	Wage analyst	1
	None given	2
5	Yes	14
	No	10
	No answer	0

Information about Sculpture

1	Yes	24
	No	1
	No answer	0
2	Like	16
	Dislike	0
	Neutral	9
	No answer	0
3	Too large	1
	Too small	2
	Right size	20
	No answer	2
4	Yes	16
	No	5
	No opinion	4
	No answer	0
5	Yes	21
	No	1
	No opinion	3
	No answer	0
6	Yes	16
	No	6
	No opinion	3
	No answer	0
7	Fairly well	20
	Extremely	2
	Not at all	1
	No answer	2
8	Yes	22
	No	2
	No answer	1
9	Replace	7
	Remove	1
	Leave	17
	No answer	0
10	Yes	5
	No	9
	Not sure	10
	No answer	1
11	Yes	4
	No	12
	No answer	9
12	Yes	5
	No	5
	Not sure	8
	No answer	7
	Offensive:	
	Yes	0
	No	19
	No answer	6
13	Yes	22
	No	0
	Not sure	2
	No answer	1
14	b	13
	c	2
	b & c	5
	a, b, & c	3
	No answer	2
15	a	2
	b	8
	c	5
	a & b	2
	a or b	1
	b & c	3
	a; b, & c	3
	No answer	1

156

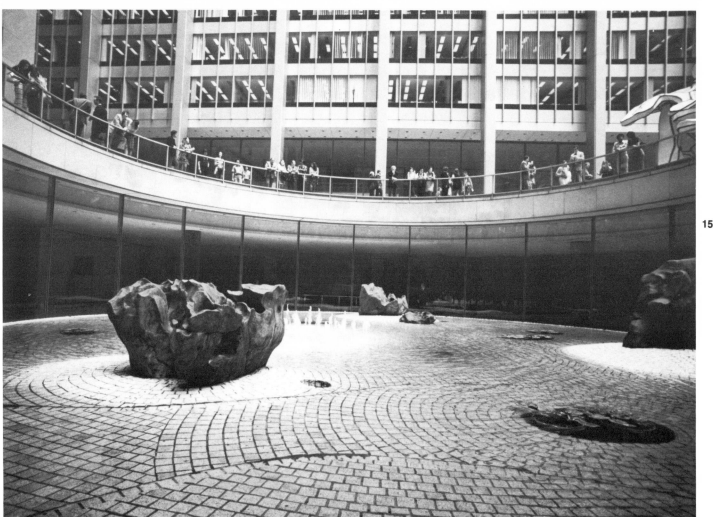

Security Pacific Plaza
San Diego, California
Sculpture by Clement Meadmore

Statistical Information

1 Under 18 0
 18–25 11
 26–35 11
 36–55 2
 Over 55 1

2 Male 15
 Female 10

3 High school 0
 High school and technical training 1
 Some college and technical training 1
 Some college or degree 16
 Undergraduate degree and
 graduate study 7

4 Architect 1
 Assistant billing supervisor 1
 City planner 3
 Civil engineer 2
 Construction engineer 1
 Credit adjuster 1
 Draftsman 2
 Financial analyst 1
 Graduate student 1
 Lawyer 1
 Management consultant 1
 Microfilm operator 1
 Property agent 1
 Secretary 6
 Student 1
 Title insurance 1

5 Yes 23
 No 2

Information about Sculpture

1 Yes 23
 No 1
 No answer 1

2 Like 8
 Dislike 9
 Neutral 8
 No answer 0

3 Too large 8
 Too small 2
 Right size 15
 No answer 0

4 Yes 12
 No 9
 No opinion 4
 No answer 0

5 Yes 15
 No 5
 No opinion 4
 No answer 1

6 Yes 15
 No 6
 No opinion 3
 No answer 1

7 Fairly well 12
 Extremely 2
 Not at all 10
 No answer 1

8 Yes 12
 No 13
 No answer 0

9 Replace 12
 Remove 0
 Leave 12
 No answer 1

10 Yes 5
 No 5
 Not sure 13
 No answer 2

11 Yes 1
 No 20
 No answer 4

12 Yes 6
 No 2
 Not sure 12
 No answer 5

 Offensive:
 Yes 3
 No 21
 No answer 1

13 Yes 20
 No 4
 Not sure 1
 No answer 0

14 b 12
 c 1
 a & c 1
 b & c 4
 a, b, & c 6
 No answer 1

15 a 2
 b 10
 c 3
 e 1
 a & b 1
 b & c 2
 a, b, & c 6

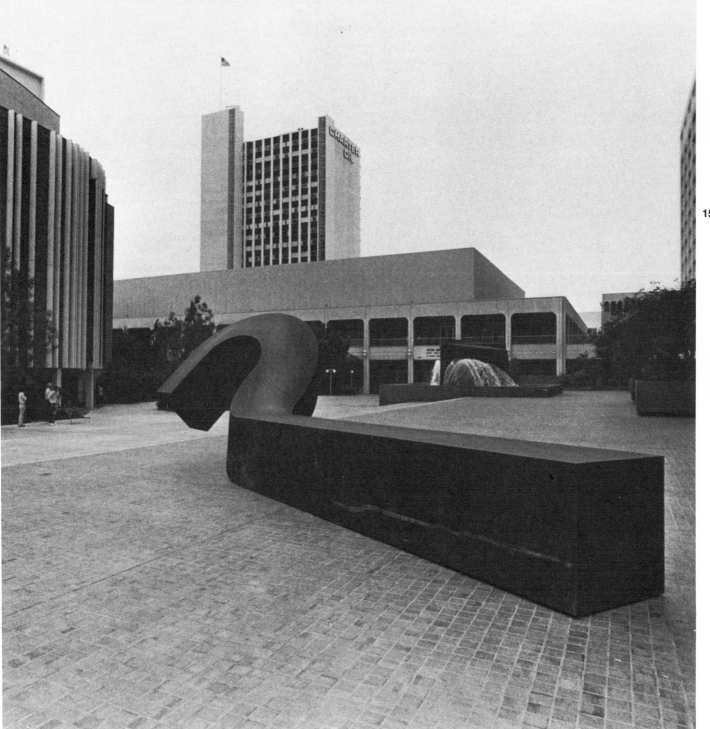

Time-Life Plaza
New York
Sculpture by William Crovello

Statistical Information

1	Under 18	2
	18–25	13
	26–35	4
	36–55	5
	Over 55	1
2	Male	13
	Female	12
3	High school	7
	High school and technical training	3
	Some college and technical training	0
	Some college or degree	10
	Undergraduate degree and graduate study	4
	No answer	1
4	Accountant	1
	Business systems analyst	1
	Clerk	2
	College administrator	1
	Computer programmer	1
	Cosmetologist	1
	Electrical engineer	1
	Insurance company executive	1
	Laborer	1
	Machine operator	1
	Public servant	1
	Radio-TV director	1
	Receptionist	1
	Registered nurse	1
	Student	5
	TV broadcast engineer	1
	No occupation	1
	No answer	3
5	Yes	11
	No	14

Information about Sculpture

1	Yes	22
	No	3
2	Like	11
	Dislike	4
	Neutral	10
3	Too large	3
	Too small	3
	Right size	18
	No answer	1
4	Yes	12
	No	6
	No opinion	7
5	Yes	14
	No	4
	No opinion	7

6	Yes	16
	No	7
	No opinion	2
7	Fairly well	15
	Extremely	2
	Not at all	6
	No answer	2
8	Yes	17
	No	6
	No answer	2
9	Replace	11
	Remove	1
	Leave	11
	No answer	2
10	Yes	2
	No	8
	Not sure	13
	No answer	2
11	Yes	1
	No	19
	No answer	5
12	Yes	1
	No	5
	Not sure	13
	No answer	6
	Offensive:	
	Yes	1
	No	21
	No answer	3
13	Yes	19
	No	3
	Not sure	1
	No answer	2
14	a	0
	b	6
	c	0
	d (1) a & b	2
	(2) b & c	4
	(3) a, b, & c	11
	No answer	2
15	a	6
	b	3
	c	4
	d (1) b & c	1
	(2) a, b, & c	9
	e	0
	No answer	2

Peachtree Center
Atlanta, Georgia
Sculpture by Willi Gutmann

Statistical Information

1		
	Under 18	1
	18–25	11
	26–35	4
	36–55	3
	Over 55	3
	No answer	1

2		
	Male	13
	Female	12

3		
	High school	2
	High school and technical training	2
	Some college and technical training	3
	Some college or degree	11
	Undergraduate degree and graduate study	3
	No answer	4

4		
	Businessman	1
	Chef	1
	Clerk-typist	1
	Dictaphone operator	1
	Housewife	3
	Labor relations specialist	1
	Public relations hostess	1
	Retired systems analyst	1
	Salesman	2
	Secretary	1
	Security guard	1
	Student	2
	Student (law)	1
	Student (nursing)	1
	Teacher	1
	Truck driver	1
	Underwriter	2
	Unemployed	1
	No answer	1

5		
	Yes	14
	No	11

Information about Sculpture

1		
	Yes	19
	No	6
	No answer	0

2		
	Like	14
	Dislike	0
	Neutral	11

3		
	Too large	0
	Too small	2
	Right size	20
	No answer	3

4		
	Yes	19
	No	1
	No opinion	5

5		
	Yes	21
	No	1
	No opinion	3

6		
	Yes	19
	No	2
	No opinion	4

7		
	Fairly well	14
	Extremely	7
	Not at all	1
	No answer	3

8		
	Yes	18
	No	4
	No answer	3

9		
	Replace	4
	Remove	0
	Leave	18
	No answer	3

10		
	Yes	4
	No	6
	Not sure	13
	No answer	2

11		
	Yes	2
	No	18
	No answer	5

12		
	Yes	4
	No	3
	Not sure	11
	No answer	7
	Offensive:	1
	Yes	1
	No	19
	No answer	5

13		
	Yes	17
	No	2
	Not sure	4
	No answer	2

14		
	b	14
	c	1
	a & b	1
	a, b, & c	6
	No answer	3

15		
	a	3
	b	6
	c	1
	e (any way possible)	1
	a & b	2
	a, b, & c	8
	Federal government	1
	No answer	3

162

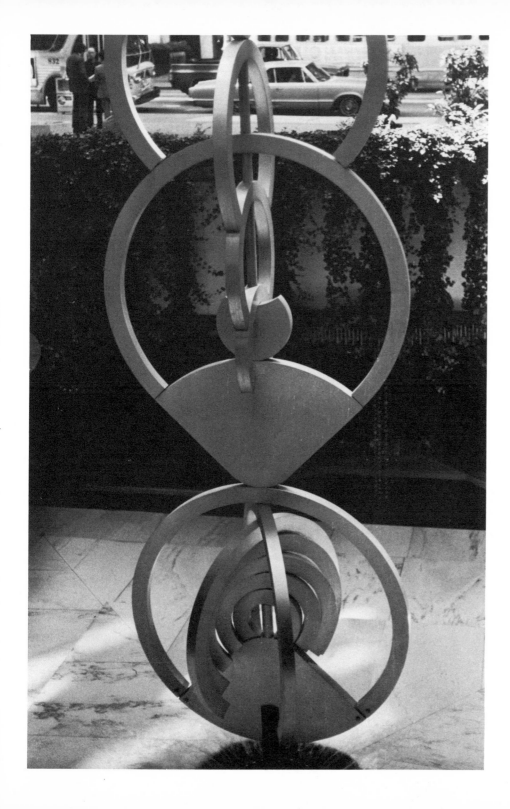

Smithsonian Museum of History and Technology
Washington, D.C.
Sculpture by Alexander Calder

Statistical Information

1. Under 18 — 15
 18–25 — 5
 26–35 — 3
 36–55 — 1
 Over 55 — 0
 No answer — 1

2. Male — 11
 Female — 14

3. High school — 15
 High school and technical training — 3
 Some college and technical training — 2
 Some college or degree — 4
 Undergraduate degree and graduate study — 1

4. Bank teller — 1
 College student — 1
 Communications worker — 1
 Farm laborer — 1
 FBI agent — 1
 High school student — 10
 Junior executive — 1
 Machine operator — 1
 Mechanic — 1
 Military (Army) — 1
 Paper boy — 1
 Student nurse — 1
 Unemployed — 1
 No answer — 3

5. Yes — 1
 No — 23
 No answer — 1

Information about Sculpture

1. Yes — 23
 No — 2

2. Like — 14
 Dislike — 3
 Neutral — 8

3. Too large — 1
 Too small — 0
 Right size — 23
 No answer — 1

4. Yes — 16
 No — 7
 No opinion — 2

5. Yes — 19
 No — 5
 No opinion — 1

6. Yes — 20
 No — 4
 No opinion — 1

7. Fairly well — 20
 Extremely — 1
 Not at all — 1
 No answer — 2

8. Yes — 18
 No — 5
 No answer — 2

9. Replace — 4
 Remove — 2
 Leave — 17
 No answer — 2

10. Yes — 9
 No — 3
 Not sure — 11
 No answer — 2

11. Yes — 6
 No — 17
 No answer — 2

12. Yes — 6
 No — 5
 Not sure — 10
 No answer — 4

Offensive:
No — 20
No answer — 5

13. Yes — 16
 No — 3
 Not sure — 4
 No answer — 2

14. a — 2
 b — 9
 c — 1
 d* — 1
 b & c — 1
 a, b, & c — 9
 No answer — 2

15. a — 10
 b — 2
 c — 3
 a & b — 1
 b & c — 3
 a, b, & c — 4
 No answer — 2

*"Artists, common people, and a person understanding art in government" (11th grade high school student).

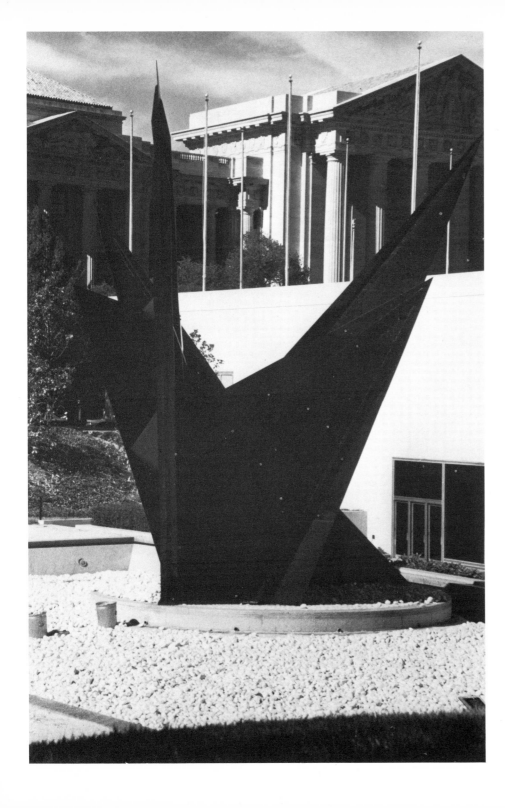

Smithsonian Museum of History and Technology
Washington, D.C.
Sculpture by José de Rivera

Statistical Information

1	Under 18	14
	18–25	5
	26–35	2
	36–55	2
	Over 55	2

2	Male	8
	Female	17

3	High school	16
	High school and technical training	0
	Some college and technical training	0
	Some college or degree	4
	Undergraduate degree and graduate study	1
	No answer	4

4	Art teacher	1
	Cook	1
	Federal Aviation Administration employee	1
	High school student	13
	Housewife	3
	Music teacher	1
	Teacher	2
	No answer	3

5	Yes	0
	No	25

Information about Sculpture

1	Yes	21
	No	2
	No answer	2

2	Like	20
	Dislike	0
	Neutral	5

3	Too large	1
	Too small	1
	Right size	21
	No answer	2

4	Yes	17
	No	3
	No opinion	4
	No answer	1

5	Yes	17
	No	2
	No opinion	5
	No answer	1

6	Yes	18
	No	2
	No opinion	4
	No answer	1

7	Fairly well	13
	Extremely	8
	Not at all	2
	No answer	2

8	Yes	22
	No	0
	No answer	3

9	Replace	2
	Remove	0
	Leave	19
	No answer	4

10	Yes	5
	No	6
	No answer	5
	Not sure	9

11	Yes	8
	No	14
	No answer	3

12	Yes	6
	No	8
	Not sure	9
	No answer	2

	Offensive:	
	Yes	6
	No	16
	No answer	3

13	Yes	14
	No	3
	Not sure	5
	No answer	3

14	a	2
	b	10
	c	4
	a & b	1
	a, b, & c	5
	No answer	3

15	a	11
	b	2
	c	5
	a & c	1
	a, b, & c	4
	No answer	2

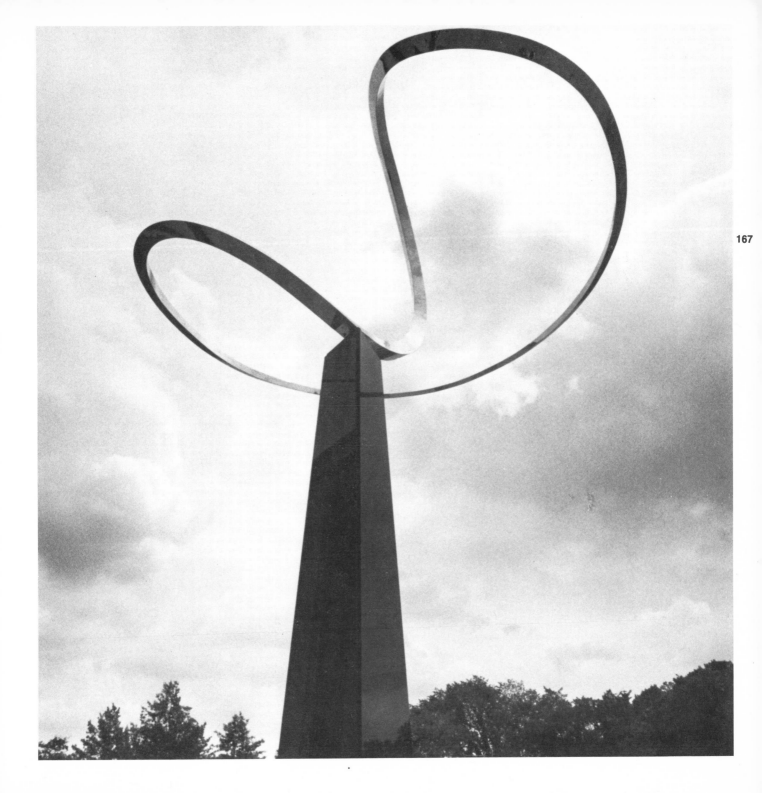

John F. Kennedy Center for the Performing Arts
Washington, D.C.
Relief Panels by Jurgen Weber

Statistical Information

1	Under 18	1
	18–25	8
	26–35	7
	36–55	9
2	Male	14
	Female	11
3	High school	4
	High school and technical training	3
	Some college and technical training	1
	Some college or degree	12
	Undergraduate degree and graduate study	5
	No answer	0
4	Artist-sculptor	1
	Attorney	2
	Bus driver	1
	College student	2
	Congressional staff-case worker	1
	Graphics designer	1
	High school student	1
	Milkman	1
	Military (Air Force)	1
	Military (USMC)	1
	Model maker	1
	Mother	1
	Office worker	1
	Probation officer	1
	Real estate broker	1
	Researcher	1
	Retired teacher	1
	Self-employed	1
	Systems analyst	1
	Teacher	2
	No answer	1
5	Yes	9
	No	16

Information about Sculpture

1	Yes	23
	No	2
2	Like	16
	Dislike	3
	Neutral	5
	No answer	1
3	Too large	2
	Too small	1
	Right size	21
	No answer	1
4	Yes	13
	No	2
	No opinion	12
5	Yes	18
	No	2
	No opinion	5
6	Yes	17
	No	4
	No opinion	4
7	Fairly well	11
	Extremely	8
	Not at all	2
	No answer	4
8	Yes	12
	No	10
	No answer	3
9	Replace	9
	Remove	1
	Leave	12
	No answer	3
10	Yes	14
	No	3
	Not sure	5
	No answer	3
11	Yes	8
	No	12
	No answer	5
12	Yes	12
	No	2
	Not sure	5
	No answer	6
	Offensive:	
	Yes	5
	No	14
	No answer	6
13	Yes	16
	No	2
	Not sure	2
	No answer	5
14	a	0
	b	7
	c	2
	d	0
	b & c	5
	a, b, & c	7
	No answer	4
15	a	4
	b	0
	c	2
	d	0
	e*	1
	a & c	2
	b & c	3
	a, b, & c	9
	No answer	4

*It depends on the area and purpose of the sculpture.

168

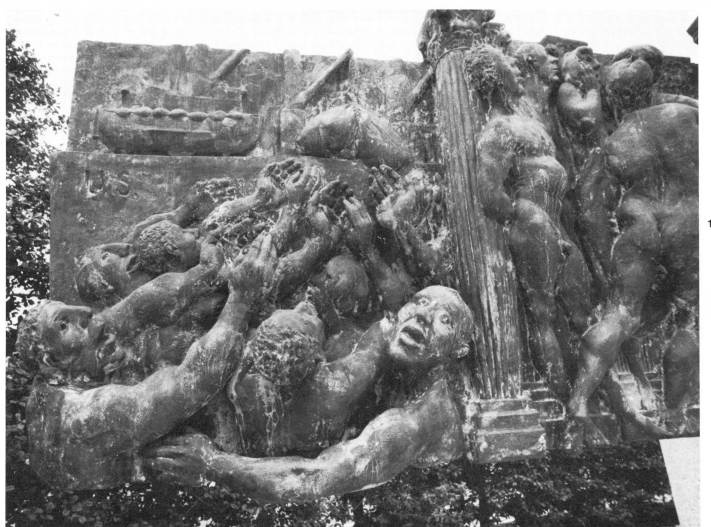

Museum of Modern Art Sculpture Garden
New York

Statistical Information

1 Under 18 — 4
 18–25 — 8
 26–35 — 4
 36–55 — 6
 Over 55 — 3

2 Male — 11
 Female — 13
 No answer — 1

3 High school — 4
 High school and technical training — 0
 Some college and technical training — 2
 Some college or degree — 7
 Undergraduate degree and
 graduate study — 12

4 Art director — 1
 Art editor — 1
 Art teacher — 1
 Commercial artist — 1
 Dancer — 1
 Fellowship program assistant — 1
 Film director — 1
 General manager — 1
 Graduate student — 2
 High school student — 3
 Librarian — 1
 Photographer — 1
 Salesman — 1
 Secretary — 1
 Social worker — 1
 Speech therapist — 1
 Stock broker — 1
 Surgical assistant — 3
 Teacher — 2

5 Yes — 19
 No — 6

Information about Sculpture

1 Yes — 23
 No — 0
 No answer — 2

2 Like — 21
 Dislike — 0
 Neutral — 1
 No answer — 3

3 Too large — 0
 Too small — 0
 Right size — 13
 No answer — 12

4 Yes — 21
 No — 2
 No opinion — 0
 No answer — 2

5 Yes — 20
 No — 2
 No opinion — 0
 No answer — 3

6 Yes* — 16
 No — 2
 No opinion — 0
 No answer — 7

7 Fairly well — 9
 Extremely — 15
 Not at all — 0
 No answer — 1

8 Yes — 24
 No — 1
 No answer — 0

9 Replace — 2
 Remove† — 7
 Leave — 12
 No answer — 1

10 Yes — 5
 No — 10
 Not sure — 6
 No answer — 4

11 Yes — 7
 No — 7
 No answer — 11

12 Yes — 6
 No — 0
 Not sure — 7
 No answer — 12

 Offensive:
 Yes — 0
 No — 16
 No answer — 9

13 Yes — 24
 No — 0
 Not sure — 1
 No answer — 0

14 b — 12
 c — 1
 b & c — 6
 a, b, & c — 6

15 a — 2
 c — 2
 a & b — 3
 a & c — 2
 b & c — 3
 a, b, & c — 12
 No answer — 1

*Two people said could be more color.
†Remove some works, 3.

170

Civic Center Plaza
Chicago
Sculpture by Pablo Picasso

Statistical Information

1	Under 18	2
	18–25	13
	26–35	7
	36–55	1
	Over 55	1
2	Male	15
	Female	9
	No answer	1
3	High school	6
	High school and technical training	2
	Some college and technical training	0
	Some college or degree	9
	Undergraduate degree and graduate study	5
	No answer	3
4	Analyst	1
	Building inspector	1
	Clerk	1
	Distribution clerk	1
	Editor	1
	Escrow clerk	1
	Fireman	1
	Graduate student	4
	Housewife	1
	Mail clerk	1
	Retired	1
	Secretary	1
	Supervisor	2
	Telephone dispatcher	1
	Title examiner	1
	Undergraduate college student	3
	Unemployed	1
	Illegible	1
	No answer	1
5	Yes	18
	No	7
	No answer	0

Information about Sculpture

1	Yes	25
	No	0
2	Like	19
	Dislike	2
	Neutral	3
	No answer	1
3	Too large	3
	Too small	2
	Right size	19
	No answer	1
4	Yes	13
	No	4
	No opinion	8
	No answer	0

5	Yes	20
	No	2
	No opinion	2
	No answer	1
6	Yes	20
	No	4
	No opinion	1
	No answer	1
7	Fairly well	14
	Extremely	8
	Not at all	1
	No answer	2
8	Yes	19
	No	4
	No answer	2
9	Replace	4
	Remove	0
	Leave	20
	No answer	1
10	Yes	8
	No	7
	Not sure	9
	No answer	1
11	Yes	4
	No	19
	No answer	2
12	Yes	11
	No	2
	Not sure	8
	No answer	4
	Offensive:	
	Yes	1
	No	22
	No answer	2
13	Yes	20
	No	1
	Not sure	4
	No answer	0
14	a	1
	b	9
	b & c	4
	a, b, & c	10
	No answer	1
15	b	3
	c	5
	e	2
	a & b	1
	a, b, & c	13
	No answer	1

172

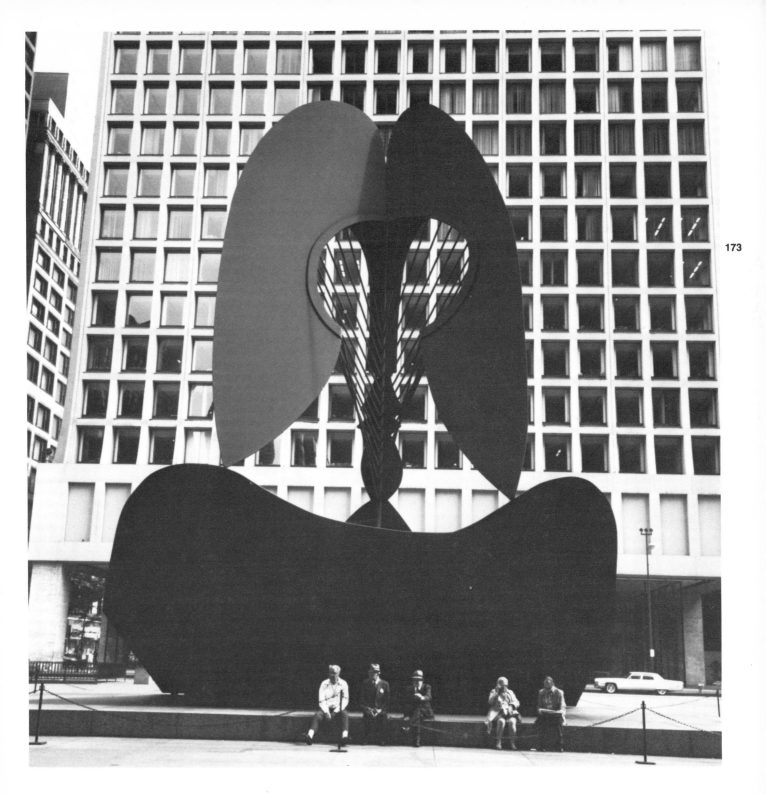

Lafayette Square
Washington, D.C.
Sculpture by Clark Mills

Statistical Information

1	Under 18	0
	18–25	12
	26–35	9
	36–55	3
	Over 55	1
2	Male	15
	Female	10
3	High school	5
	High school and technical training	1
	Some college and technical training	0
	Some college or degree	6
	Undergraduate degree and graduate study	13
4	Accountant	2
	Administrator	1
	Attorney	2
	Clerk	1
	Consultant	1
	Draftsman	2
	Economist	2
	Engineer	1
	Graphics manager	1
	Illustrator	1
	Language director	1
	Peace Corps Overseas staff engineer	1
	Physician	1
	Secretary	6
	No answer	2
5	Yes	13
	No	12

Information about Sculpture

1	Yes	22
	No	3
2	Like	11
	Dislike	2
	Neutral	12
3	Too large	1
	Too small	0
	Right size	23
	No answer	1
4	Yes	15
	No	6
	No opinion	4
5	Yes	14
	No	6
	No opinion	5
6	Yes	14
	No	7
	No opinion	4

7	Fairly well	20
	Extremely	0
	Not at all	3
	No answer	2
8	Yes	15
	No	10
9	Replace	6
	Remove	2
	Leave	17
10	Yes	8
	No	9
	Not sure	8
11	Yes	12
	No	10
	No answer	3
12	Yes	6
	No	5
	Not sure	11
	No answer	3
	Offensive:	
	Yes	3
	No	17
	No answer	5
13	Yes	20
	No	3
	Not sure	1
14	a	3
	b	2
	b & c	6
	a, b, & c	13
	No answer	1
15	a	4
	b	3
	c	4
	a & b	2
	a & c	1
	b & c	6
	a, b, & c	4
	No answer	1

174

John F. Kennedy Federal Center
Boston
Sculpture by Dimitri Hadzi

Statistical Information

1	Under 18	1
	18–25	8
	26–35	8
	36–55	5
	Over 55	3
2	Male	12
	Female	13
3	High school	8
	High school and technical training	3
	Some college and technical training	1
	Some college or degree	6
	Undergraduate degree and graduate study	6
	No answer	1
4	Account executive	1
	Airline reservationist	1
	Clerk	1
	Counter clerk	1
	Delinquency prevention planner	1
	File clerk typist	2
	IRS agent	1
	IRS manager	1
	Lawyer	1
	Medical secretary	1
	National Service officer	1
	Nurse's helper	1
	Office cashier	1
	Park leader	1
	Practical nurse	1
	Procurement specialist	1
	Retired	2
	Secretary	2
	Stock broker	1
	Teacher	1
	Typist-switchboard operator	1
	No answer	1
5	Yes	13
	No	11
	No answer	1

Information about Sculpture

1	Yes	24
	No	1
2	Like	15
	Dislike	3
	Neutral	7
3	Too large	2
	Too small	4
	Right size	15
	No answer	4
4	Yes	15
	No	5
	No opinion	5

176

5	Yes	22
	No	0
	No opinion	3
6	Yes	20
	No	2
	No opinion	3
7	Fairly well	18
	Extremely	4
	Not at all	2
	No answer	1
8	Yes	21
	No	4
	No answer	0
9	Replace	7
	Remove	0
	Leave	18
	No answer	0
10	Yes	6
	No	6
	Not sure	13
	No answer	0
11	Yes	3
	No	19
	No answer	3
12	Yes	4
	No	3
	Not sure	10
	No answer	8
	Offensive:	
	Yes*	1
	No	19
	No answer	5
13	Yes	17
	No	3
	Not sure	5
	No answer	0
14	a	2
	b	6
	c	2
	d (1) a & b	1
	(2) b & c	1
	(3) a, b, & c	12
	No answer	1
15	a	5
	b	2
	c	4
	d (1) b & c	4
	(2) a, b, & c	9
	No answer	1

*"This work is too complicated and confusing to be associated with a federal office building. The ideal piece should be more ordered and understandable" (Male lawyer, 26–35 age group).

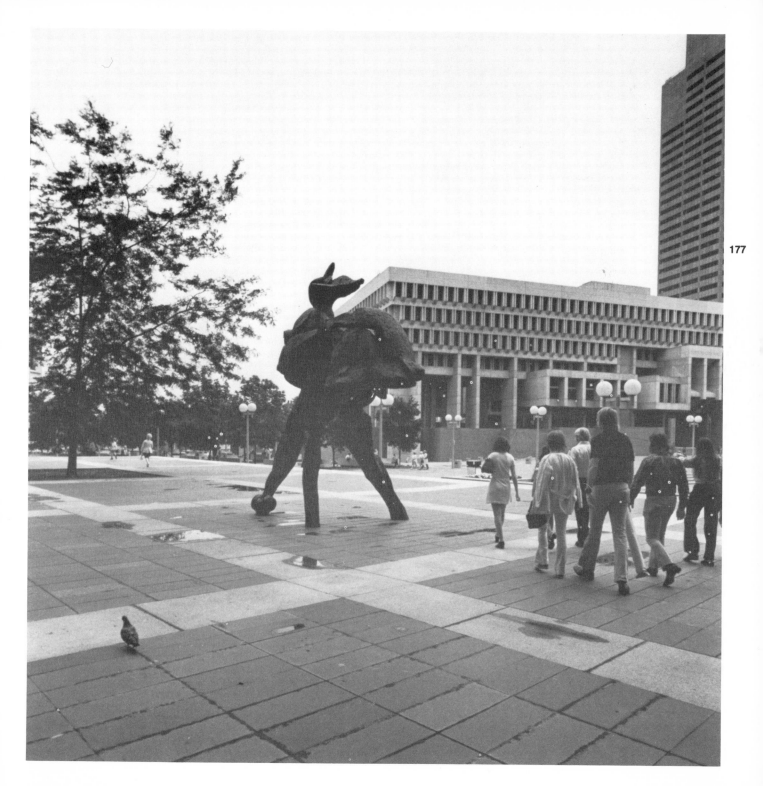

Franklin D. Murphy Sculpture Garden
University of California at Los Angeles
Los Angeles

Statistical Information

1	Under 18	1
	18–25	19
	26–35	3
	36–55	2
	Over 55	0
2	Male	17
	Female	8
3	High school	2
	High school and technical training	0
	Some college and technical training	0
	Some college or degree	18
	Undergraduate degree and graduate study	5
4	Artist	1
	Bus driver	1
	Chief of operations, survey research center	1
	College student	10
	College student (art/design)	5
	College student and movie actor	4
	Graduate student	1
	High school student	1
	Professor	1
5	Yes	19
	No	5
	No answer	1

Information about Sculpture

1	Yes	25
	No	0
2	Like	19
	Dislike	0
	Neutral	5
	No answer	1
3	Too large	0
	Too small	1
	Right size	9
	No answer	15
4	Yes	19
	No	2
	No opinion	3
	No answer	1
5	Yes	16
	No	3
	No opinion	4
	No answer	2
6	Yes	19
	No	2
	No opinion	3
	No answer	1

7	Fairly well	16
	Extremely	8
	Not at all	1
	No answer	0
8	Yes	22
	No	3
	No answer	0
9	Replace	3
	Remove	4
	Leave*	13
	No answer	2
10	Yes	3
	No	1
	Not sure	2
	No answer	19
11	Yes	1
	No	5
	No answer	19
12	Yes	0
	No	0
	Not sure	3
	No answer	22
	Offensive:	
	No	5
	No answer	25
13	Yes	21
	No	1
	Not sure	3
14	b	10
	a & b	1
	b & c	3
	b & property owners	1
	a, b, & c	10
15	a	5
	c	3
	a & b	4
	a & c	1
	b & c	2
	a, b, & c	10

*Additional works 3

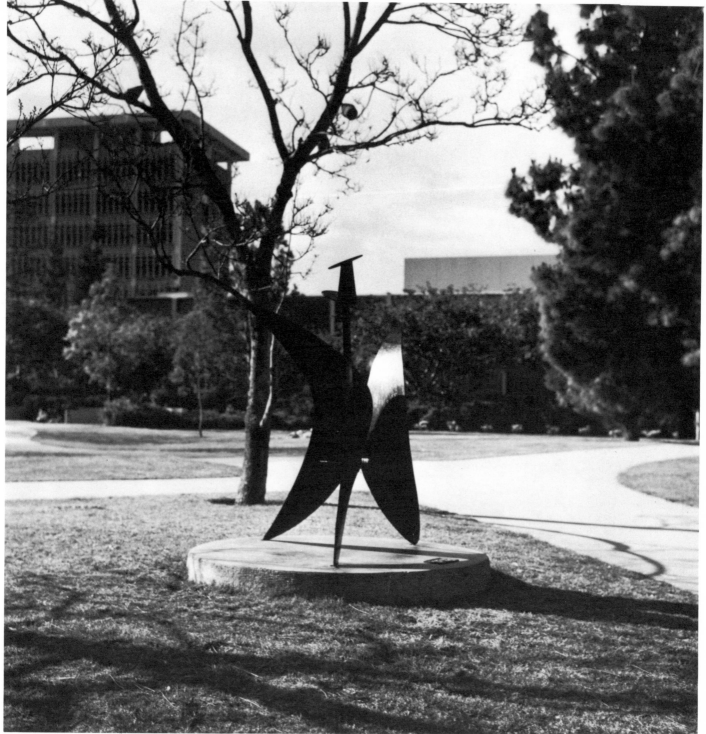

George Washington University
Washington, D.C.
Sculpture by Rudolph Heintze

Statistical Information

1	Under 18	1
	18–25	15
	26–35	5
	36–55	4
	Over 55	0
2	Male	14
	Female	11
3	High school	3
	High school and technical training	0
	Some college and technical training	0
	Some college or degree	10
	Undergraduate degree and graduate study	12
4	Clerk	1
	College admissions counselor	1
	College student	8
	Economist	1
	Engineer	1
	Executive director	1
	Government program manager	1
	Personnel director	1
	Porter	2
	Professor	1
	Receptionist	1
	Student (graduate)	5
	No answer	1
5	Yes	18
	No	7

Information about Sculpture

1	Yes	22
	No	3
2	Like	14
	Dislike	7
	Neutral	4
3	Too large	2
	Too small	2
	Right size	21
4	Yes	17
	No	7
	No opinion	1
5	Yes	19
	No	4
	No opinion	1
	No answer	1
6	Yes	19
	No	5
	No opinion	1
7	Fairly well	13
	Extremely	7
	Not at all	4
	No answer	1

8	Yes	16
	No	9
	No answer	0
9	Replace	7
	Remove	2
	Leave	16
10	Yes	7
	No	9
	Not sure	9
11	Yes	4
	No	13
	No answer	8
12	Yes	5
	No	2
	Not sure	8
	No answer	10
	Offensive:	
	Yes	0
	No	21
	No answer	4
13	Yes	25
	No	0
14	b	11
	a & b	1
	b & c	5
	a, b, & c	7
	a or b or c or any combination	1
15	a	4
	b	1
	c	2
	a & b	3
	a & c	2
	b & c	4
	a, b, & c	8
	a or b or c or any combination	1

180

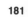

Appendix C
Information and Resources

Books, publications, and articles with particular applications to outdoor sculpture programs

Books

Art in Architecture by Louis G. Redstone. McGraw-Hill, New York, 1968.

182 *Art in European Architecture* by Paul Damaz. Reinhold, New York, 1956.

The New Patrons of the Arts by Gideon Chagy. Abrams, New York, 1973.

Articles

"On Correlating Sculpture with Architecture" by Albert Radoczy. *Arts and Architecture*, April 1948, pp. 28–30.

"The Humanizing Role of Sculpture" by Art Brenner. *AIA Journal* 60 (September 1973), pp. 24–27.

"Monumental Task" *Industrial Design*, November 1970, pp. 34–39.

"The Public Sculpture Problem" by Lawrence Alloway. *Studio International*, October 1972, pp. 122–125.

"Shall We Have a Renaissance?" by Barbara Rose. *Art in America*, March–April 1967, pp. 30–39.

Issues of Periodicals Devoted Primarily to Public Art or Outdoor Sculpture
Art in America, May–June 1974.
Arts, January 1975.
Design and Environment, Summer 1974.
Landscape Architecture, July 1971.

Catalogs and Other Special Publications

Catalogs (In cases where catalogs have been sold out, consult libraries or state arts councils.)

American Sculpture of the Sixties, catalog of exhibition, 1967. Los Angeles County Museum of Art, Los Angeles.

Franklin D. Murphy Sculpture Garden, catalog of permanent collection at the University of California at Los Angeles. Dickinson Art Center, U.C.L.A., Los Angeles.

Monumenta, catalog of Biennial Exhibition of Outdoor Sculpture at Newport, Rhode Island, 1974. Monumenta, Box 163, Newport, R.I.

Outdoor Sculpture 1974, catalog of exhibition September 21 – October 19, 1974. Merriewold West Gallery, Far Hills, N.J.

Public Sculpture/Urban Environment, catalog of exhibition September 29 – December 29, 1974. The Oakland Museum, Oakland, Calif.

Sculpture in the Park, catalog of exhibition of sculpture in Grant Park, Chicago, August – November 1974. The Art Institute of Chicago, Chicago.

Sculpture in the Park 1974, catalog of exhibition in Van Saun Park, Paramus New Jersey. The North Jersey Cultural Council, Paramus, N.J.

Sculpture Off the Pedestal, catalog of 1973 – 1974 exhibition in Grand Rapids, Michigan. The Grand Rapids Art Museum, Grand Rapids, Mich.

Twentieth Century Monumental Sculpture, catalog of exhibition October 12 – November 9, 1974. Marlborough Gallery, Inc., New York.

Vermont International Sculpture Symposium, catalog of Vermont International Sculpture Symposium. George Little Press (1973), Charlotte, Vt.

Other

"Americans and the Arts," brochure describing results of survey sponsored by the Associated Councils of the Arts. Available for $2 from A.C.A. Publications, Box 4764, Tulsa, Okla. 74104.

1% Art in Civic Architecture, publication prepared by RTKL Associates, Inc. of Baltimore, Maryland, with text by Bernard Perlman. Funded by the National Endowment for the Arts in Washington, D.C.

"Fact Sheet," information on the process of implementing an outdoor sculpture exhibition, prepared by the North Jersey Cultural Council, Paramus, N.J.

Visual Aids

Slides

Object and Environment: The Use and Placement of Outdoor Sculpture, 80 slides in presentation including audiotape and text. The American Society of Landscape Architects Foundation, 1750 Old Meadow Road, McLean, Va. 22101.

Painting and Sculpture in the Early 70's, 60 glass-mounted slides. Sandak Inc., 180 Harvard Avenue, Stamford, Conn. 06902.

Recent Sculpture, 45 slides of contemporary sculpture. Art Now, Inc., 144 N. 14th Street, Kennilworth, N.J. 07033.

Storm King Art Center: Permanent Collection, 47 glass-mounted slides of contemporary works in a natural landscape setting. Sandak, Inc., 180 Harvard Avenue, Stamford, Conn. 06902.

Films

The films listed here deal primarily with the works, work processes, attitudes, and concepts of individual sculptors. They are useful tools in bridging the communications gap between artist and audience. One in particular, *The Calder Man*, presents a very instructive view of the total process of the creation, fabrication, and installation of a work of public outdoor sculpture.

The Museum of Modern Art
Department of Film Circulating Programs
11 West 53 Street
New York, N.Y. 10019
Available for rental by schools, universities, colleges, museums, libraries, and other accredited educational institutions. Catalog available.

Alberto Giacometti, 1966, 12 minutes, sound, color.
The Calder Man, 1967, 15 minutes, sound, color.
Sonambients: The Sound Sculpture of Harry Bertoia, 1971, 16 minutes, sound, color.
Sort of a Commercial for an Icebag (Claes Oldenburg's first kinetic sculpture, *Giant Soft Icebag*), 1970, 16 minutes, sound, color.
Works of Calder, 1950, 18 minutes, sound, color.

The American Federation of Arts
Films on Art
41 East 65th St.
New York, N.Y. 10021
Rental films. Catalog available.

Alberto Giacometti, 30 minutes, color.
Artists: Claes Oldenburg, 30 minutes, black and white.
Birth of a Bronze (Jacques Lipchitz), 1954, 16 minutes, color.
Five British Sculptors at Work (Kenneth Armitage, Reg Butler, Lynn Chadwick, Barbara Hepworth, Henry Moore), 1964, 28 minutes, color.
Harry Bertoia's Sculpture, 23 minutes, color.
Images of Leonard Baskin, 1965, 28 minutes, color.
José de Creeft, 26 minutes, black and white.

Keinholz on Exhibit (impact of Keinholz's sculpture on public at an exhibition at the Los Angeles County Museum of Art), 25 minutes, black and white.

Commercial Galleries

The following commercial galleries either specialize in sculpture for outdoor or architectural settings or represent a number of artists whose work is particularly suitable for the outdoor setting.

Alice Simsar Gallery, 301 North Main Street, Ann Arbor, Mich. 48104.
Architectural Art, 1067 Green Street, San Francisco, Calif. 94133.
Arras Gallery, 29 West 57th Street, New York, N.Y. 10019.
Galerie Denise René, 6 West 57th Street, New York, N.Y. 10019.
Grace Borgenicht Gallery, Inc., 1018 Madison Avenue, New York, N.Y. 10021.
Judith Selkowitz Fine Arts, 219 East 69th Street, New York, N.Y. 10021.
Leo Castelli, 4 East 77th Street, New York, N.Y. 10021.
M. Knoedler & Co., 21 East 70th Street, New York, N.Y. 10021.
Marlborough Gallery, 40 West 57th Street, New York, N.Y. 10019.
Merriewold West Gallery, Box 747, Far Hills, N.J. 07931.
The Pace Gallery, 32 East 57th Street, New York, N.Y. 10019.
Sculpture Now, Inc., 142 Greene Street, New York, N.Y. 10012.
Zabriskie Gallery, 29 West 57th Street, New York, N.Y. 10019.

The following are not standard commercial galleries, but do offer services in the realm of outdoor sculpture.

SITE, Inc., 60 Greene Street, New York, N.Y. 10012. SITE, Inc. is a group of artists, writers, and technicians organized for the purpose of exploring and developing new concepts for the use of art in the urban environment.
Triad Designs, 137 Greene Street, New York, N.Y. 10012.

Fabricators

Among the following, not all specialize in contemporary large-scale sculpture. Of those that do, Lippincott, Inc. and Milgo Art Systems are the best known.

Arthur Bruce Hoheb, 39 – 48 24th Street, Long Island City, N.Y. 11101.
Bedi-Rassy Art Foundry, 227 – 31 India Street, Greenpoint, Brooklyn, N.Y. 11222.

Lippincott, Inc., 400 Sackett Point Road, North Haven, Conn. 06473.
Milgo Art Systems, 520 Morgan Avenue, Brooklyn, N.Y. 11222.
Modern Art Foundry, Inc., 18 – 70 41st Street, Long Island City, New York, N.Y. 11105.
Noggle Bronze Works, Prescott, Ariz. 86301.
Renaissance Art Foundry, 30 Meadow Street, South Norwalk, Conn. 06854.
Roman Bronze Works, Inc., 96 – 18 43rd Avenue, Corona, N.Y. 11368.
Sculpture Services, Inc., 9 East 19th Street, New York, N.Y. 10003.

Museums

The following museums have carried out or participated in the planning and implementation of various kinds of outdoor sculpture exhibitions.

The Art Institute of Chicago, Chicago, 1974.
The Contemporary Arts Center, Cincinnati, Ohio, 1970.
The Fine Arts Gallery of San Diego, San Diego, Calif., 1973.
The Grand Rapids Art Museum, Grand Rapids, Mich., 1973 – 1974.
The Los Angeles County Museum, Los Angeles, Calif., 1967.
The Oakland Museum, Oakland, Calif., 1974.

Sources for Consultation

Valuable assistance and direction may also be obtained from state arts councils and from university art departments.

The American Federation of Arts, 41 East 65th Street, New York, N.Y. 10021. Consultation for corporations, film programs. (Membership required.)
Business Committee for the Arts, 1270 Avenue of the Americas, New York, N.Y. 10020. Counseling for corporations.
Museum of Modern Art Advisory Service, Museum of Modern Art, 11 West 53rd Street, New York, N.Y. 10019. Advisory service available to corporations.
North Jersey Cultural Council, 368 B Paramus Road, Paramus, N.J. 07652. Counseling available to communities and community organizations about implementing outdoor sculpture exhibitions.
Women's Committee of the Grand Rapids Art Museum, Grand Rapids, Mich.

Bibliography

Books

Adams, Adeline. *The Spirit of American Sculpture.* New York: The Gillis Press, 1923.

Aesthetic Realism: We Have Been There. New York: Definition Press, 1969.

Arnheim, Rudolph. *Visual Thinking.* Berkeley: University of California Press, 1969.

Ashton, Dore. *Modern American Sculpture.* New York: Abrams, 1969.

Battcock, Gregory. *The New Art.* New York: Dutton, 1966.

———— ed., *Minimal Art.* New York: Dutton, 1968.

Boulding, Kenneth E. *The Meaning of the 20th Century.* New York: Harper & Row, 1964.

Brumme, C. Ludwig, ed. *Contemporary American Sculpture.* New York: Crown, 1948.

Burnham, Jack. *Beyond Modern Sculpture.* New York: Braziller, 1973.

Caffin, Charles. *American Masters of Sculpture.* New York: Doubleday, 1903.

Canaday, John. *Mainstreams of Modern Art.* New York: Henry Holt & Co., 1959.

————. *Culture Gulch.* New York: Farrar, Straus & Giroux, 1969.

Chagy, Gideon. *The New Patrons of the Arts.* New York: Abrams, 1973.

Craven, Wayne. *Sculpture in America.* New York: Thomas Y. Crowell, 1968.

Crosby, Theo. *Architecture: City Sense.* New York: Van Nostrand Reinhold, 1965.

Cullen, Gordon. *Townscape.* New York: Reinhold, 1961.

Damaz, Paul. *Art in European Architecture.* Preface by LeCorbusier. New York: Reinhold, 1956.

Davis, Douglas. *Art and the Future: A History/Prophecy of the Collaboration between Science, Technology and Art.* New York: Praeger, 1973.

DeWolfe, Ivor. *The Italian Townscape.* New York: Braziller, 1966.

Ellul, Jacques. *The Technological Society.* Translated by John Wilkinson. New York: Knopf, 1964.

Focillon, Henri. *The Life of Forms in Art.* Translated by Charles Beecher Hogan and George Kubler. New Haven: Yale University Press, 1942.

Forcese, Dennis P., and Richner, Stephen. *Social Research Methods.* Englewood Cliffs, N.J.: Prentice-Hall, 1973.

Giedion, Siegfried. *Space, Time and Architecture: The Growth of a New Tradition.* 3d ed. Cambridge, Mass.: Harvard University Press, 1954.

Giedion-Welcker, Carola. *Contemporary Sculpture: An Evolution in Volume and Space.* New York: Wittenborn, 1955.

Goldwater, Robert J. *What Is Modern Sculpture?* New York: The Museum of Modern Art, 1969.

Goode, James M. *Open-Air Sculpture of Washington: A Comprehensive Historical Guide.* Washington, D.C.: The Smithsonian Institution Press, 1974.

Greenberg, Clement. *Art and Culture: Critical Essays.* Boston: Beacon Press, 1961.

Gutheim, F.A. "Urban Space and Urban Design," in *The Future Use of Urban Land,* edited by J. Wingo. Baltimore: John Hopkins, 1963.

Hammacher, A. M. *The Sculpture of Barbara Hepworth.* Translated by James Brockway. New York: Abrams, n.d.

Hunter, Sam, and Jacobus, John. *American Art of the 20th Century.* New York: Abrams, 1973.

Kassler, Elizabeth B. *Modern Gardens and the Landscape.* New York: Museum of Modern Art, 1964.

Kepes, Gygory, ed. *The Man-made Object.* New York: Braziller, 1966.

Kranz, Stewart. *Science and Technology in the Arts.* New York: Van Nostrand Reinhold, Co., 1974.

Kulterman, Udo. *The New Sculpture: Environments and Assemblages.* New York: Praeger, 1968.

Lippard, Lucy. *Six Years: The Dematerialization of the Art Object.* New York: Praeger, 1973.

McMullen, Roy. *Art, Affluence, and Alienation: The Fine Arts Today.* New York: New American Library, 1969.

McSpadden, Joseph. *Famous Sculptors of America.* Dodd, Mead, 1924.

Maillard, Robert, ed. *Dictionary of Modern Sculpture.* New York: Tudor Publishing Co., 1960.

Martin, J. L., Nicholson, Ben, and Gabo, N., eds. *Circle: International Survey of Constructive Art.* New York: Praeger, 1971.

Moholy-Nagy, Laszlo. *The New Vision.* New York: Breiver, Warren & Putman, 1932.

————. *Vision in Motion.* Chicago: P. Theobald, 1947.

Molesworth, H. D. *European Sculpture: From Romanesque to Neoclassic.* New York: Praeger, 1965.

Muller, Gregoire. *The New Avant-Garde: Issues for the Art of the Seventies.* New York: Praeger, 1972.

Mumford, Lewis. *Art and Technics.* New York: Columbia University Press, 1952.

On the Future of Art. Essays by Arnold J. Toynbee, Louis I. Kahn, Annette Michelson, B. F. Skinner, James Seawright, J. W. Burnham, and Herbert Marcuse. Introduction by Edward F. Fry. New York: Viking, 1970.

Osborne, Harold, gen. ed. *The Appreciation of the Arts.* 3 vols. New York: Oxford University Press, 1969. Vol. 2, *Sculpture,* by L. R. Rogers.

Owings, Nathaniel Alexander. *The American Aesthetic.* New York: Harper & Row, 1969.

Poggioli, Renato. *The Theory of Avante-Garde.* Translated by Gerald Fitzgerald. New York: Harper & Row, 1971.

Pope-Hennesy, cons. ed. *A History of Western Sculpture.* 4 vols. Greenwich, Conn.: New York Graphic Society. Vol. 4, *Sculpture: 19th and 20th Centuries,* by Fred Licht. London: George Rainbird Ltd., 1967.

Proske, Beatrice. *Brookgreen Gardens, Sculpture.* Printed by order of the Trustees, Brookgreen Gardens, South Carolina, 1968.

Quinby, Florence Cole. *The Equestrian Monuments of the World.* New York, 1913.

Read, Herbert. *The Art of Sculpture.* New York: Pantheon, 1956.

————. *A Concise History of Modern Sculpture.* New York: Praeger, 1964.

————. *Art and Alienation.* London: Thames & Hudson, 1967.

Redstone, Louis G. *Art in Architecture.* New York: McGraw-Hill, 1968.

Ritchie, Andrew. *Abstract Painting and Sculpture in America.* New York: Museum of Modern Art, 1951.

————. *Sculpture of the Twentieth Century.* New York: Museum of Modern Art, 1952.

Rose, Barbara. *American Art Since 1900: A Critical History.* New York: Praeger, 1967.

Rosenberg, Harold. *The Anxious Object: Art*

Today and Its Audience. New York: Horizon Press, 1964.

——. *The De-definition of Art.* New York: Horizon Press, 1972.

Schnier, Jacques. *Sculpture in Modern America.* Berkeley: University of California Press, 1948.

Selz, Jean. *Modern Sculpture: Origins and Evolution.* Translated by Annett Michelson. New York: Braziller, 1963.

Seuphor, Michel. *The Sculpture of the Century, Dictionary of Modern Sculpture.* New York: Braziller, 1961.

Seymour, Charles. *Tradition and Experiment in Modern Sculpture.* Washington, D.C.: American University Press, 1949.

Sommer, Robert. *Street Art.* New York: Links Books, 1975.

Taft, Lorado. *The History of American Sculpture.* New York: Macmillan, 1903.

——. *Modern Tendencies in Sculpture.* Chicago: The University Press, 1921.

Trier, Edward. *Form and Space.* New York: Praeger, 1962.

Valentiner, Wilhelm. *Origins of Modern Sculpture.* New York: Wittenborn, 1946.

Wheeler, Mortimer. *Roman Art and Architecture.* Praeger, 1964.

Wilenski, R. H. *The Meaning of Modern Sculpture.* Boston: Beacon Press, 1961.

Zijderveld, Anton. *The Abstract Society.* Garden City, N.Y. : Anchor Books, 1971.

Periodicals

Alloway, Lawrence. "Monumental Art at Cincinnati." *Arts Magazine,* November 1970, pp.32–36.

——. "The Public Sculpture Problem." *Studio International,* October 1972, pp. 122–125.

——. Robert Smithson's Development." *Artforum,* November 1973, pp. 53–61.

Art in America, May–June 1974 (entire issue).

Baker, Elizabeth. "Mark di Suvero's Burgundian Season." *Art in America,* May–June 1974, pp. 59–62.

Borgzinner, Jon. "Chicago's New Picasso." *The Art Gallery,* March 1975, pp. 18–22.

Brenner, Art. "The Humanizing Role of Sculpture." *AIA Journal* 60 (September 1973), pp. 24–27.

Brown, Carol. "An Artist's 'Third Hand.' " *Phoenix,* June 1974, pp. 65, 95.

Corbin, Patricia. "Sculpture Out in the Open." *House and Garden,* December 1974, pp. 39, and 42.

Davis, Douglas. "Public Art: The Taming of the Vision." *Art in America,* May–June 1974, pp. 84–85.

Design and Environment, Summer 1974 (entire issue).

"A Different Dam." *Parks and Recreation,* May 1972, pp. 39, 64.

Dolanyi, Anna, and Fejes, Zoltan. "Jardin Sculpture: A Rich, Sensory Universe." *Landscape Architecture* 61 (July 1971), pp. 320–323.

Freedman, Doris. "Public Sculpture." *Design and Environment,* Summer 1974, p.19.

Gent, George. "The Growing Corporate Involvement in the Arts." *Art News,* January 1973, pp. 21–25.

——. "Survey Finds Many Would Pay $25 Tax for Culture." *New York Times,* Apr. 4, 1974.

"Going On." *AIA Journal* 60 (September 1973), p. 8.

Goldin, Amy. "The Esthetic Ghetto: Some Thoughts about Public Art." *Art in America,* May–June 1974, pp. 30–35.

Goode, James M. "Outdoor Sculpture: Washington's Overlooked Monuments." *Historic Preservation* 25 (January–March 1973), pp. 4–14.

Greenberg, Clement. "The New Sculpture." *Partisan Review,* June 1949, pp. 637–642.

Gutheim, F. A. "Civic Monumental Sculpture." *American Magazine of Art,* August 1933, pp. 371–378.

Hanks, Nancy. "Art to the People." *The Saturday Evening Post,* April 1974, pp. 80–83, 135.

Hughes, Robert. "Sea with Monuments." *Time,* Sept. 2, 1974, p. 60.

Huxtable, Ada Louise. "Public Sculpture — A City's Most Pervasive Art." *New York Times,* Sept. 15, 1974.

Kepes, Gyory. "The Artist as Environmentalist: A Proposal." *Ekistics* 34 (November 1972), pp. 372–374.

Kriegsman, Alan M. "A Closer Look at How Americans View Culture." *Washington Post,* Apr. 4, 1974.

Kurtz, Stephen. "Punctuating the Plaza." *Arts Magazine,* November 1967, p. 23.

Lacy, Bill N. "New Guidelines for Federal Architecture." *Art in America,* September–October, 1972.

Landscape Architecture 61 (July 1971) (entire issue).

Lippard, Lucy. "A is for Artpark." *Art in America,* November–December 1974, pp. 37–38.

Louviere, Vernon. "Picasso as a Spur to Productivity," under "Panorama of the Nation's Business." *Nation's Business,* July 1974, p. 39.

Malcolm, Andrew H. "Chicago to Get 50-Foot High Sculpture by Calder." *New York Times,* Apr. 24, 1973.

Margrill, Anita. "On Manhattan's Streets for Fun and Clout." *Landscape Architecture* 62 (July 1972), pp. 315, 353.

Meadmore, Clement, Fry, Edward, and Rose, Barbara. "Symposium on Three Dimensions." *Arts Magazine,* January 1975, pp. 62–65.

"Medians." *Grounds Maintenance,* July 1972, pp. 14–16.

Namuth, Hans. "The Kites of Guatemala." *Architecture Plus,* July – August 1974, pp. 64–69.

Nemser, Cindy. "Lila Katzen: A Human Approach to Public Sculpture." *Arts Magazine,* January 1975, pp. 76–78.

O'Doherty, Brian. "The Grand Rapids Challenge." *Art in America,* January–February 1974, pp. 78–79.

——. "Public Art and the Government: A Progress Report." *Art in America,* May – June 1974, pp. 44–49.

Page, Ruth, and Milens, Sanders. "Roadside Sculpture." *Parks and Recreation,* April 1972, pp. 34–37.

"The People Watchers." *Atlanta,* October 1970, pp. 58–61.

"Picasso's Prestressed Sculpture." *Engineering News-Record,* Aug. 8, 1968, pp. 20–21.

Pohs, Henry A. "One Man against the Mountain." *National Sculpture Review,* Winter 1967–68, pp. 23–26.

"Proposed Sculpture Garden for the Art Institute of Chicago: Project of Graduate School, I.I.T." *Arts and Architecture,* June 1961, pp. 18–19.

Radoczy, Albert. "On Correlating Sculpture with Architecture." *Arts and Architecture,* April 1948, pp. 28–30.

Robins, Corinne. "New York: Public Sculpture in Public Places." *Arts Magazine,* Summer 1967, pp. 50–51.

"Rockne Krebs at the Philadelphia Museum of Arts," in "Review of Exhibitions." *Art in America,* September–October 1973, pp. 118–119.

Rose, Barbara. "Looking at American Sculpture." *Artforum,* February 1965, pp. 29–36.

——. "Shall We Have a Renaissance?," *Art in America,* March–April 1967, pp. 30–39.

"A Sculpture First." *National Sculpture Review* 22 (Fall 1973), pp. 20–21.

"Sculpture-In-the-Open-Air." *Landscape Architecture* 28 (July 1928), p. 314.

Shapiro, David. "Sculpture as Experienced: The Monument That Suffered." *Art in America,* May–June 1974, pp. 55–58.

Sommer, Robert. "People's Art." *AIA Journal* 58 (December 1972), pp. 29–34.

Terrell, Angela. "Honoring Mary Bethune: A Proud, Principled Woman." *Washington Post,* July 8, 1974.

"Time, Weather, and Sculpture." *Architectural Review* (December 1947), p. 206.

Wines, James. "The Case for Site Oriented Art." *Landscape Architecture* 61 (July 1971), pp. 317–319.

Catalogs and Other Special Publications

American Sculpture of the Sixties. Essays by Lawrence Alloway, John Coplans, Clement Greenberg, Max Kozloff, Lucy R. Lippard, James

Monte, Barbara Rose, and others. Los Angeles: Los Angeles County Museum, 1967.
Art Now 74: A Celebration of the American Arts. John F. Kennedy Center for the Performing Arts, May 30 – June 16, 1974. Washington, D.C.: Artrend Foundation, 1974.
"Atlanta Gateway Park." MGIC Investment Corporation. Brochure.
British Painting and Sculpture: 1960–1970. London: The Tate Gallery and the British Council, 1970.
"The City Is for People." San Diego, Calif.: Fine Arts Gallery of San Diego, July 1973. Brochure.
David Smith. Available from the Storm King Art Center, Mountainville, N.Y.
Franklin D. Murphy Sculpture Garden. Los Angeles: University of California at Los Angeles, n.d.
José De Rivera: Retrospective Exhibition 1930–1971. Available from the Grace Borgenicht Gallery, New York.
Kosso Eloul. Available from the Arras Gallery, Ltd., New York.
Martin Chirino. Printed by Kenner Printing Co., Inc., New York. Available from the Grace Borgenicht Gallery, New York.
Monumenta. Introduction by Sam Hunter. Monumenta Newport, Inc., Newport, R.I.
National Community Arts Program. H.U.D., 1973. Washington, D.C.: Government Printing Office.
The National Endowment for the Arts: Visual Arts Program Guidelines, Fiscal Year 1974. Washington, D.C.: Government Printing Office, #870-653.
New York City Public Sculpture by 19th Century American Artists. New York: The Metropolitan Museum of Art.
Nicolas Schöffer. Available from the Galerie Denise René, New York.
1% Art in Civic Architecture. Text prepared by Bennard B. Perlman. Baltimore, Md.: RTKL Associates, Inc., 1973.
Outdoor Sculpture 1974. Available from the Merriewold West Gallery, Far Hills, N.J.
"Peachtree Center." Atlanta, Ga. April 1973. Brochure.
Roy Gussow. Available from the Grace Borgenicht Gallery, New York.
Ruth Asawa's San Francisco Fountain. San Francisco, 1973.
Sculpture in the Park 1974. Paramus, N.J.: North Jersey Cultural Council.
Sculpture Off the Pedestal. Introduction by Barbara Rose. Grand Rapids, Mich.: The Grand Rapids Art Museum, 1973.
"Sculpture on the Highway." Vermont International Sculpture Symposium, University of Vermont, Burlington, Vt. 05401. Brochure.
Twentieth Century Monumental Sculpture. Available from the Marlborough Gallery, Inc., New York.

Vermont International Sculpture Symposium. Text by Lois Ingram. Charlotte, Vt.: George Little Press, Inc., 1973.

Unpublished Material

American Institute of Architects Research Programs, Washington, D.C. "Sample Survey Check List." (Mimeographed.)
Brancoli, David. Public Information Officer, Bank of America, San Francisco, Calif. Letter and mimeographed material, May 15, 1973.
Brenner, Art. "Sculpture and Architecture." Article based in part on a previous article appearing in *Leonardo,* Vol. 4, 1971. (Mimeographed.)
———. Letter, Feb. 12, 1973.
Collins, DuTot & Associates. "University of Pennsylvania Campus Fine Arts Study." Philadelphia: Collins, DuTot & Associates, 1970.
Damaz, Paul. "National Survey on Legal Contracts Covering Architectural Works of Art," including additional memos and recommendations regarding the New York City Ordinance. Study for AIA, December 1971. (Mimeographed.)
Dubuffet, Jean. "Text of M. Dubuffet's Remarks." Oct. 24, 1972. The Chase Manhattan Bank.
Everett, Roxanne. Vice President, Lippincott Inc., North Haven, Conn. Letter, brochures, xeroxed press releases, May 17, 1973.
Fine Arts Gallery of San Diego. Press release, June 7, 1973. (Mimeographed.)
Hiers, Lee C. Research Associate, Atlanta Chamber of Commerce, Atlanta, Ga. Letter, Aug. 8, 1973.
Institute of Contemporary Art, Boston, Mass. "Arts Renewal: Boston's Visual Environment." Symposium handout material, May 1 – 4, 1974. (Mimeographed.)
Keeler, Mrs. M. S. Unpublished report on "Sculpture Off the Pedestal," February 1974. (Mimeographed.)
———. Updated unpublished report on "Sculpture Off the Pedestal," including the earthwork by Robert Morris. October 1974. (Mimeographed.)
———. Unpublished report on the Grand Rapids Alexander Calder stabile, "La Grande Vitesse." (Mimeographed.)
Krigbaum, David M. Publicity Director, Phoenix Civic Plaza. Letter, Feb. 6, 1973.
Littman, Robert R. Art Director, Association for a Better New York. Letter and xeroxed press releases, May 17, 1973.
Merlino, Maxine. Acting Dean, School of Fine Arts, California State University, Long Beach, Calif. Letter and mimeographed report on the 1965 Symposium, Jan. 23, 1973.
Mitchell, W. S. President, Safeway Stores, Inc. Letter and xeroxed material, June 27, 1973.
Rosenthal, Tony. Letter and mimeographed material, Nov. 16, 1974.

Seitel, Fraser P. Press Relations Manager, The Chase Manhattan Bank. Letter, photographs, xeroxed material, May 25, 1973.
Strand, Mrs. Eugene. Pasadena, Calif. Letter to William Bridgers of Cornell, Bridgers, Troller & Hazlett, Oct. 13, 1972.
Syracuse University, the George Arents Research Library for Special Collections in the Syracuse University Libraries. The James Earle and Laura Gardin Fraser Collection. Syracuse, New York.
Tinnirello, Joseph J. Director of Architectural and Facilities Services, Pepsico, Inc., Purchase, N. Y. Letter and mimeographed material, Aug. 22, 1973.
Turner, Susan. Research Associate, Atlanta Chamber of Commerce, Atlanta, Ga. Letter, June 4, 1973.
Ylvisaker, William T. Chairman, Gould Inc. "Opening Remarks: Pablo Picasso's *Bather,*" Mar. 10, 1975. (Mimeographed.)

Interviews

Beck, Mrs. Ralph. Executive Director, Greater Atlanta Arts Council, Atlanta, Ga. Interview, August 1973.
Bransdorfer, Mrs. Stephen. Member, Women's Committee of the Grand Rapids Art Museum, Grand Rapids, Mich. Telephone interview, January 1974.
Damaz, Annie. Art Consultant, New York. Telephone interview, December 1974.
Conway, Don. Director of Research Programs, The American Institute of Architects, Washington, D.C. Interviews, October 1974 and January 1975.
Downing, Roland O. Assistant Vice President, The First National Bank of Atlanta, Ga. Interview, August 1973.
Feuerlicht, Herbert A. Sculptor, New York. Telephone interview, July 1974.
Gardiner, Henry G. Director, The Fine Arts Gallery of San Diego, San Diego, Calif. Interview, August 1973.
Gutheim, F. A. Washington, D.C. Interview, November 1973.
Harris, Charles S. Senior Associate, Roy Littlejohn Associates, Washington, D.C. Periodic interviews, 1972–1975.
Hewryk, Titus. University of Pennsylvania Planning Office, Philadelphia. Interview, September 1974.
Idema, Marilyn. Public Relations Director, Embarcadero Center, San Francisco, Calif. Interview, November 1972.
Keeler, Mrs. M. S. Member, Women's Committee of the Grand Rapids Art Museum, Grand Rapids, Mich. Periodic interviews and correspondence, January 1974–December 1974.

Kline, D. C. Professor Emeritus, Art Department, The George Washington University, Washington, D. C. Interview, October 1972.

Lacy, Bill. Director, Architecture + Environmental Arts Program of the National Endowment for the Arts, Washington, D.C. Interview, October 1973.

Lehr, Harold. Sculptor, New York. Interview, October 1972.

Margrill, Anita. Sculptor, New York. Several interviews between October 1972 and January 1975 and extensive correspondence.

Myers, Fred. Director, Grand Rapids Art Museum, Grand Rapids, Mich. Telephone interview, January 1974. Personal interview, May 1974.

O'Doherty, Brian. Director, Visual Arts Program of the National Endowment for the Arts, Washington, D.C. Interview, March 1974.

Perlman, Bennard. Artist and Art Consultant, Baltimore, Maryland. Interview, Institute of Contemporary Arts, Boston, May 1974.

Sanders, W. H. Peachtree Center, Atlanta, Ga. Interview, August 1973.

Talbot, Kenneth. Collins, DuTot & Associates, Philadelphia. Telelphone interview, April 1974.

Tarbox, Gurdon L., Jr. Director, Brookgreen Gardens, Murrells Inlet, S.C. Interview, October 1972.

Venable, Sara Jane. Coordinator of Art, Lansing, Michigan School District, Lansing, Mich. Interview, July 1973.

Watson, Ronald. Chairman, Art Department, Acquinas College, Grand Rapids, Mich. Interviews, March 1974 and May 1974.

Wines, James. President, SITE, Inc., New York. Interview, February 1974.

Yasko, Karel. General Services Administration, Washington, D.C. Periodic interviews, 1973–1975.

Index

Edited by Susan Davis
Designed by Michel Goldberg
Set in 10 point Helvetica by
Gerard Associates/Graphics Art, Inc.